PLANET ARCTIC

PLANET ARCTIC

Life at the Top of the World

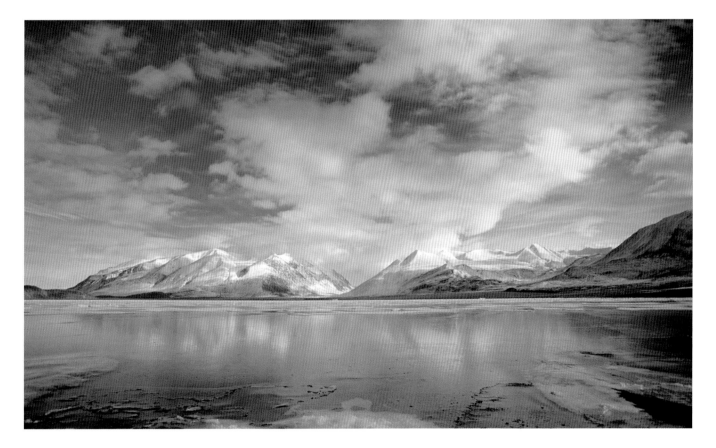

WAYNE LYNCH

FIREFLY BOOKS

A FIREFLY BOOK

Published by Firefly Books Ltd. 2010
Copyright © 2010 Firefly Books Ltd.
Text and images © 2010 Wayne Lynch

First printing

Book design: Counterpunch Inc. / Linda Gustafson, Peter Ross

The publisher gratefully acknowledges the financial support for our publishing program by the Government of Canada through the Canada Book Fund as administered by the Department of Canadian Heritage.

Published in the United States by
Firefly Books (U.S.) Inc.
P.O. Box 1338, Ellicott Station
Buffalo, New York 14205

Published in Canada by
Firefly Books Ltd.
66 Leek Crescent
Richmond Hill, Ontario L4B 1H1

Printed in China

Publisher Cataloging-in-Publication Data (U.S.)
Lynch, Wayne.
 Planet Arctic : life at the top of the world /
photographer Wayne Lynch.
[240] p. : col. photos. ; cm.
Includes index.
Summary: Photographs depict the unique environment and variety of animals, birds and plants of the Arctic.

ISBN-13: 978-1-55407-632-1
ISBN-10: 1-55407-632-3
1. Arctic regions – Pictorial works. 2. Arctic regions – Description and travel. 3. North Pole – Description and travel. 4. Landscape photography – Arctic regions. 5. Animals – Arctic regions. I. Title.
577.09113 dc22 G610.L963 2010

Library and Archives Canada Cataloguing in Publication
Lynch, Wayne
 Planet Arctic : life at the top of the world / Wayne Lynch.
Includes index.
ISBN-13: 978-1-55407-632-1
ISBN-10: 1-55407-632-3
1. Animals–Arctic regions–Pictorial works. 2. Arctic regions–Pictorial works. I. Title.
QL105.L965 2010 591.70911'3 C2010-900546-5

Title spread: Ellesmere Island, the most northern landmass in the Canadian Arctic Archipelago.

Pages 6–7: In many portions of the Arctic, polar bears are forced to fast on land when the sea ice melts in summer.

Page 8: Scientists predict that as a result of global warming, the Arctic Ocean will be seasonally ice-free in summer by 2030.

With love to Aubrey, mon trésor

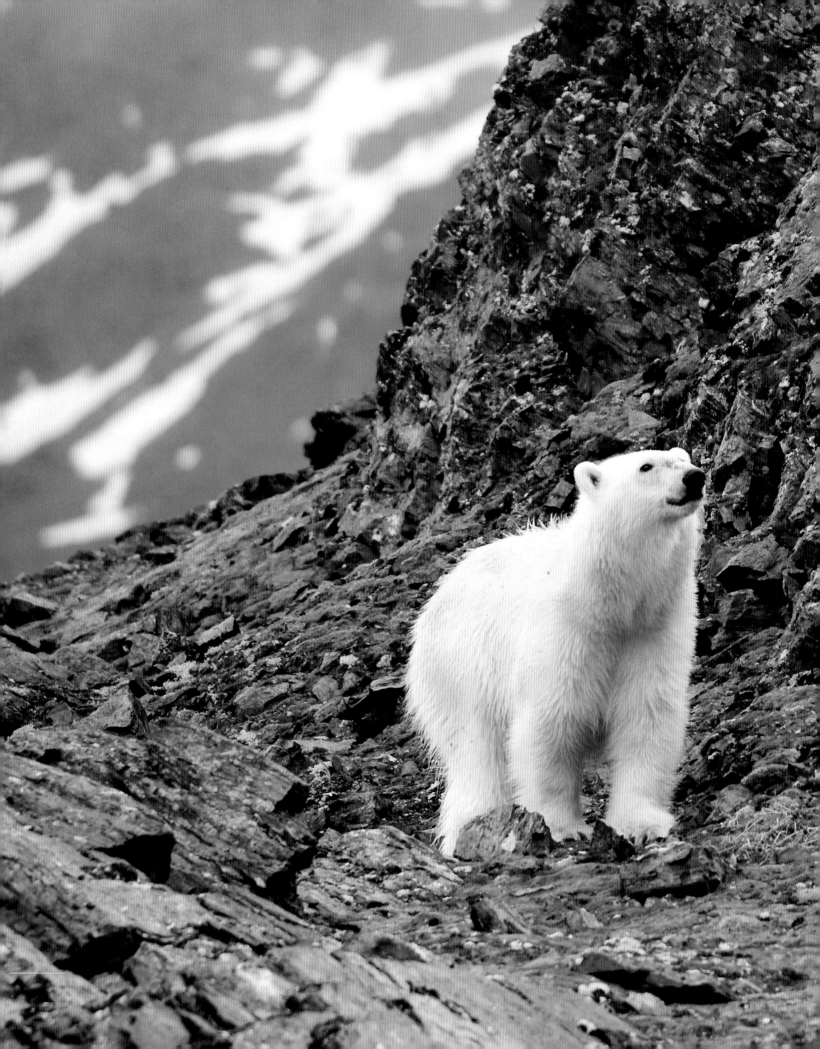

ACKNOWLEDGMENTS

My sincere thanks to the wildlife scientists whose efforts in the field and technical writings have made it possible for me to understand the rich and fascinating biology of arctic wildlife. In particular, I am grateful to: Dr. Fenja Brodo, Peter Clarkson, Dr. George Calef, Dr. Gordon Court, Dr. Andrew Derocher, Dr. David Gray, Dr. Bernd Heinrich, Dr. David Henry, Dr. Paul Johnsgard, Dr. Kit Kovacs, Dr. Olga Kukal, Dr. David Mech, Dr. Pl Prestrud, Dr. Tom Smith and Dr. Ian Stirling.

My gratitude also to my longtime friend Joe Van Os of Joseph Van Os Photo Safaris, who over the past three decades has hired me as a naturalist on numerous trips to the Arctic, which allowed me to broaden my experience of the area; and to the many staff members at Parks Canada, in particular André Guindon, who have helped me whenever they could.

This is my fifth book working with editor Tracy C. Read at Bookmakers Press, and she continues to be a skilful, insightful purveyor of the written word and a darn nice person to work with. At Firefly Books, associate publisher Michael Worek was professional and helpful, as was managing editor Nicole Caldarelli and designer Linda Gustafson.

One last person deserves thanks above all others, my best buddy and wife of 35 years, Aubrey Lang. She reviewed the text with her usual sharp eye and perceptiveness and often accompanied me in the field when we paddled, backpacked and camped in some of the most remote areas of the Arctic. Her tenacity is remarkable, and her unwavering belief in our relationship is a constant reminder of how lucky I am to have met her.

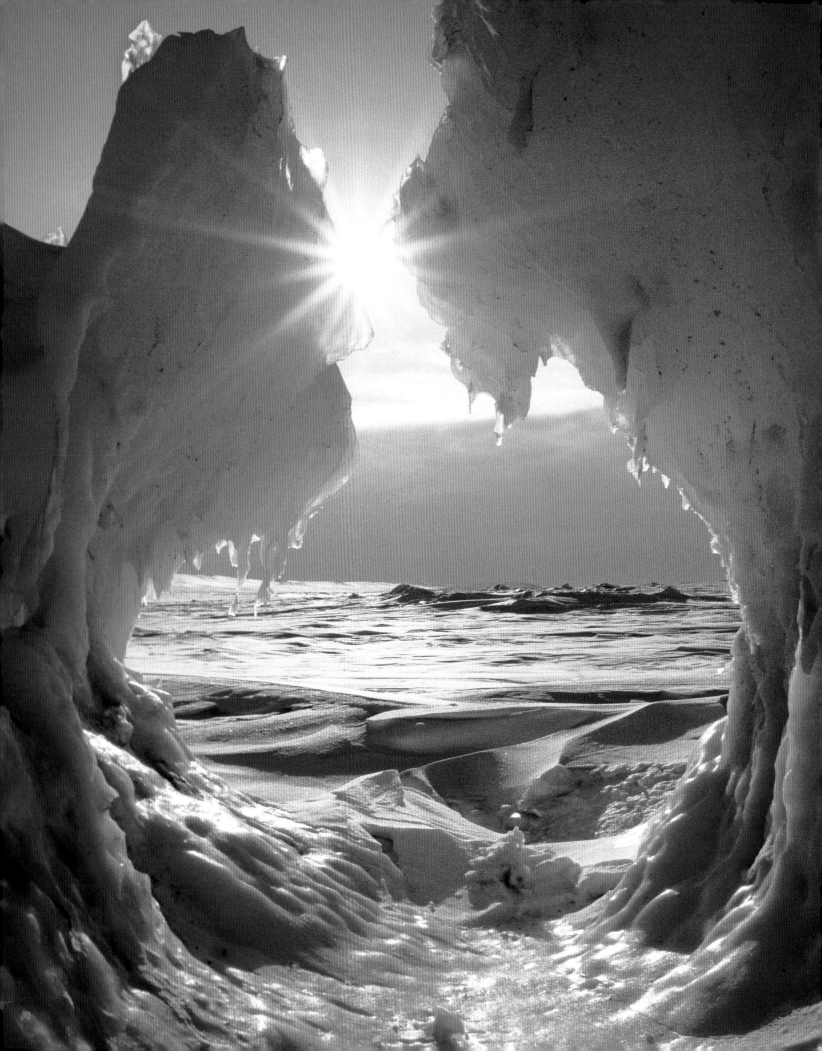

CONTENTS

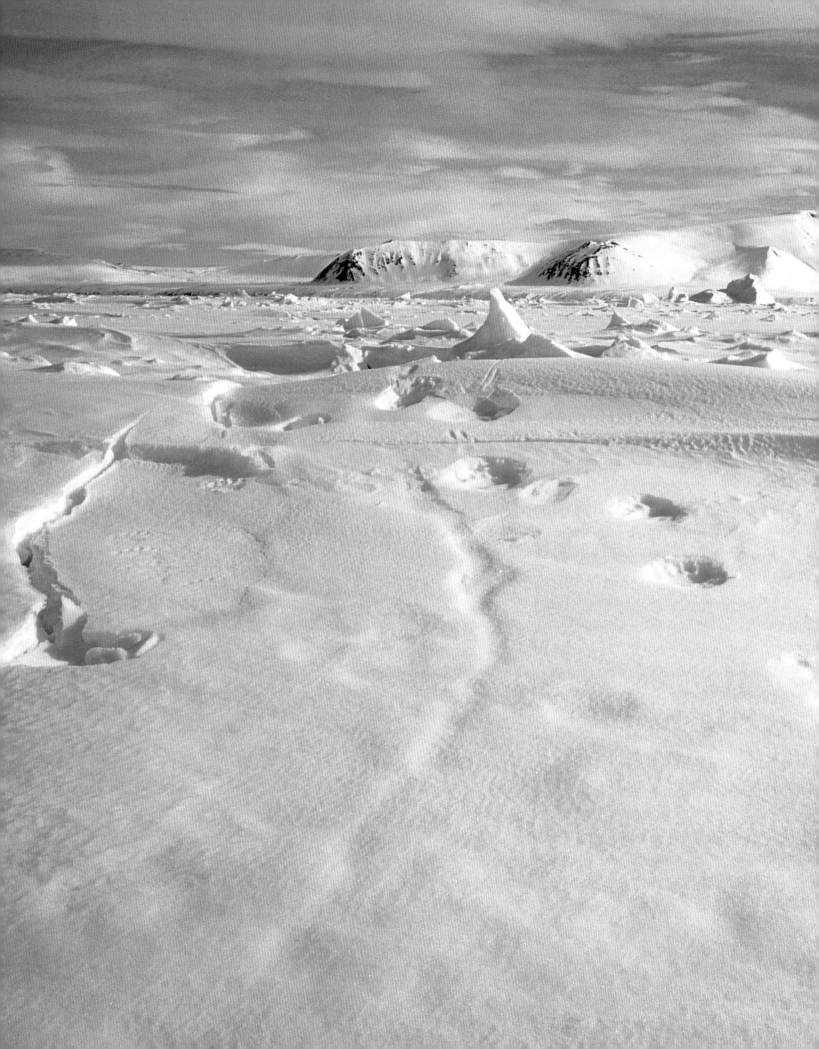

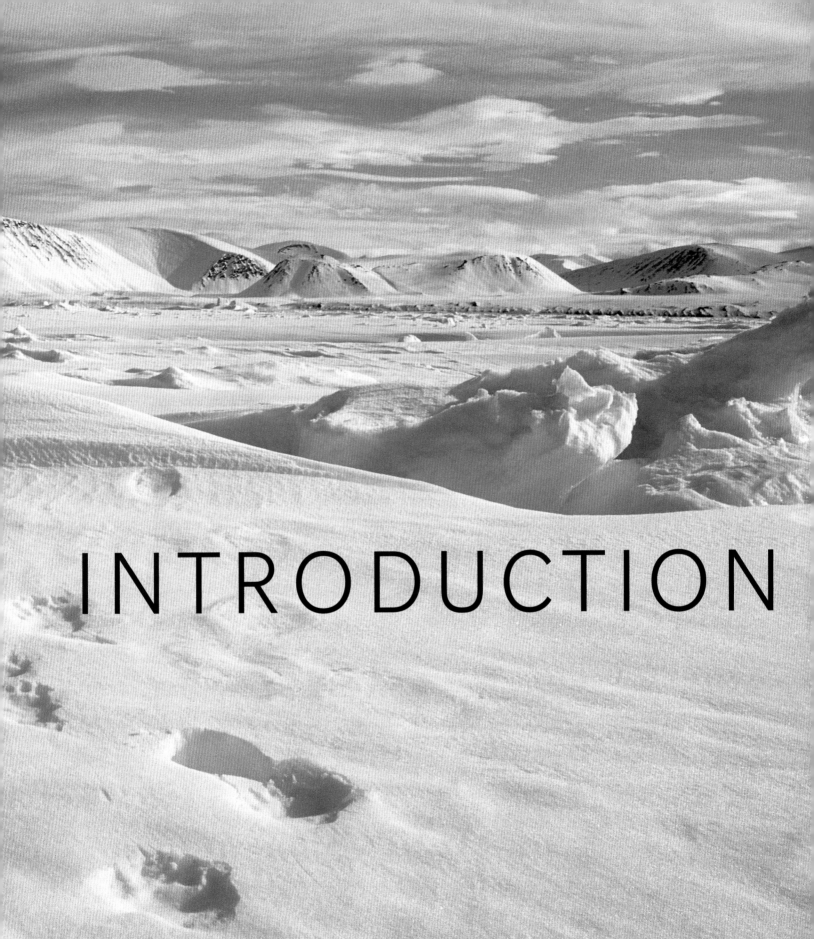

INTRODUCTION

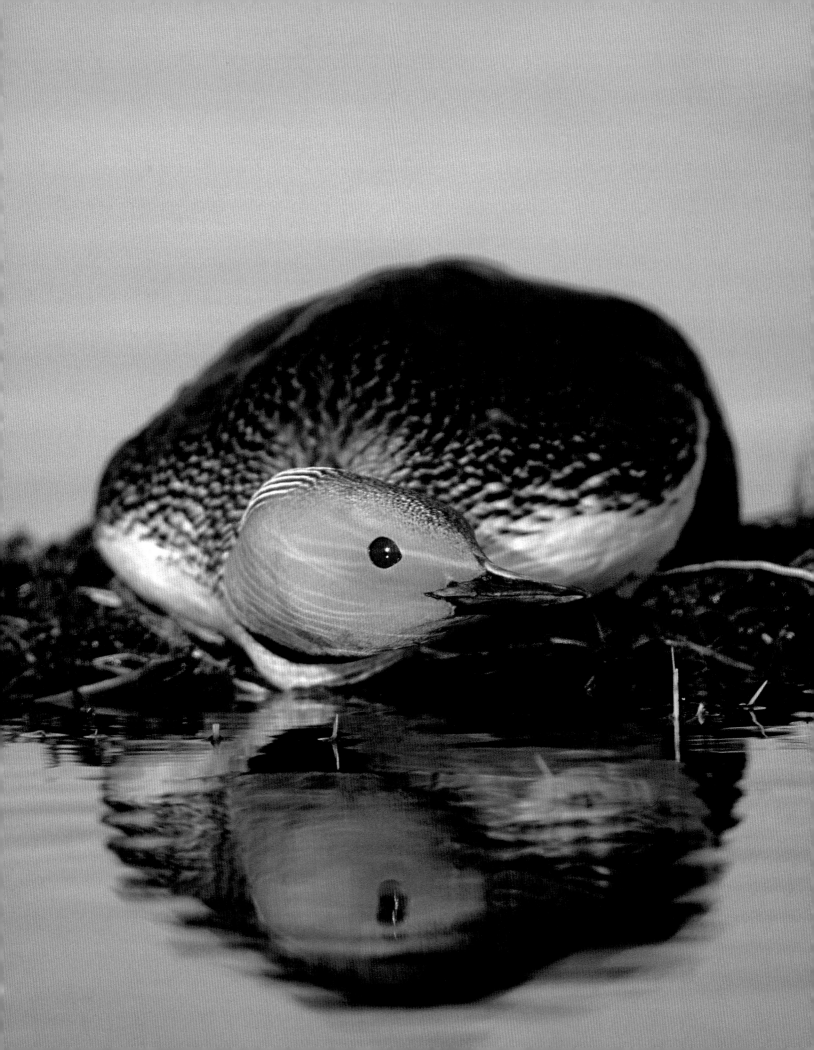

I confess: I'm addicted to the Arctic. For more than thirty years, I've traveled to those mystical lands north of 60 degrees where, at the height of summer, the sun never sets, and the land pulses with life. I recall the chaos and cacophony of seabird cliffs and the regal beauty of caribou bulls, their necks swollen with the autumn rut and their passions ablaze. I remember, too, bumblebees encrusted with hoarfrost, crimson flowers dancing in the wind, the whiteness of a snowy owl on wings that whisper and the ghostly refrain of a yodeling loon. These are but a few of the Arctic memories that have enriched my life beyond anything I could have dreamed.

When I reflect upon these years, one particular moment often comes to mind. It was early summer, and my wife Aubrey and I were camped near the northern coast of Banks Island in the Canadian High Arctic. That day, I wrote in my journal:

> Five white wolves suddenly appeared on a ridge next to camp. Their pelts were scruffy with the summer molt, but they moved with the fluid grace of highly tuned hunters. They stared at us for a few moments, each of them alert and tense, and then moved on. As the pack departed, one of the wolves lagged behind the others and howled in our direction a dozen times or more. The howl of a wolf is a haunting sound that penetrates deep into the soul of the listener, stirring the embers of existence and fanning them into glorious flame. The five wolves that visited our camp this afternoon were gone in a matter of minutes, but the sight and sound of these legendary beasts left me flushed with excitement for hours afterward.

Before we set out on our journey north, let's briefly review what we mean by the term "Arctic." In many ways, its definition depends largely upon the scientific bent of the user. For instance, geographers frequently use the Arctic Circle – 66 degrees 32 minutes north latitude – as the Arctic's southern boundary. It circles the globe roughly 1,620 miles (2,700 km) from the North Pole and encloses 8 percent of the Earth's surface.

Climatologists, on the other hand, define the Arctic using summer temperatures as a guide, joining together all the points in the Northern Hemisphere where the average temperature of the warmest month of the year is 50 degrees F (10°C). Everything north of that line – which is called the 50-degree-F isotherm – is considered part of the Arctic. Since plants and animals have a greater reaction to climate than they do to degrees of latitude, this definition is more meaningful from an ecological standpoint.

The boundary used by most ecologists is the northern tree line, and this is the one I have used in *Planet Arctic*. The tree line is a physical boundary that a person can see and easily understand. Throughout much of its course, the tree line actually parallels the 50-degree-F isotherm, so the two boundaries encompass roughly the same geographical area.

Those of us who have traveled to the Arctic understand it as a place in which humanity is put into perspective. Visitors are awed and humbled, both by the land and by its creatures. But even if you never have a chance to experience this hinterland carved from the cold, it is my hope that *Planet Arctic* will help you to appreciate the logic and purpose in the lives of its inhabitants. Travel with me now to a world that is often frozen but never lifeless, often darkened but never dull, often daunting but never forgotten.

Opening spread: In the fractured shorefast ice along the coast of Baffin Island, ringed seals commonly excavate caves under the drifting snow in which they can rest and shelter from the cold. Their presence explains the area's attractiveness to hunting polar bears, which detect the seals and then pinpoint their location with their acute sense of smell. The rooftop snow of some seal lairs may be hard-packed and three feet (0.9 m) thick. Even so, a large polar bear can crash through the roof in a single pounce and grab the seal before it is able to escape through its plunge hole in the ice.

Page 12: This red-throated loon was successful in its attempt to evade an arctic fox loping across the tundra near the shoreline, apparently oblivious to the bird sitting conspicuously on its lakeside nest. During the 27-day incubation period, both the male and female loon take turns sitting on the nest, although the female does the greater share. The off-duty bird spends most of its time foraging, sometimes many miles away.

Right: The tree line marks the boundary between the spruce and larch forests of the boreal forest ecosystem and the openness of the arctic tundra. Unlike the sharp alpine tree line of many mountainsides, the arctic tree line is a broad boundary; in places, it is many miles wide. Typically, as you move north, the trees gradually thin out and shorten. As their numbers dwindle, the remaining arboreal frontiersmen huddle in clusters, surrounded by fingers of encroaching tundra. The spruce trees pictured have been pruned on one side by the abrasive action of wind-driven ice crystals.

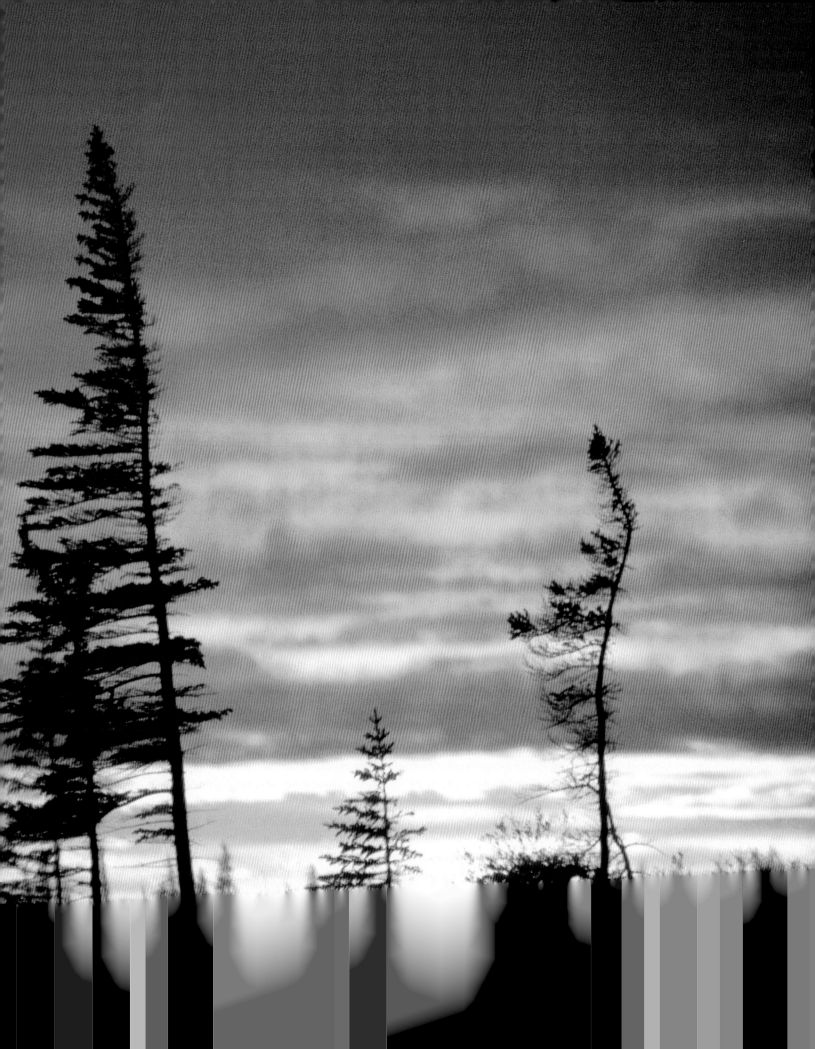

THE LARGE
AND THE

LEGENDARY

Some of my fondest memories of arctic wildlife are so vivid that it seems I can still feel the wind in my hair and hear the comforting songs of familiar tundra birds decades after the moment has passed. Such is my remembrance of a playful herd of muskoxen grazing beside a swollen stream on Banks Island in Canada's Northwest Territories. It was the height of summer and the living was easy for these shaggy northern beasts, which had been drawn streamside by lush green sedges. For over an hour, I watched them feeding quietly. Suddenly, one of the yearlings in the herd waded into the shallows and began to splash and jump in circles. It was soon joined by a second yearling and an adult female. All three tossed their heads, twisted, pawed and whirled around as if infected with an irrepressible glee.

The tangible joy of the moment brought tears to my eyes, and I wiped them away before my companions could see how stirred I had been by such a simple event in nature. The exuberant display was over in less than a minute; soon after, the muskoxen quietly forded the stream and wandered out of sight. Yet even now, as I write these words half a lifetime later, I struggle with my emotions as I recall the deep feelings these animals evoke in me.

The muskox (*Ovibos moschatus*) is just one of the three large land mammals whose power, reputation and glamour infuse a trek across the arctic tundra with excitement. The two others are the caribou (*Rangifer tarandus*), known in Eurasia as reindeer, and the brown bear (*Ursus arctos*), which in North America is often called the grizzly. A large body requires ample food to fuel the internal fires of life, so it is not surprising that these three animals derive most of their energy from plants, the most abundant source of food on the arctic tundra. During the summer, muskoxen and caribou eat mainly grasses, sedges and willows; in winter, caribou add lichens to their menu. Tundra grizzlies also graze on greenery, adding roots and berries when they are seasonally nutritious. Grizzlies, however, are also opportunistic hunters with the will and weaponry to overpower prey. In spring, arctic grizzlies occasionally hunt and chase newborn caribou and muskoxen calves; in summer, they might excavate tons of turf to uncover burrowing ground squirrels; and in every season, they defend and dine on any carcass they find.

A sizable physique produces a host of benefits for an arctic animal. In a cold environment, heat loss occurs largely through the surface of an animal's body. A big animal has a smaller surface area relative to its body mass than does a small animal and is thus better suited to withstand the cold. On the other hand, the small body size and large surface area of newborn animals is the reason many need to be sheltered and warmed in order to prevent them from becoming lethally chilled.

A large-bodied animal is also able to carry extra fat without the additional weight serving as an encumbrance to movement. In the halcyon days of summer, Svalbard reindeer, a wild subspecies of caribou, may pad their backs, flanks and rumps with layers of fat, increasing their weight by up to 30 percent. A bull muskox may carry an additional 110 pounds (50 kg) between its lowest weight in late winter to its highest weight at the end of summer. In the waning days of summer, grizzlies become frenzied feeders, eating for up to 20 hours a day and consuming 20,000 calories. Scientists have estimated that a hungry grizzly might

gobble up as many as 200,000 soapberries in a single day. A female grizzly on the Tuktoyaktuk Peninsula in Canada's Northwest Territories has done even better, packing on four pounds (1.8 kg) every day for a month from mid-August onward. Large animals with ample fat reserves can also fast for great lengths of time, an ability that buffers them against the inevitable hardships which arise during periods of poor food supply and adverse weather, both of which regularly occur in the Arctic.

Largeness also potentially confers mobility, and the wanderlust of caribou, muskoxen and grizzlies exemplifies this principle well. Herds of muskoxen may plod great distances between High Arctic islands, traversing hundreds of miles of sea ice to locate better feeding conditions. Great numbers of caribou commonly migrate more than 500 miles (800 km) each autumn and spring as they shuttle between regions of treeless tundra and the protective fringe of the tree line where they frequently overwinter. Grizzly bears can be equally far-ranging. Alaskan researchers tracked a male grizzly in the Brooks Range that roamed across a home range of over 520 square miles (1,350 sq km) – an area greater than that of many Caribbean Islands.

My encounters with caribou, muskoxen and grizzlies have been many and varied, but only once did I fear for my life. Aubrey and I were on a photo assignment for Parks Canada in the splendid rolling tundra of the British Mountains in northern Yukon. When we'd flown in earlier in the day by helicopter, I'd spotted the stone remains of an ancient human food cache on a hilltop. Aubrey and I decided to hike from camp to investigate. But as we trudged up the slope, our heads bent in effort, a grizzly bear suddenly appeared at the top of the hill,

glaring down at us. With no trees to climb for safety, we had no choice but to slowly turn around and make our way back to camp, all the while hopefully repeating a message of peaceful comfort to the bear. Nice bear, nice bear. Go home bear, go home. Unfortunately, the bear wasn't listening. It started to follow us, swinging its broad muscular head from side to side in the easy manner the grizzly uses so effortlessly to cover distance.

A couple of miles of hummocky tundra separated us from our camp and our three backpacking companions. Hiking across such tundra is tiring at best, but with a grizzly bear following behind you, it is nothing short of terrifying. Halfway to camp, my courageous wife suggested that I leave her behind and go on alone, arguing that there was no point in both of us getting mauled or killed. Insisting that two hikers always have a better chance than one, I urged her on.

And so the game persisted, with us stumbling along, breathlessly checking the tundra behind us, and the bear slowly following our path, never altering its determined pace. After what seemed like hours but was probably less than 40 minutes, we reached our campsite, where we hoped our companions would offer the safety of numbers. At that point, the grizzly simply changed its course, moving off about 300 feet (91 m). Then it began to dig for roots.

In hindsight, it's quite likely that the bear, which lived in the remote British Mountains, had never seen or smelled a human before and had followed us out of simple curiosity. The bruin stayed within sight of our camp for several hours. When we finally turned in at around 11 o'clock that night, our ursine shadow had melted into the golden glow of the midnight sun.

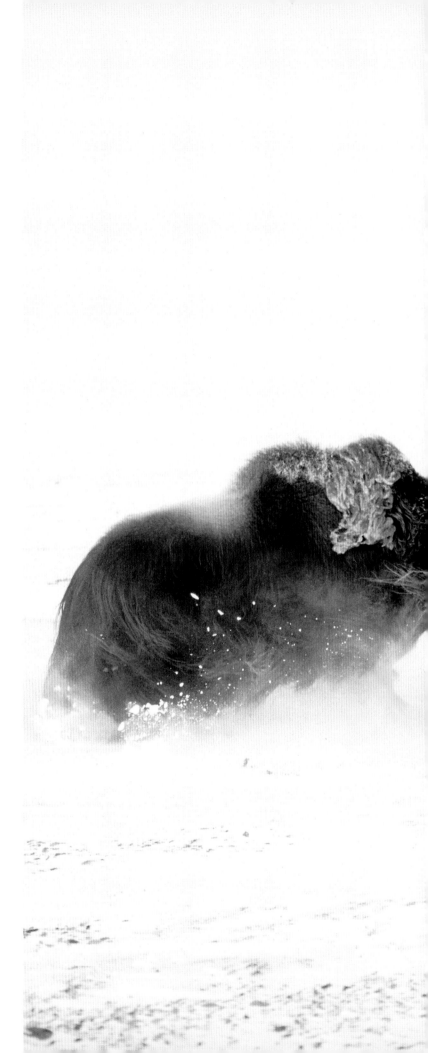

Chapter opening: Biologists readily conclude that the bulky 660-pound (300 kg) body and short legs of the muskox did not evolve for flight and speed afoot. These shaggy arctic beasts employ another strategy to defend themselves from hungry wolves and bears – they group together and fight tenaciously. When threatened by a predator, the muskox exhibits a natural tendency to back up against a fellow beast, boulder or hillside and then face the danger head-on. When huddled shoulder to shoulder, a herd of adult muskoxen presents a dangerous and formidable phalanx of might and hardened horns – an armory of lethal weaponry. Imprudent wolves have been gored and killed.

Right: The outer layer of a muskox's pelt is composed of long, thick guard hairs that hide an underlay of fine fur. The guard hairs, which can be up to 22 inches (56 cm) long, hang like a fluttering skirt around the animal's legs, where they serve as an effective barrier against the wind's icy penetration. The underfur is a thick insulating mat of extremely fine hairs – in fact, some of the finest in the animal kingdom, softer even than camel hair or cashmere. Only the hair of the vicuna, a relative of the camel that lives in the high Andes of South America, is finer. By comparison, the average human hair is four to six times thicker.

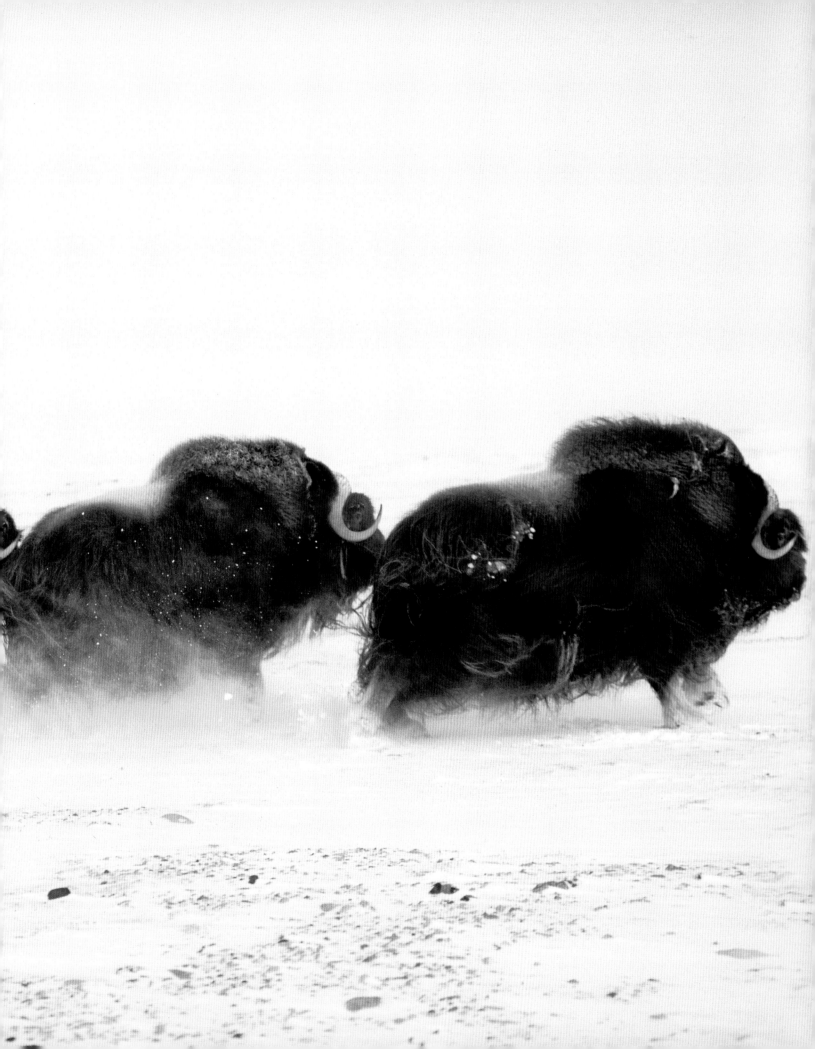

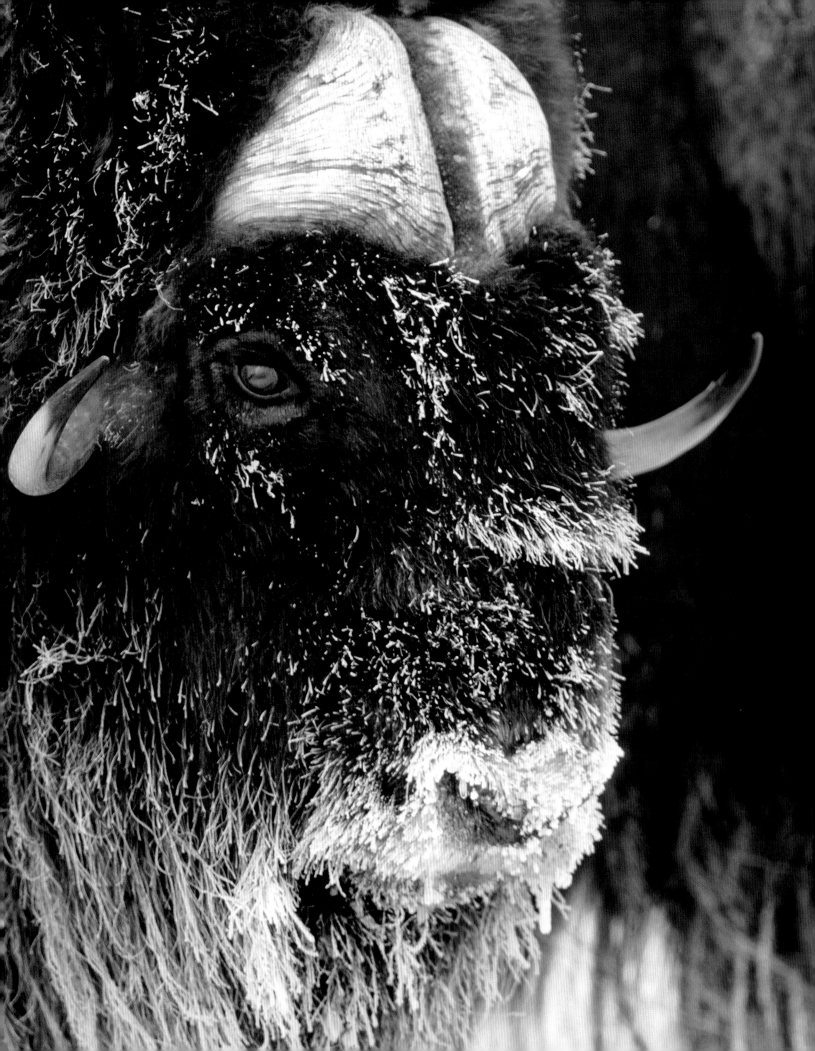

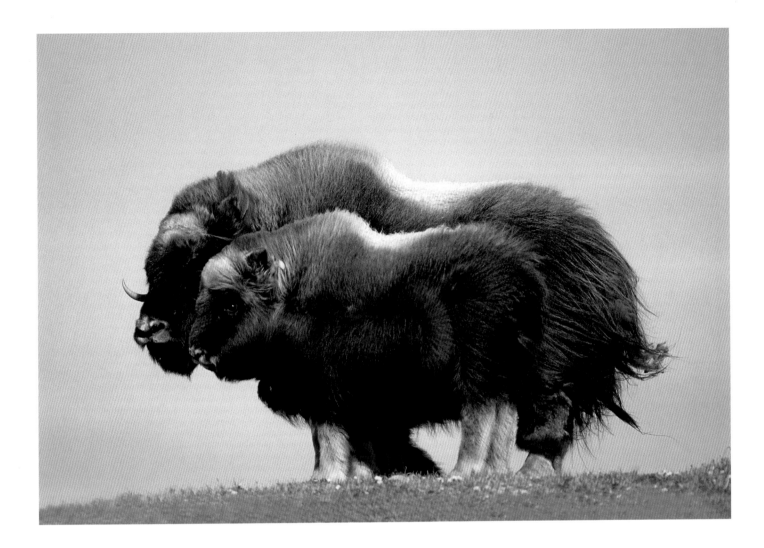

Left: Both male and female muskoxen have horns that first appear when the animal is about a year old; by the time the muskox is about six, the horns have reached their full size. During the late-summer rutting season, in August and September, rival bulls forcefully butt heads in contests of strength. They may charge each other at a full gallop when they are 150 feet (45 m) apart and collide with a head-smashing crash that can be heard 600 feet (180 m) away. When bulls are evenly matched, they may clash 20 times in a row before one of them finally concedes defeat and runs off. The muskox pictured here is an adult bull.

Above: The calf pictured is a year old and past the most vulnerable stage of its early life. Muskox mothers typically give birth to a single calf (twins are rare) in late April or early May. In many parts of the Arctic at that time of the year, temperatures can dip to a bone-chilling minus 16 degrees F (−27°C). Although newborns sometimes die of hypothermia if they are doused with a freezing rain, a dry calf is capable of tolerating extremely cold temperatures, even when combined with wind, because its short, curly hair is made up of a protective underfur and guard hairs.

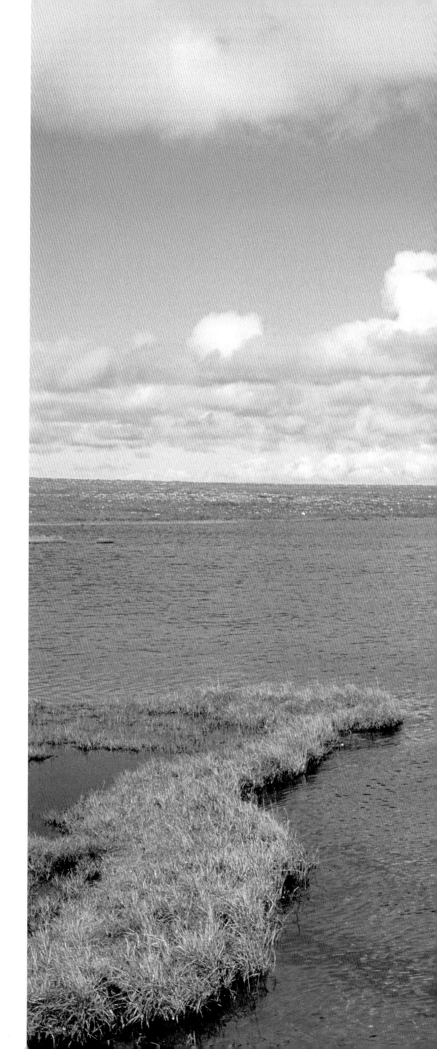

When I took this photograph, the muskox bull and I were each surrounded by swarms of blood-thirsty mosquitoes. Mosquitoes are generally of little consequence to a muskox since most of its body is protected by a thick pelt of dense fur. Even so, the animal has bare skin around its eyes and nostrils that are vulnerable to attack. When the insects are especially bothersome, muskoxen will retreat to windswept ridges and remnant patches of snow to seek relief.

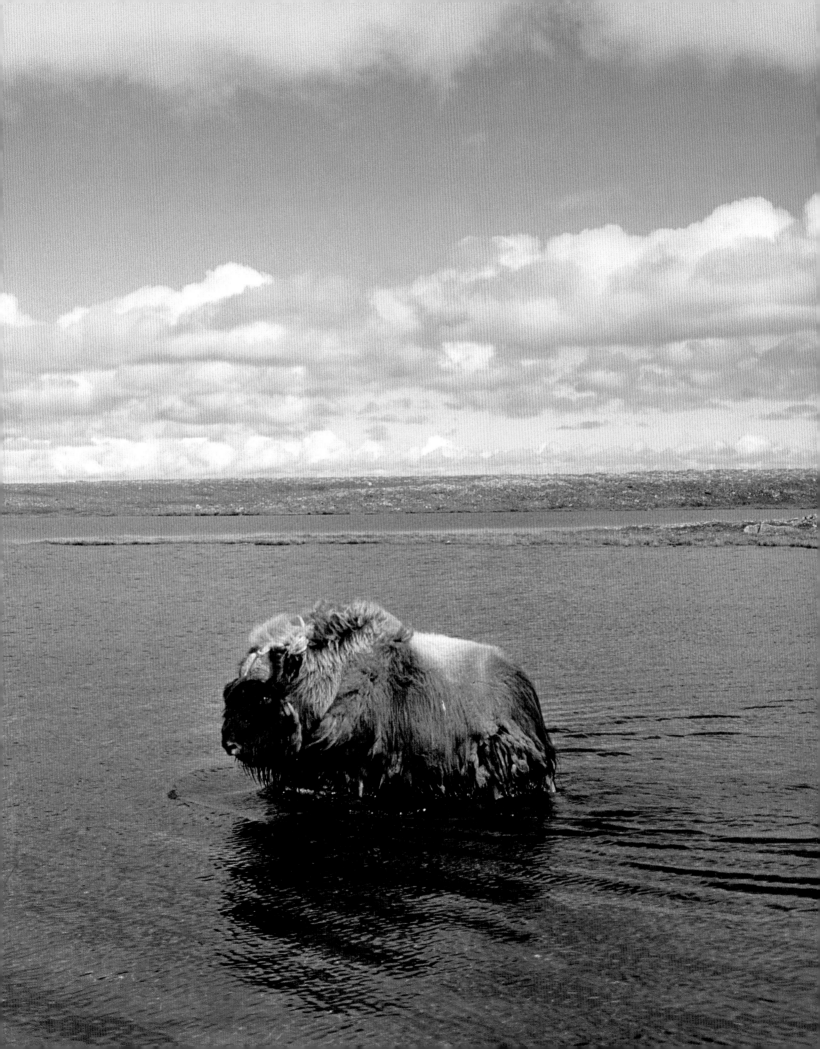

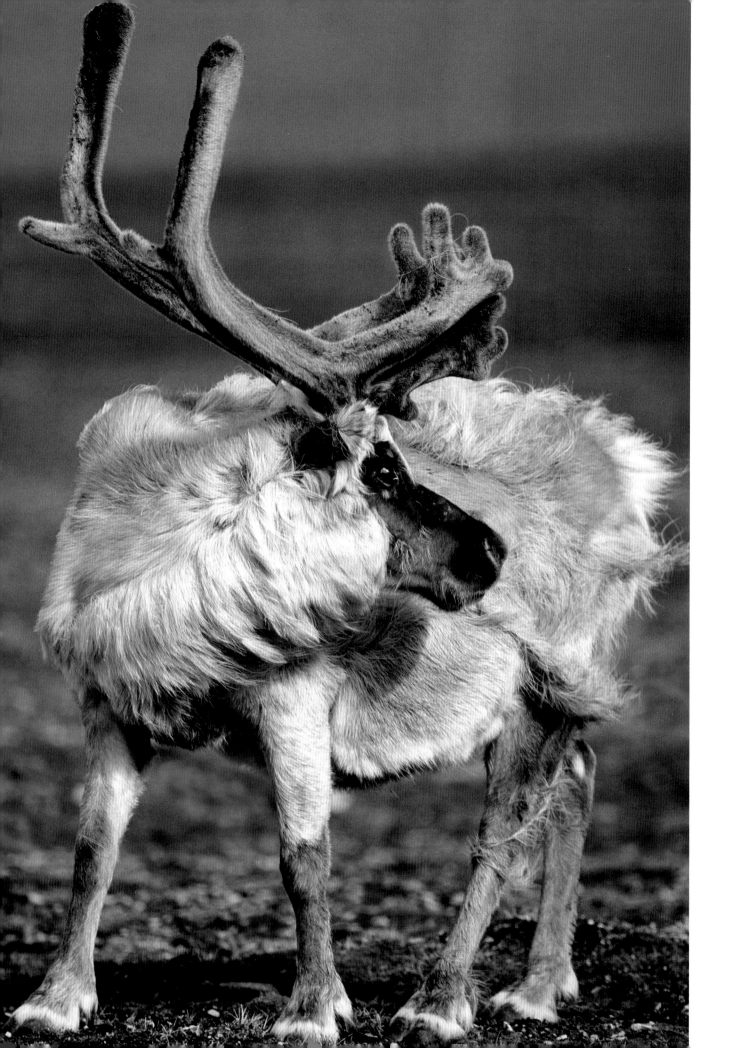

Left: This reindeer bull was in the middle of its annual summer molt in Norway's Svalbard Archipelago. From an energy standpoint, molting is an expensive process, so it naturally occurs in summer, when food is relatively plentiful. Because adult bull reindeer are generally the least nutritionally stressed age group, they molt earliest in the season. Juvenile animals, which are not as efficient at foraging as adults, molt later, while adult females with newborn calves molt last, due to the energy drain they undergo through pregnancy and nursing.

Above: A luxuriant bed of mosses adjacent to the 14th of July Glacier in Norway's Svalbard Archipelago has been fertilized by the spilled food and bird droppings from a nearby seabird cliff. Packed with nesting black-legged kittiwakes, thick-billed murres and northern fulmars, such colonies transfer the biological richness of the oceans to the land. Caribou and arctic geese commonly graze in tundra such as this, taking advantage of the nutrition-rich vegetation.

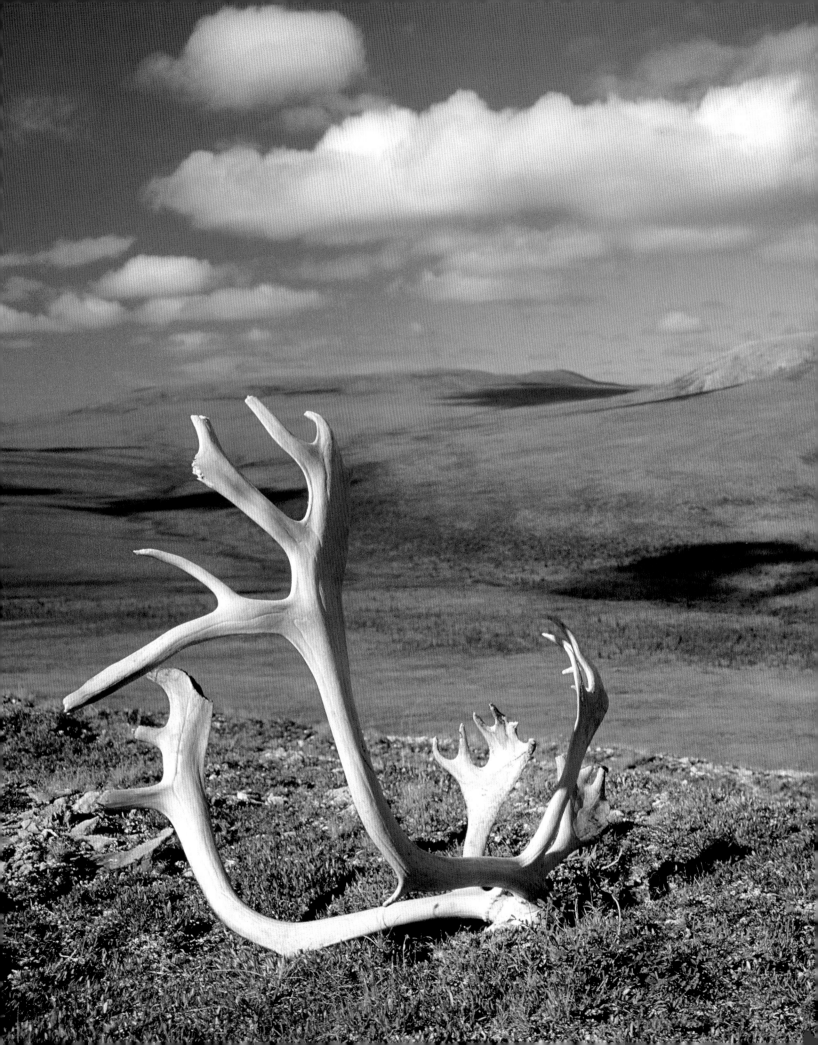

Left: Every year, hundreds of thousands of caribou antlers are shed. Why, then, is the Arctic not littered with these bony racks? High in calcium and other important minerals, cast-off antlers are chiselled up by hares, lemmings, voles and ground squirrels, as has happened to several of the tips on this antler. But the animal with the greatest appetite for the antlers is the caribou itself: individuals regularly chew on the racks strewn across the landscape, thereby recycling the minerals and keeping the tundra tidy in the process. As a result, most cast-off antlers disappear in just a couple of years.

Following spread: One of the unique features of caribou antlers is the so-called shovel, a single palm-shaped branch that sweeps forward above the ridge of the animal's muzzle like a bony miniature sail. It was dubbed the shovel because we once thought that caribou used it to dig craters in the winter snow when foraging for food. As it turns out, the caribou scrapes out feeding craters with its front hooves – the shovel probably acts as a shield to protect the eyes when bulls thrust and parry antlers in combat.

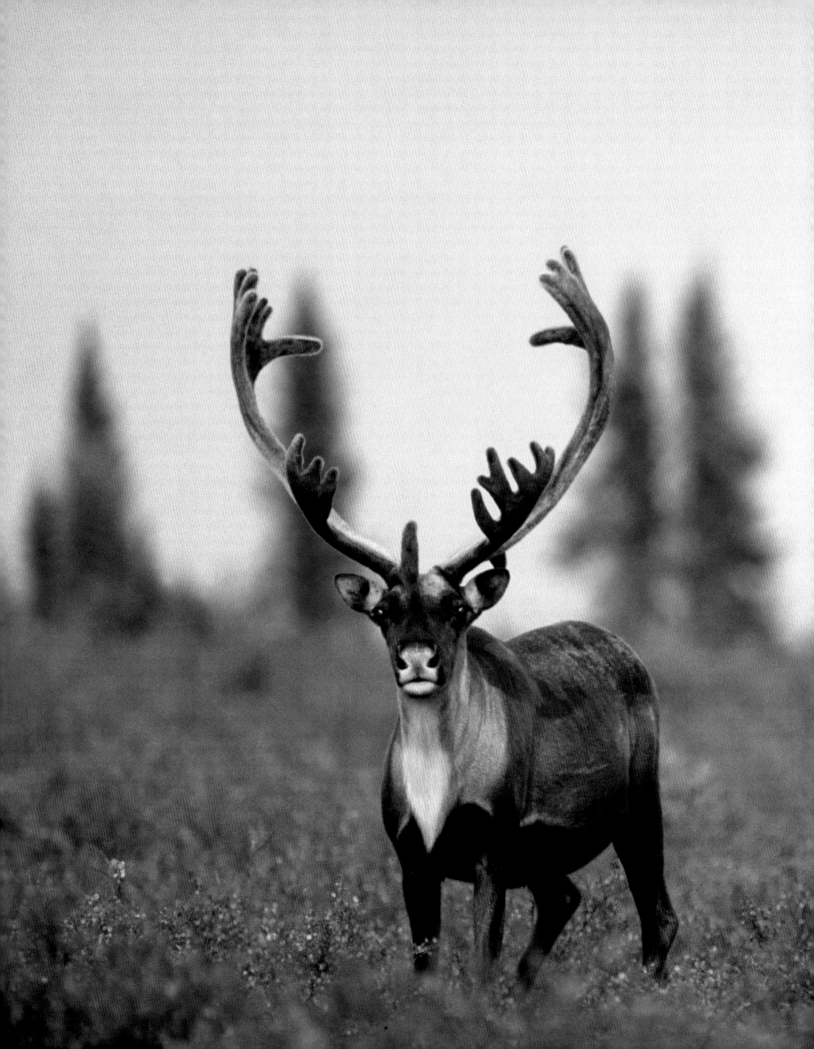

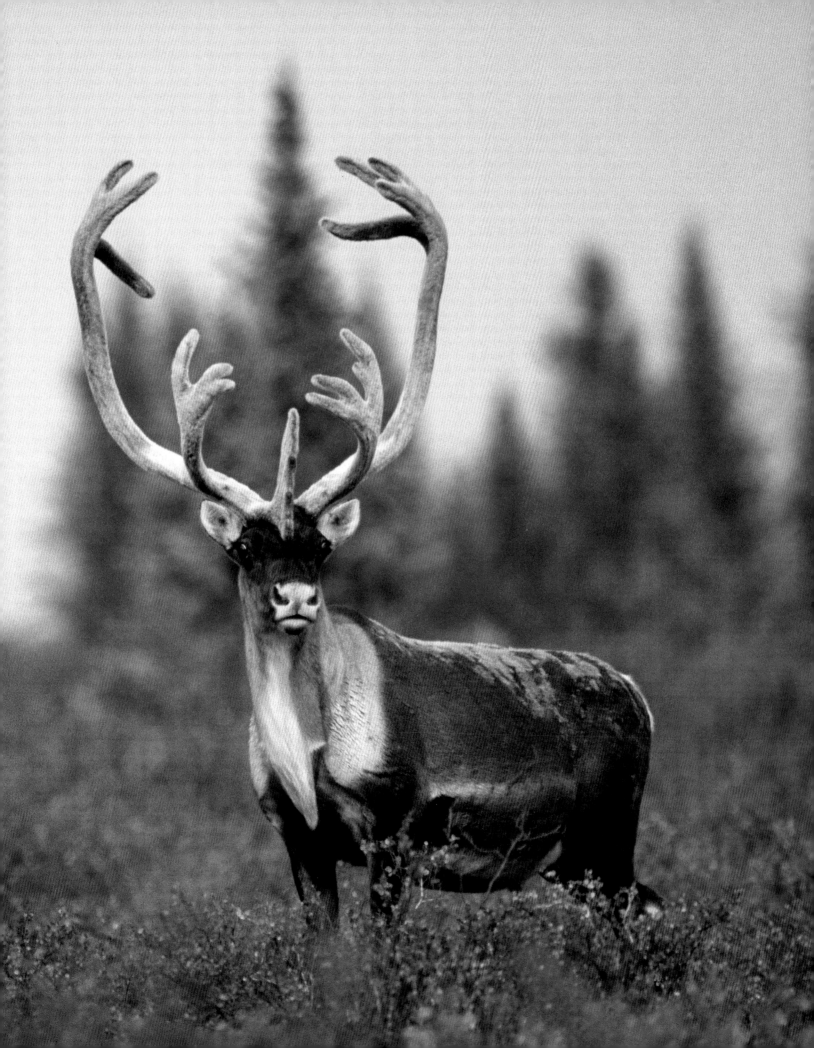

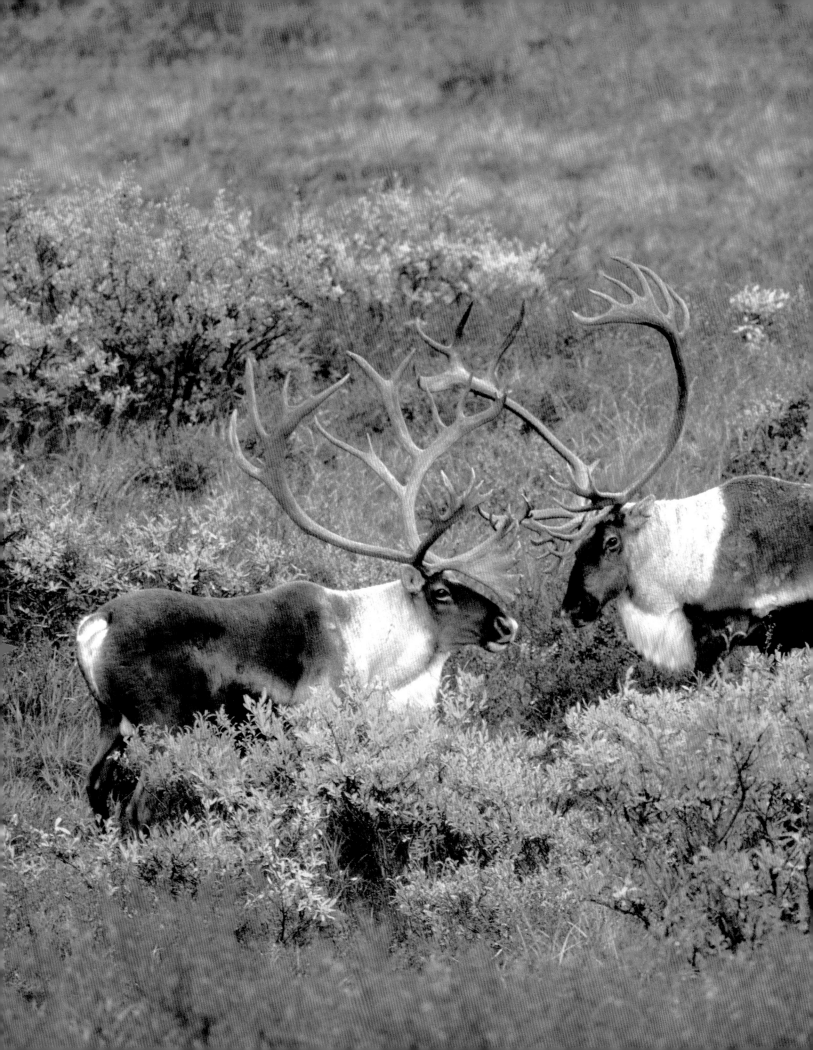

Left: The antlers of the bull caribou, as in all male deer, evolved as grappling headgear that combatants use to evaluate the strength and health of rivals during the autumn rut. As a bull ages, his headgear grows heavier and more branched, until he reaches his prime at the age of five or six. At their maximum size, a trophy caribou rack may measure 60 inches (1.5 m) on each side. Bulls cast their antlers at the end of the rut each November, and their sex drive and combativeness wanes simultaneously. The following year, they grow a new set of antlers.

Following spread: Many visitors are surprised by the verdancy of the tundra in the British Mountains in northern Yukon's Vuntut National Park, an area that is critical habitat for the spring and autumn migrations of the Porcupine Caribou Herd. Such rich tundra areas also allow for the high intake of nutritious food by cows required in early and midsummer to offset the energy drain of nursing.

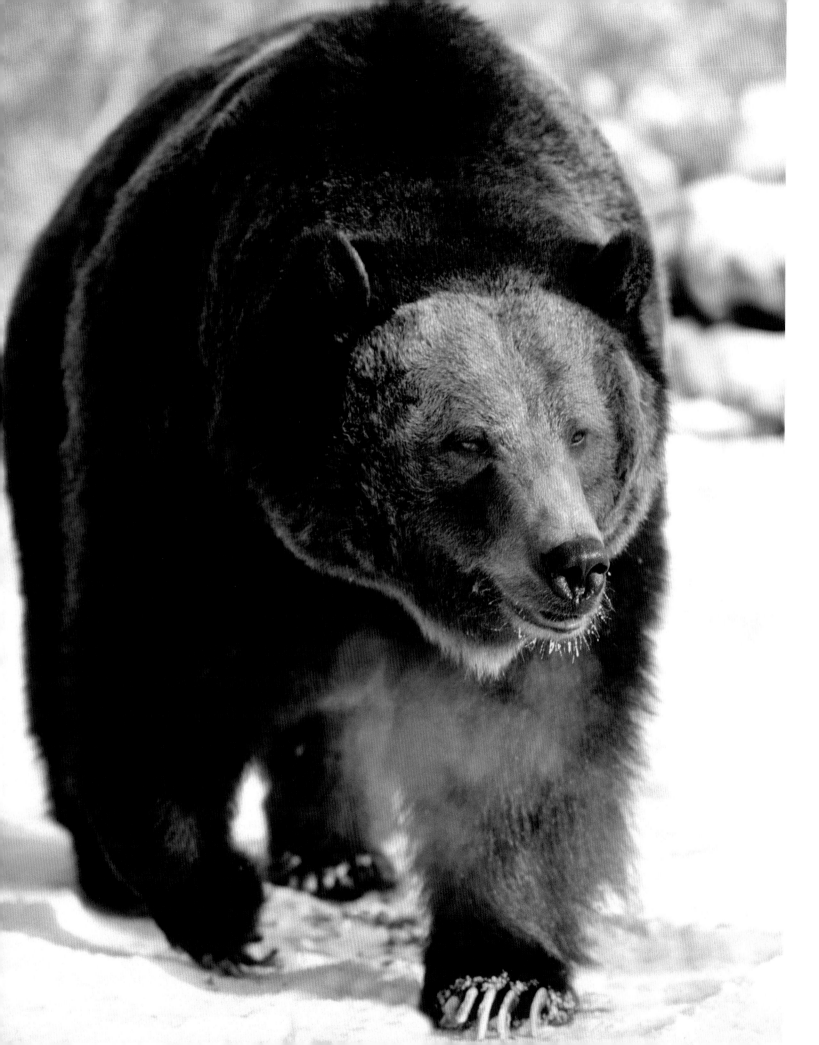

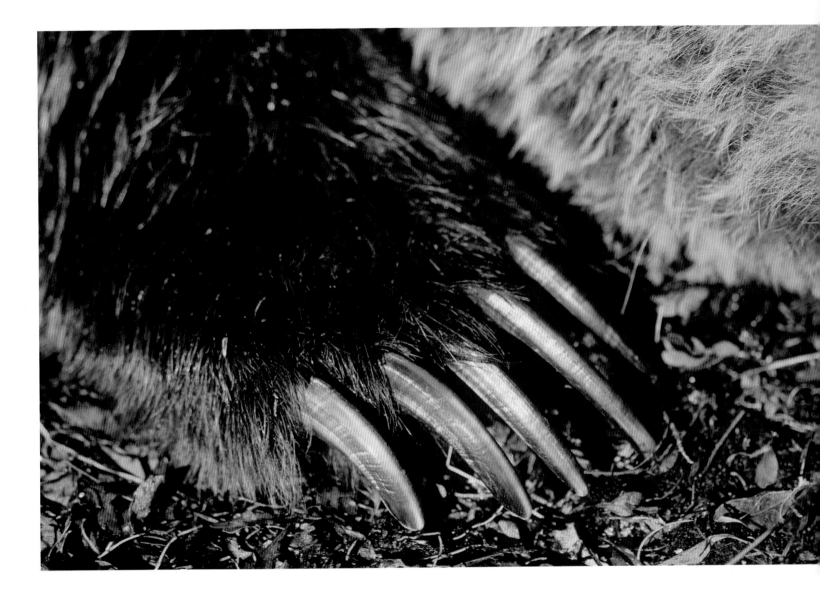

Left: This photograph was taken in early October, the time when most bears enter their winter dens. All arctic grizzlies spend the winter hibernating, and it's common for a bear to move to its den location a week or more before it starts digging. Once it does, a grizzly may excavate as much as a ton of dirt and rock. The soil forms a characteristic mound at the mouth of the den that can be recognized from a distance. Many dens are dug beneath the roots of willows and alders, which stabilize the soil in the ceiling and keep it from collapsing.

Above: These claws belonged to an adult male grizzly that was tranquilized near the Horton River in Canada's Arctic Barrenlands. From its base to its tip, the longest claw was nearly five inches (13 cm) in length, roughly the same length as a ballpoint pen. Such claws evolved as instruments of excavation, and grizzlies use them to dig for the nutritious roots of many different tundra plants. In Alaska, I watched a female grizzly till a tundra slope as she dug for peavine (*Hedysarum alpinum*) roots. She would plant her front claws into the soil, rock backwards with her entire weight, lift up a section of sod and flip it upside down. She then scratched away the soil with her claws and nibbled off the exposed roots.

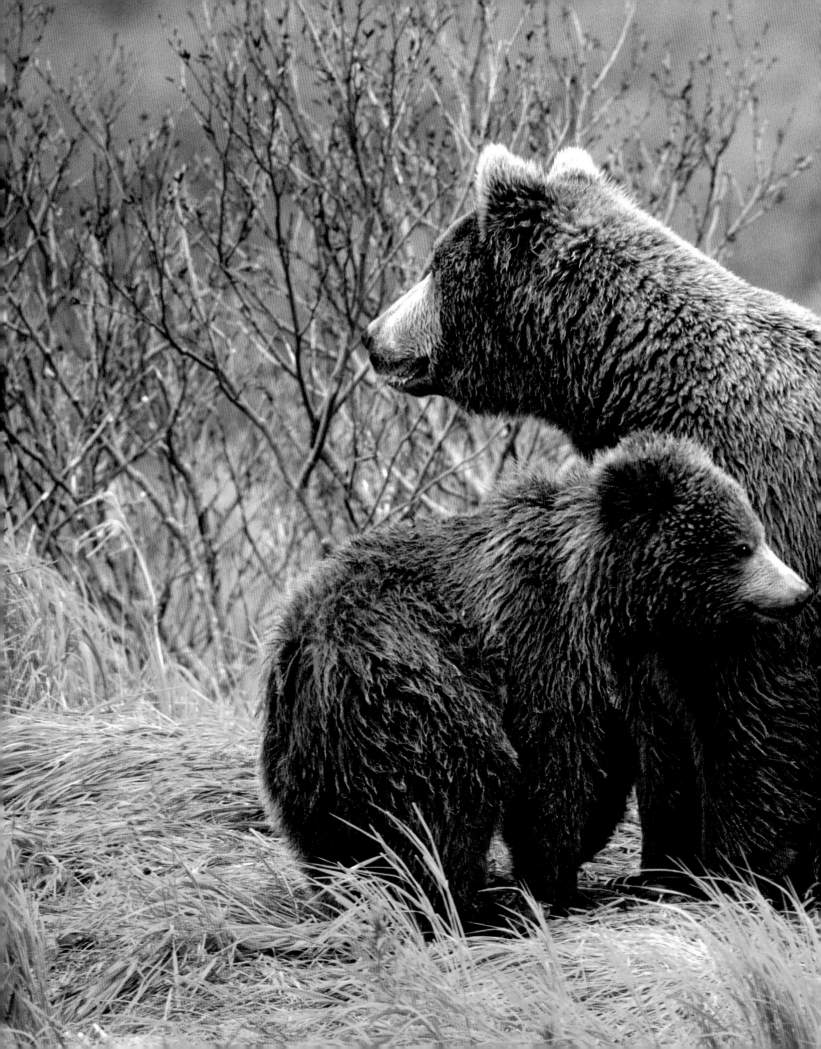

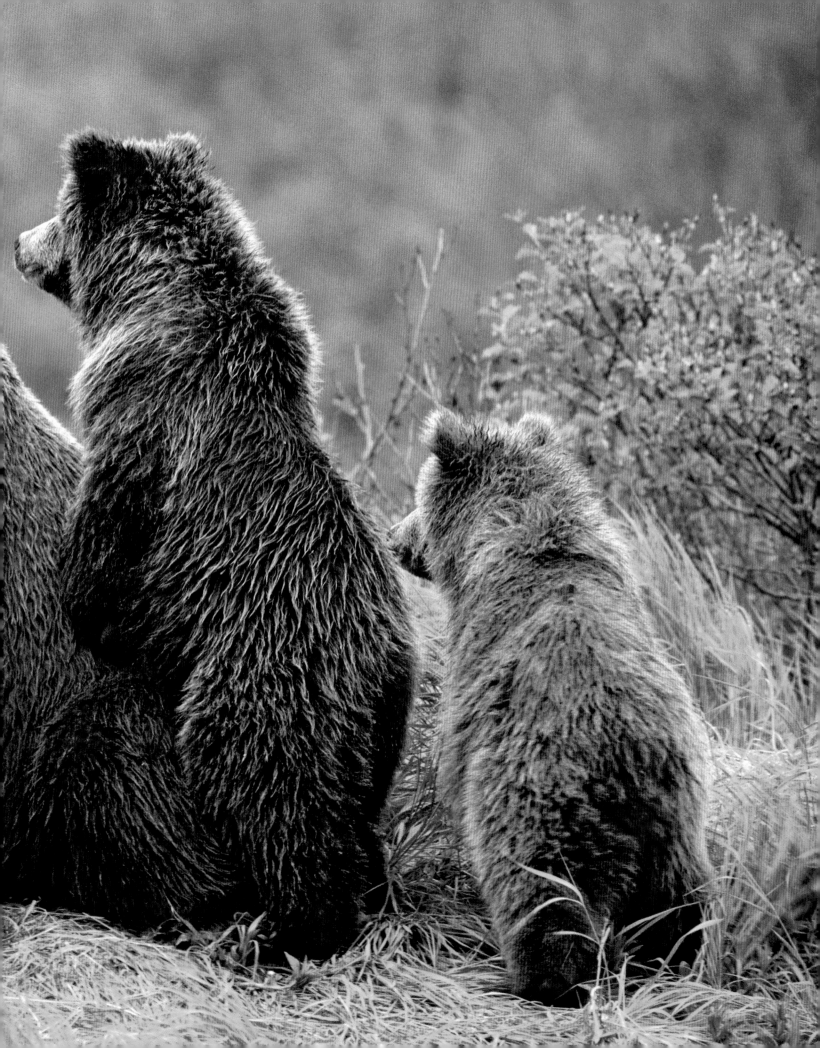

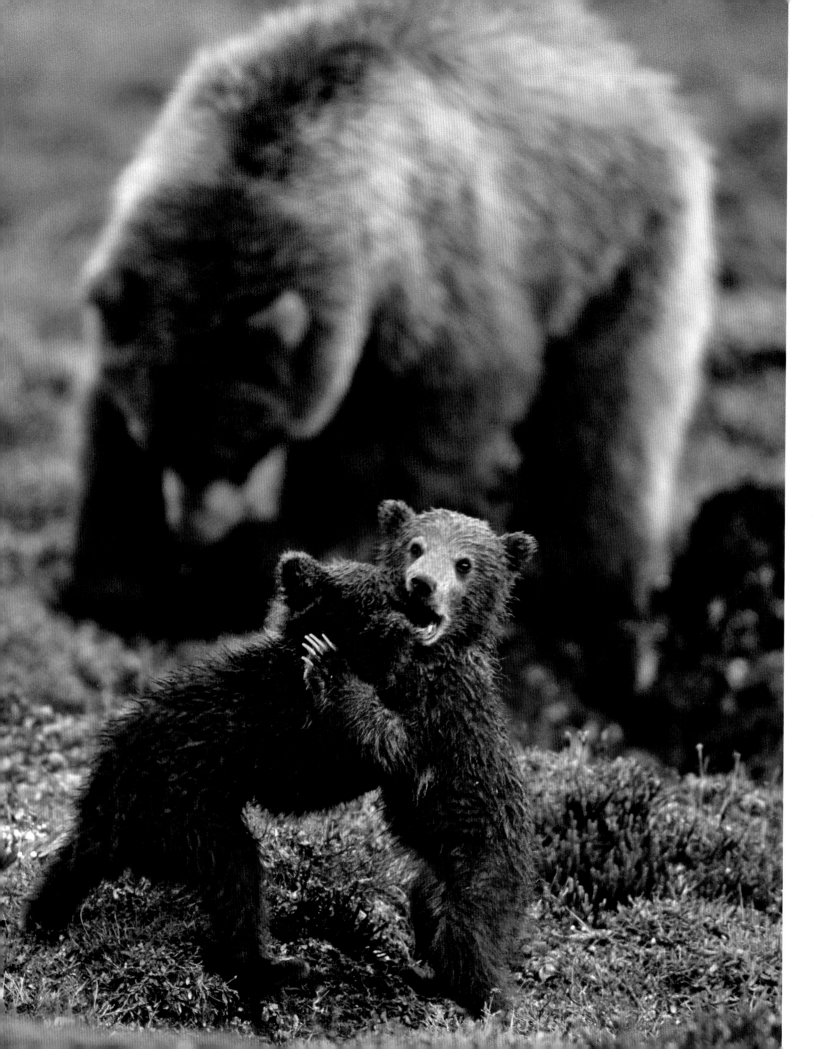

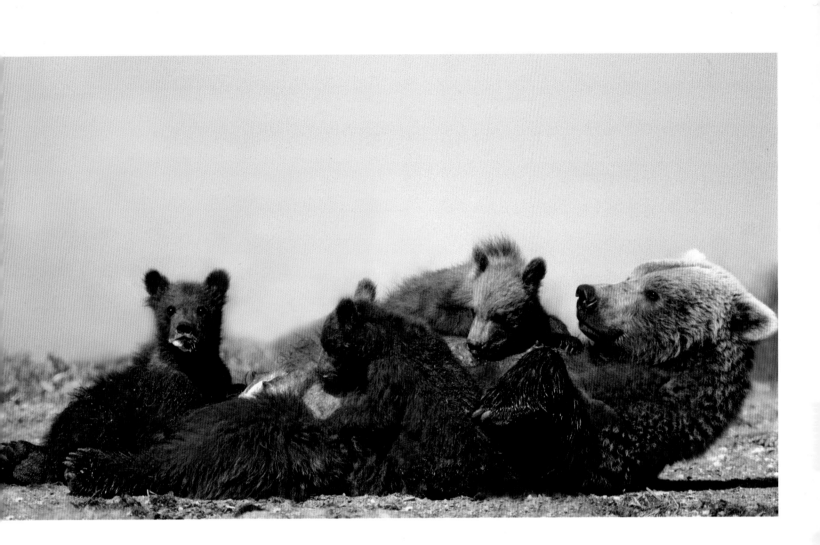

Previous spread: This mother grizzly bear and her three cubs were alarmed at the sighting of a large adult male bear. The family was understandably concerned, since large adult male bears are known to kill yearling cubs. Biologists speculate that this so-called infanticide occurs for three possible reasons: to reduce competition for food and space, to provide food and to create a breeding opportunity for a male bear. Of the three, most biologists believe the last reason is the most common, although each explanation may operate at one time or another.

Left: These newborn grizzly cubs were busy playing as their mother overturned clumps of tundra in search of nutritious roots in northern Alaska. Play behavior varies depending upon the age of the bear. Not surprisingly, cubs are the most playful bears, but mothers frequently enjoy playtime with their offspring as well, especially if their cub is without a littermate. Play behavior in bears also varies among individuals – some bears are just naturally more playful than others, and some retain their playfulness throughout their lives.

Above: Although young grizzly cubs begin to eat grasses and sedges at four months, the bulk of their nutrition comes from the rich fatty milk they get from their mother. Cubs of this age may still nurse eight to 10 times a day. Some may nurse until they are more than two years old, but most stop relying on milk after their first summer.

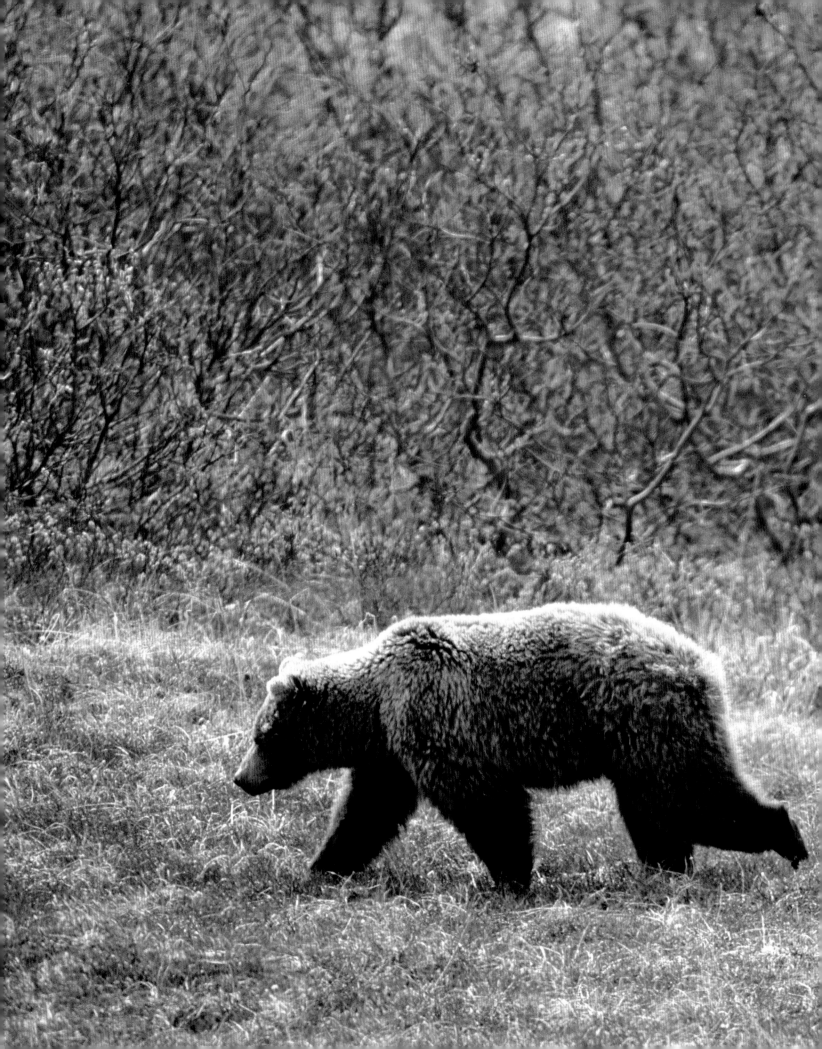

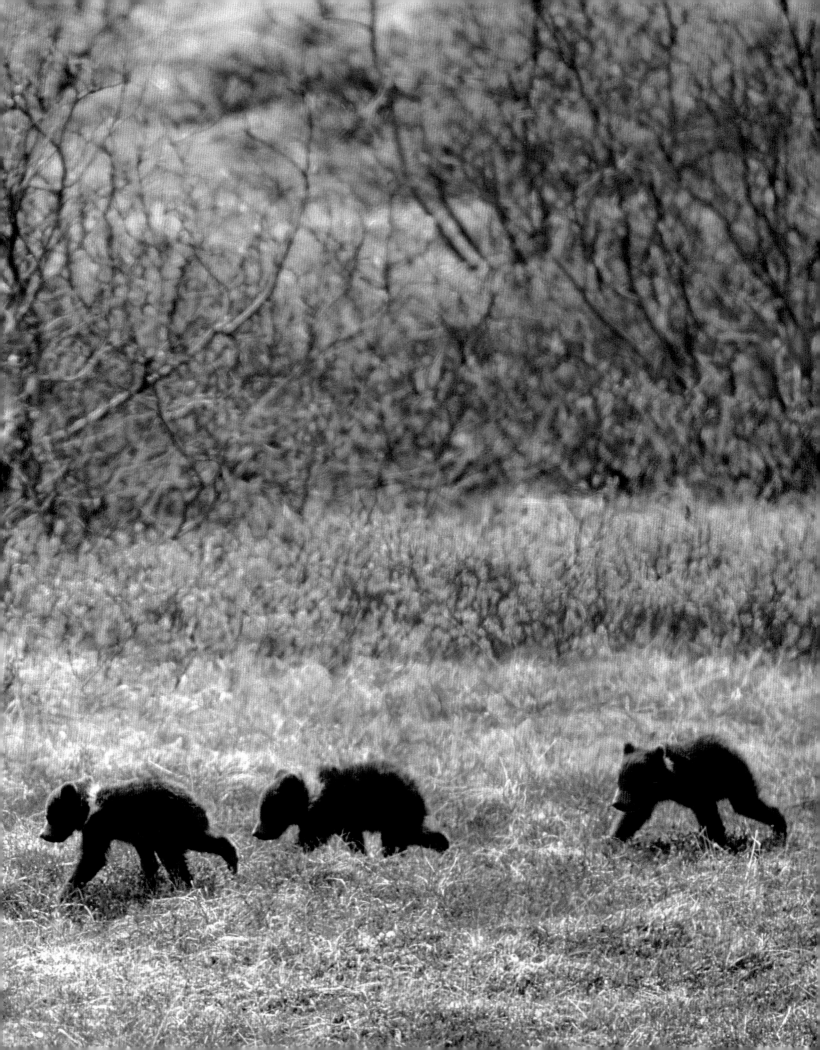

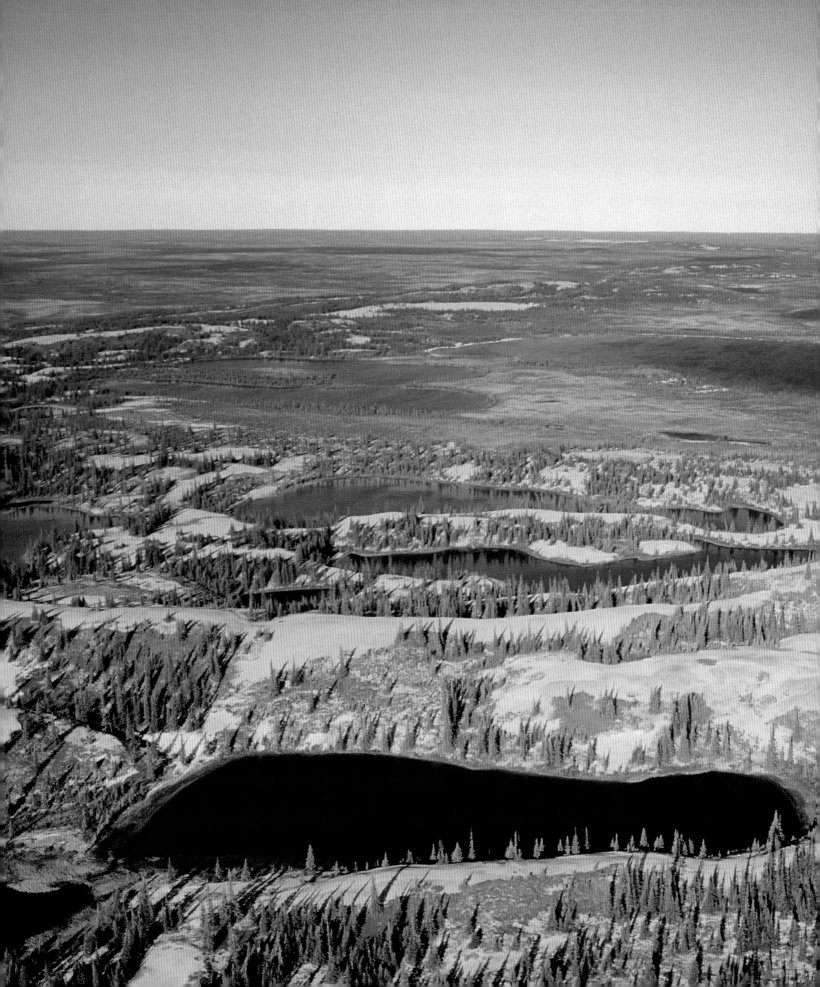

Previous spread: The number of cubs a mother grizzly is able to raise depends mainly upon the quality of her diet. Females with a high-quality food source, such as spawning salmon, may raise three cubs or more. In contrast, mother bears on a meager diet of peavine roots and soapberries often raise just one or two cubs. This mother grizzly in northern Alaska had no access to salmon, yet she had triplets. Perhaps the abundance of arctic ground squirrels in her home range was enough to boost her nutritional status.

Left: Snaking across the arctic tundra in North America are land formations called eskers – long, winding ridges of sand and gravel that can reach heights of 100 feet (30 m). Eskers are of interest to me because of their importance to arctic wildlife. Many different animals, from wolverines to caribou, use these dry, elevated ridges as travel corridors to cross stretches of soggy, mosquito-infested tundra. The slopes are likewise an easy place for wolves, ground squirrels, foxes and grizzlies to dig their dens.

ARCTIC

MINIATURES

Sometimes, the pursuit of the overlooked leads to an unexpected reward. One summer, while backpacking in the British Mountains of northern Yukon, I was drawn to a ridge top by a bright orange pile of rocks. The stones looked as if they had been liberally coated with orange paint and were visible from hundreds of yards away. As I hiked closer, I saw that the eye-catching coloration was not part of the rock at all but came from a textured crust of jewel lichens (*Xanthoria elegans*). The Polar Inuit of northern Greenland call these colorful lichen *sunain anak,* meaning the sun's excrement.

As a photographer, I'm strongly attracted to beating hearts and don't normally spend much time examining lichens and their ilk, but the jewel lichens were so striking that I convinced myself to make an exception and take some photographs. It was a perfect Arctic afternoon. There was just enough breeze to keep the mosquitoes at bay, the sky was cluttered with a flotilla of cumulus clouds, and the ridge top overlooked waves of tundra-cloaked hills that were fingered here and there by shafts of sunlight. It was easy to find beauty in everything before me, and I soon became engrossed in capturing the patterns within the lichen.

The soothing sound of the wind was suddenly interrupted by the agitated alarm call of an arctic ground squirrel (*Spermophilus parryii*). I hadn't noticed the rodents as I climbed up the hill, and since I'd been on the ridge top for nearly half an hour, I wondered why the squirrels hadn't called sooner if they'd found my presence alarming. Twisting around to search for the caller, I found myself instead staring squarely at an adult wolverine (*Gulo gulo*), barely 30 feet (9.1 m) behind me.

Wolverines are elusive, wide-ranging carnivores that occur at low densities throughout their range. I had seen only one in my life, but here I was with one close enough to join me for a chat. "Photograph the beast, you damn fool." That was the voice of my photo agent yelling inside my head, but the lens I had mounted on my camera at the time was an extreme wide-angle, which makes everything in the viewfinder look small and far away. The wolverine loitered for a few seconds, perhaps deciding whether I was friend or foe, then loped off down the slope and across a distant valley. Excitedly, I grabbed my binoculars and watched the animal slowly disappear. Months later, when I sent the photographs to my agent, he asked about the blurry dot in the distance that I had been so excited about. The consolation? Great memories never need a photograph for validation.

Certainly the hardiest and most widespread organisms in the Arctic are the lichens, of which there are at least 2,000 species. Lichens are found everywhere in the Arctic, plastered on rocks, crusted on bones and splattered on cast-off antlers. Many kinds also grow directly on the ground. Carolus Linnaeus, the famous 18th-century Swedish taxonomist, called lichens "the poor trash of vegetation." More than 200 years later, we know lichens to be some of the toughest organisms on the planet.

Despite their plantlike appearance, lichens are not plants at all but belong to the fungal group of organisms. A lichen is actually a composite of two very different organisms, a fungus and an alga. The alga photosynthesizes sugars that the fungus needs to grow. In return, the fungus shelters the alga in a moist, protected environment. Biologists view the lichen as a

finely controlled parasitism in which a fungus "captures" the alga and uses it to create a lichen. Most species of algae that are involved in lichens are also free-living. One lichen specialist described the relationship as "the union between a captive algal damsel and a tyrant fungal master."

Everyone knows the Arctic is a cold environment, but few people realize that it is also a very dry one. Much of the Arctic is actually classified as a cold desert. Deserts are usually defined as areas receiving fewer than 10 inches (25 cm) of precipitation per year. Many of Canada's High Arctic islands receive only eight to 10 inches (20–25 cm) of moisture per year. The ice-covered Arctic Ocean receives just six to seven inches (15–18 cm).

The cold, dry weather of the Arctic naturally influences the kinds of plants that grow there. While trees don't grow in the Arctic, many plants and shrubs are hardy enough to survive. Along the southern fringe of the Arctic adjacent to the tree line, there are thick patches of willow (*Salix* spp) and birch (*Betula* spp) bushes, some of which can grow as tall as a person. As you move farther north and get deeper into the Arctic, the plants get shorter and grow closer to the ground. In fact, most arctic plants grow less than 12 inches (30 cm) tall. Not only are the plants shorter, but they also grow farther apart and are separated by patches of bare ground. In the harshest, most northern parts of the Arctic, no plants can grow at all. The ground is just dirt, gravel and rock.

To survive in this demanding climate, plants, especially wildflowers, have evolved an intriguing array of strategies. To begin with, most wildflowers are small and hug the ground, a direct consequence of a short growing season that can be measured in weeks. Warmth is another reason to stay low beneath the icy, chilling grip of arctic winds. Like many other arctic flowers, the purple saxifrage (*Saxifraga oppositifolia*) displays its showy blossoms within a few inches of the tundra surface.

Another strategy that arctic plants use to stay warm is to wrap themselves in a fur coat. The leaves of willows and a number of wildflowers are cloaked in fine hairs that trap air next to the plant's surface. When the air is warmed by the sun, life-giving heat leaks into the plant. Within the fluffy seed head of the cottongrass (*Eriophorum* sp.) the temperature may be 36 Fahrenheit degrees (20 C degrees) warmer than the outside air. These protective hairs also stabilize the layer of warm air surrounding the leaves and offset the wind's ability to sweep away the accumulated heat.

To cope with the relatively arid conditions, a number of arctic plants have evolved adaptations that are similar to those of desert plants. A waxy covering on leaves retards water loss, and the fine hairs that keep leaves warm also reduce moisture loss through evaporation by protecting the plant's pores from the desiccating arctic winds.

For me, the Arctic has been a decades-long voyage of humbling discoveries. Just when I think I understand how a certain flower procreates or how a commonplace willow hedges its bets against the cold and conclude that I've nothing new to learn from examining yet another patch of moss or lichens, I'm surprised all over again by the myriad ways that nature solves the challenges of the polar world.

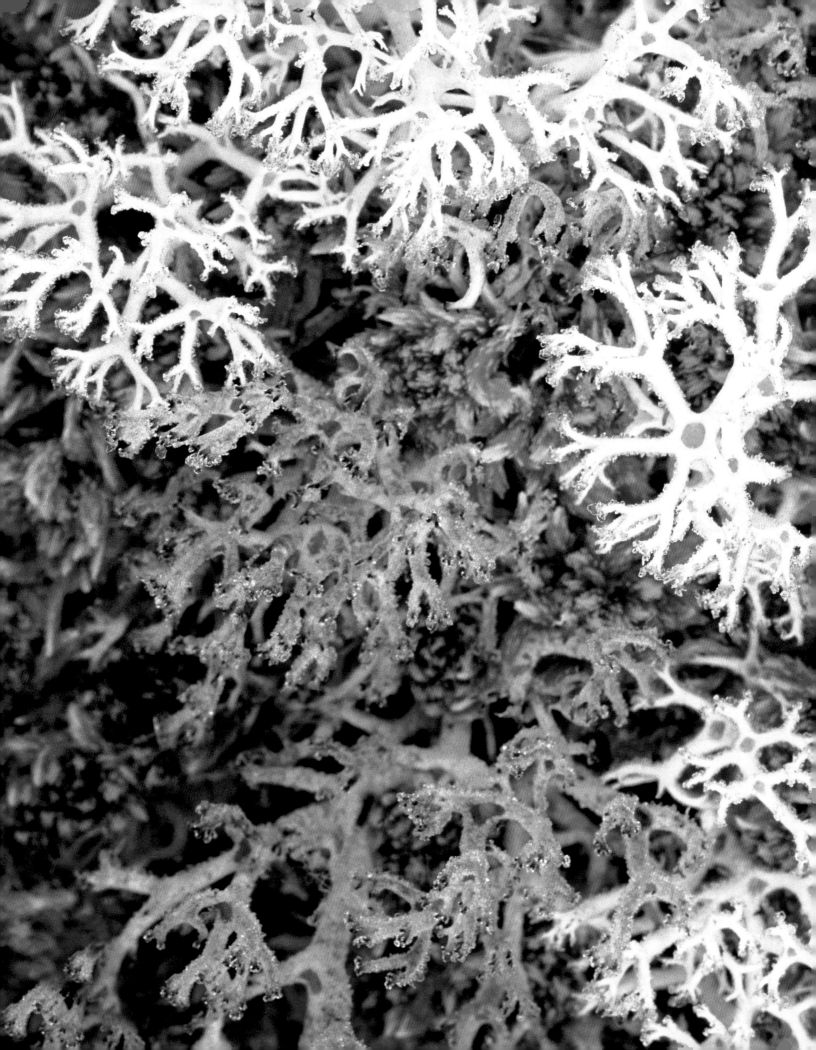

Chapter opening: Many arctic flowers grow as rosettes, dense mats or cushions, all forms that reduce wind movement among the leaves of the plant. On sunny days, warm air becomes trapped in the tiny cracks and crevices of such plants. When the leaves contain the red pigment anthocyanin, as they do in the purple saxifrage, the heating affect is even greater. A scientist in northern Greenland recorded a toasty temperature of 38 degrees F (3.5°C) in a clump of purple saxifrage when the air temperature was 10 degrees F (−12°C).

Previous spread: Lichens in the genus *Cladonia*, the so-called reindeer mosses, may constitute half of a caribou's winter diet. While the caribou's taste for lichens is unique among hoofed mammals, however, the animal cannot live on lichens alone. If it eats nothing else, a caribou will lose weight even if it consumes 12 pounds (5.4 kg) of the crunchy stuff a day, which is theoretically enough to meet its daily caloric needs.

Right: The spider saxifrage (*Saxifraga platysepala*) derives its name from the multiple red runners that sprout from the base of its stem like the legs on an arachnid. The common name saxifrage is derived from the Latin *saxum* (a rock) and *frango* (to break) and is presumably based on the plant's growth habit: many saxifrages grow in the crevices of rocks and so appear to break the rocks apart. After the flowers wilt, a tiny pore in the remaining seed capsule, which persists into winter, gradually releases seeds as the capsule is rattled by the wind. Seeds shaken loose in winter may be scattered widely over the ice and snow.

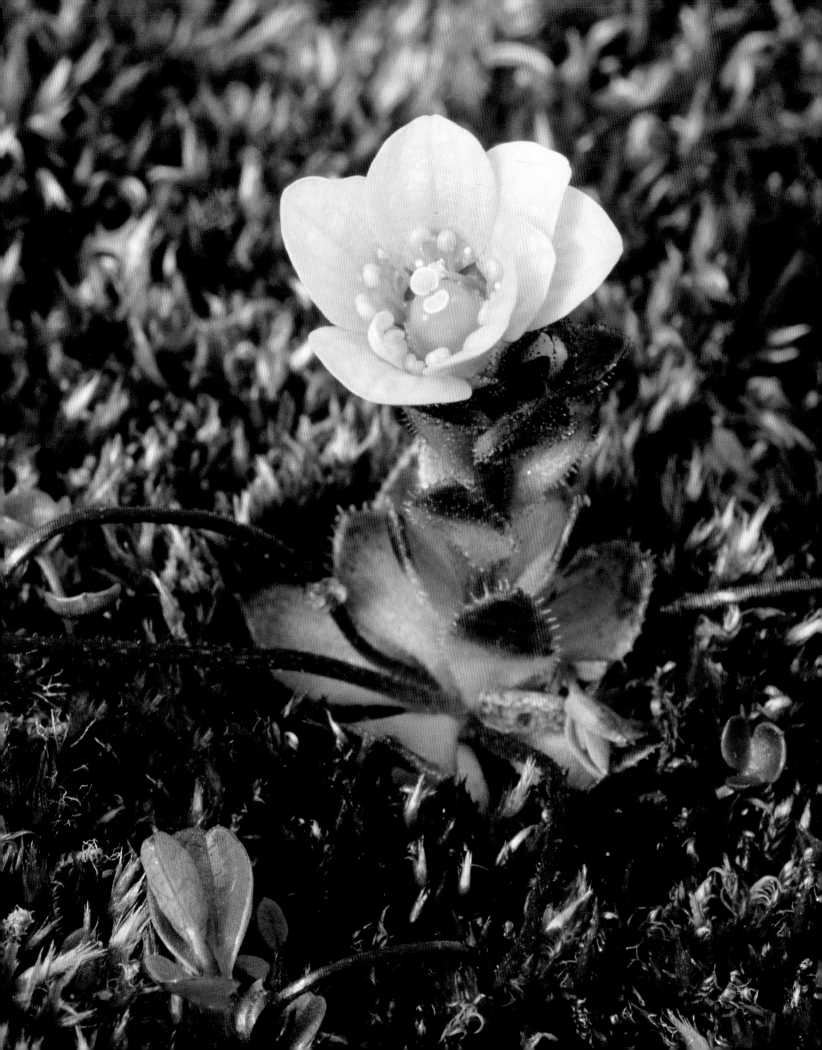

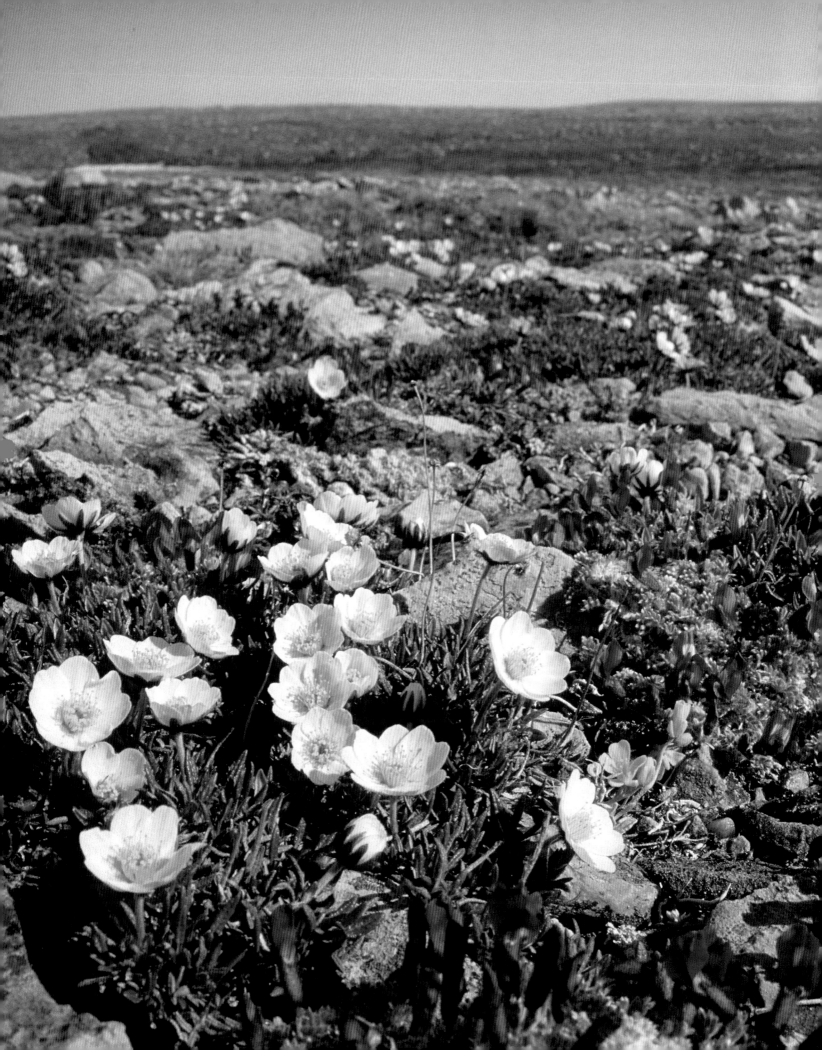

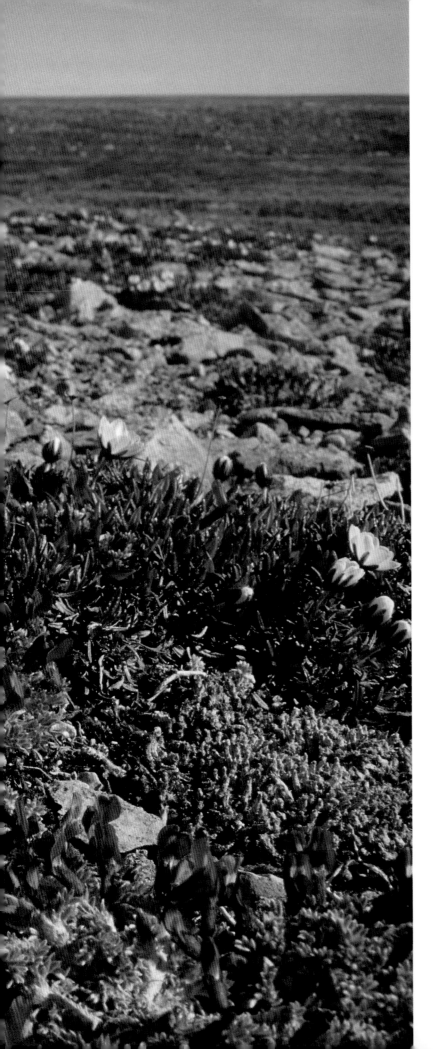

In the lower latitudes of the Arctic, as here on Canada's Victoria Island at 70 degrees north latitude, the flower displays in summer transform the dry rocky landscape into an astonishing carpet of color. The creamy white mountain avens (*Dryas integrifolia*) moves as it tracks the position of the sun to capture the maximum amount of solar heat. The purple oxytropis (*Oxytropis arctobia*) grows on a dense cushion of velvety leaves. Although oxytropis is conspicuous in bloom, at other times, the plant blends so well with the rocky ground that it is easy to overlook.

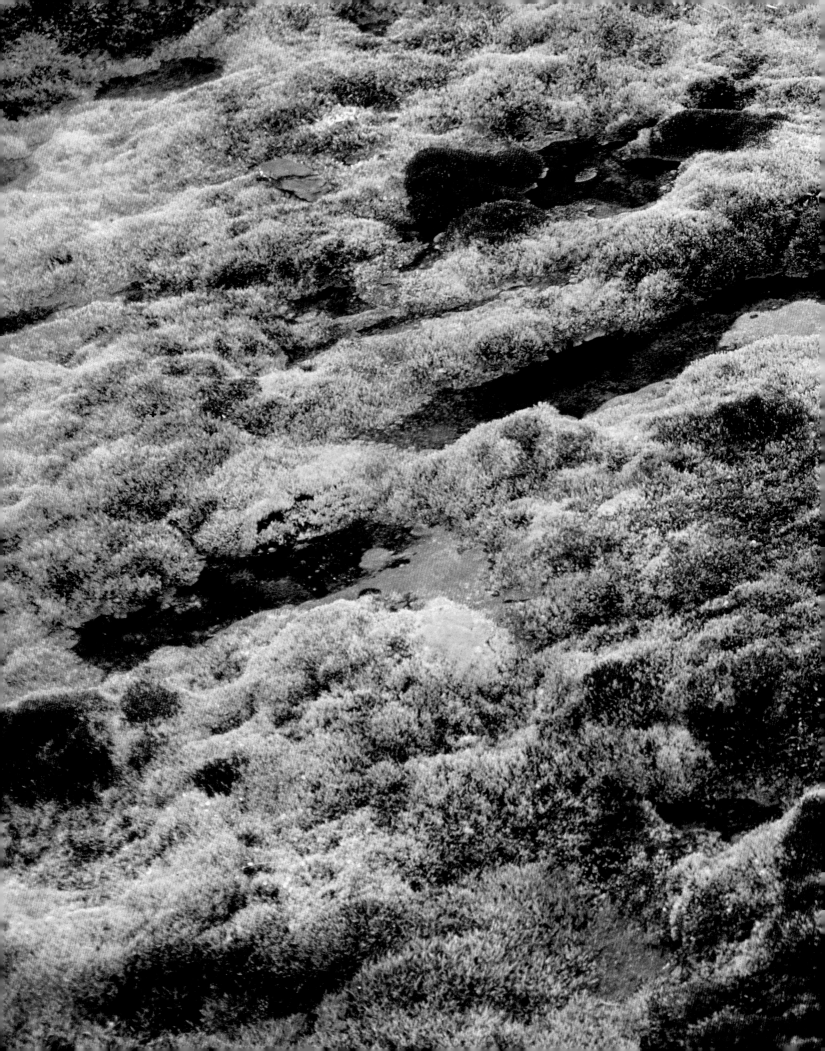

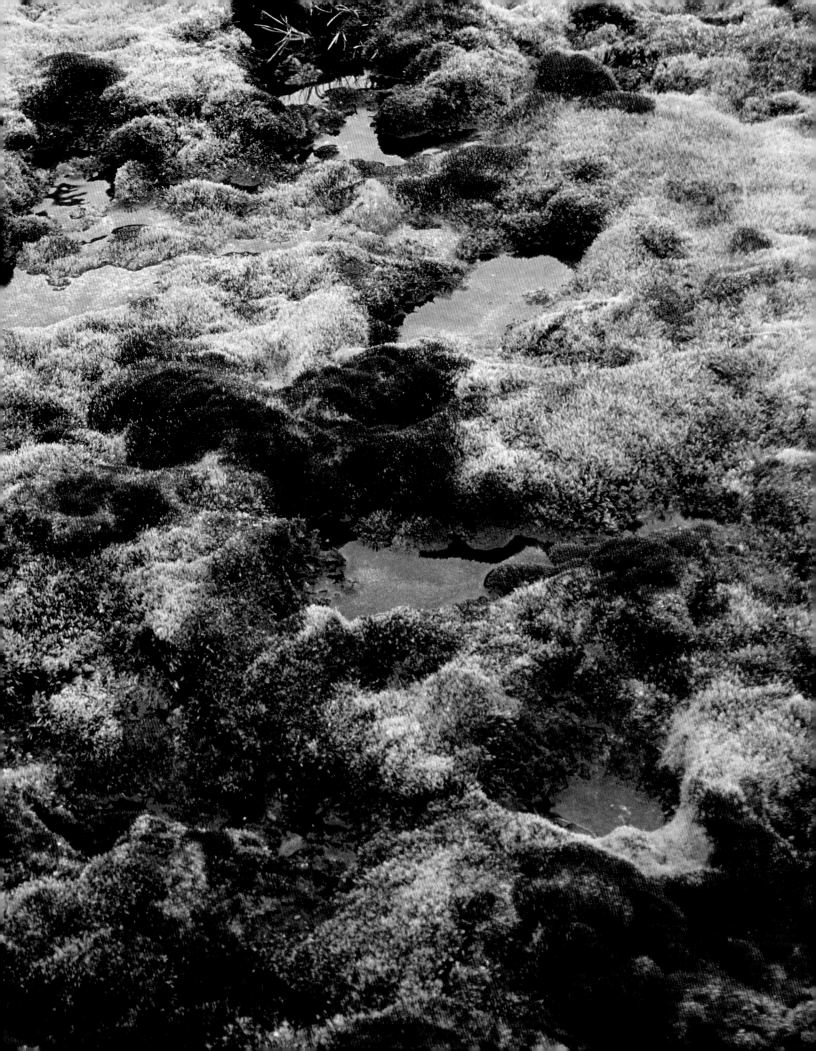

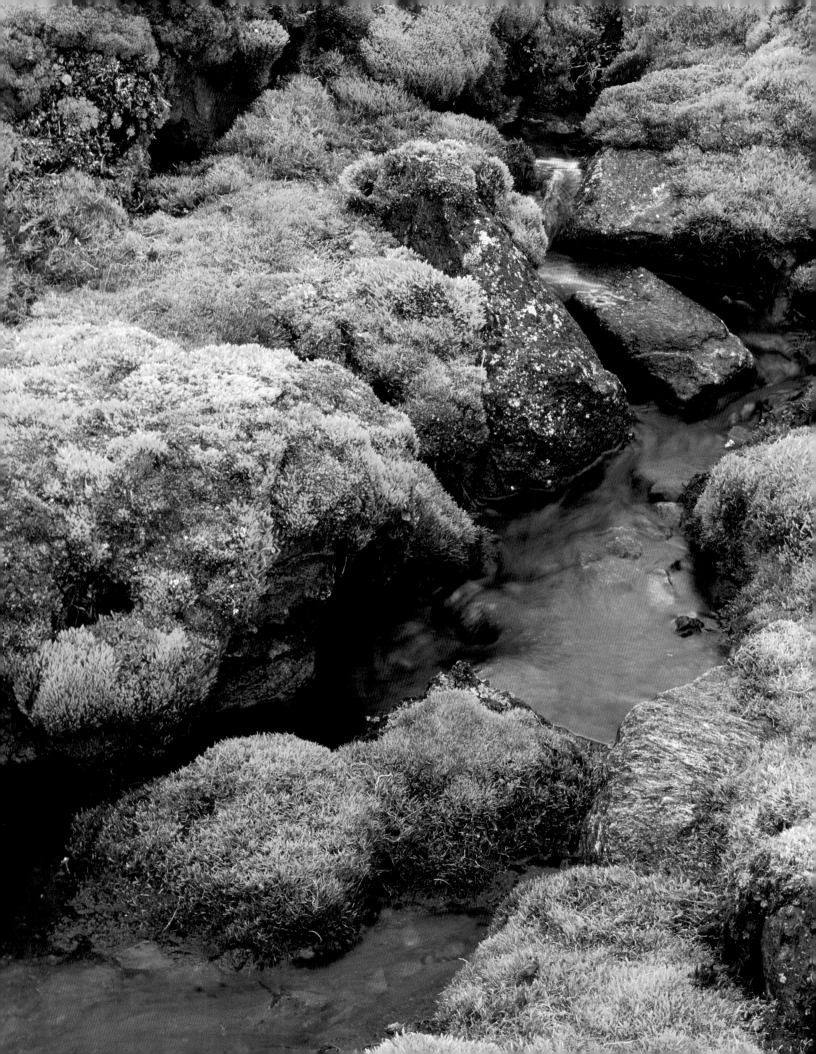

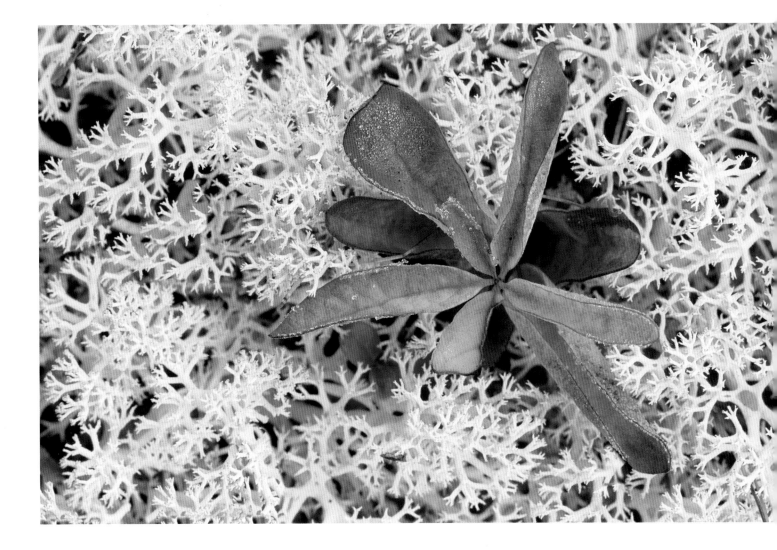

Previous spread: Mosses thrive in the Arctic, where, despite being in a perpetual state of resistance to cold and drought, they are able to grow small amounts even in the harshest of seasons. They can withstand coverage by snow or ice for more than five years; scientists believe many mosses may actually grow under a layer of ice and snow that is thin enough to transmit light. Furthermore, being dark in color, mosses absorb most of this light, which raises the plant's temperature.

Facing page: Mosses are the dominant plants in the Arctic, and their luxuriance can be surprising, as illustrated by these examples from the Svalbard Archipelago at 77 degrees north latitude. A great diversity of mosses can thrive in one area: 134 species of mosses have been recorded on Peary Land on the northern tip of Greenland. A capacity for indefinite vegetative growth is the moss's most important adaptive characteristic – a moss can spread simply by sending out shoots from the parent plant and when the wind scatters sprigs of the parent plant.

Above: The frost-tinged dwarf fireweed (*Chamerion latifolium*) finds shelter among a bed of reindeer lichen. The plant derives its common name from the habit of related species to colonize areas that have been burned by wildfires. Since such fires are uncommon in the Arctic, the dwarf fireweed grows instead along sandy damp shorelines, often in areas where the soil has been disturbed.

Previous spread: The white spikes of a lichen reach out from a patch of feather mosses. Unable to retain moisture in their tissues during dry periods, many mosses merely turn off and become dormant. Thus, when mosses seem desiccated and crusty, they're not dead, they're just resting. It's their way of surviving in the arid conditions of the Arctic. When water is once again available, the mosses almost immediately begin to photosynthesize and resume growth.

Above: The orange jewel lichen thrives in nitrogen-enriched environments, a feature that explains why the lichen is found on elevated rocks along ridge tops where generations of owls, eagles, falcons and hawks have landed to pluck prey, survey their territory and launch attacks. When the raptors leave, they frequently splash the rocks with white-wash. On Ellesmere Island, I helped a biologist search by helicopter for the nesting ledges of gyrfalcons. As we flew along the cliff faces, we were able to locate the nests simply by looking for spots where this colorful lichen was abundant.

Right: Lichens are almost indestructible. No landscape is too cold, too dry or too dark to keep them out. A French researcher once subjected a lichen to minus 460 degrees F (−237°C) and the organism survived. No location in the Arctic – or in the entire universe, for that matter – gets that cold. Being so tough, it's not surprising that individual lichens can live a long time. In the Arctic, some are thousands of years old and have lived on Earth since the earliest days of human civilization.

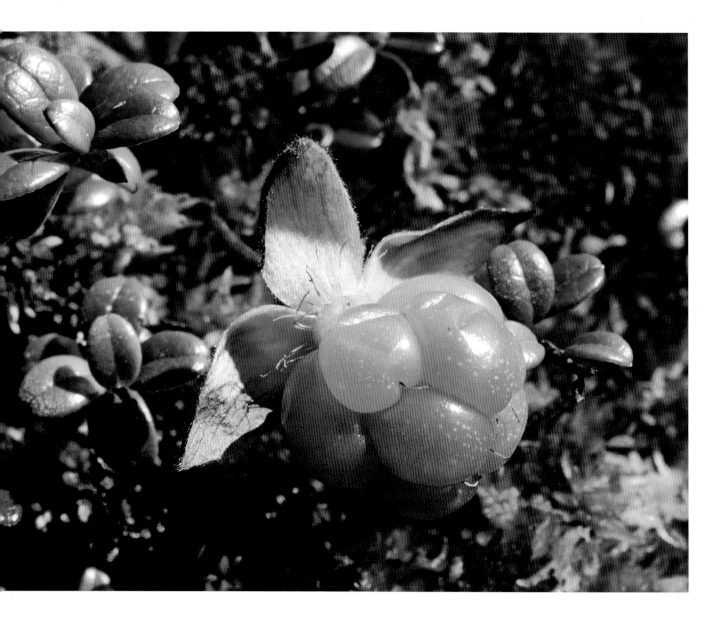

There are no poisonous berries in the Arctic, and all berries that do grow here are eaten by wildlife. The greatest variety occurs along the southern edge of the Arctic, where conditions are somewhat wetter and the growing season is slightly longer. Among arctic berries, my favorite is the cloudberry (*Rubus chamaemorus*), also called the baked-apple. This appetizing berry, roughly the size of a domestic raspberry, is soft and juicy and has a rich custard flavor. Inuit blend the berries with seal oil and chewed caribou fat and beat the mixture until it has the consistency of whipped cream. In Alaska, it's called Eskimo ice cream.

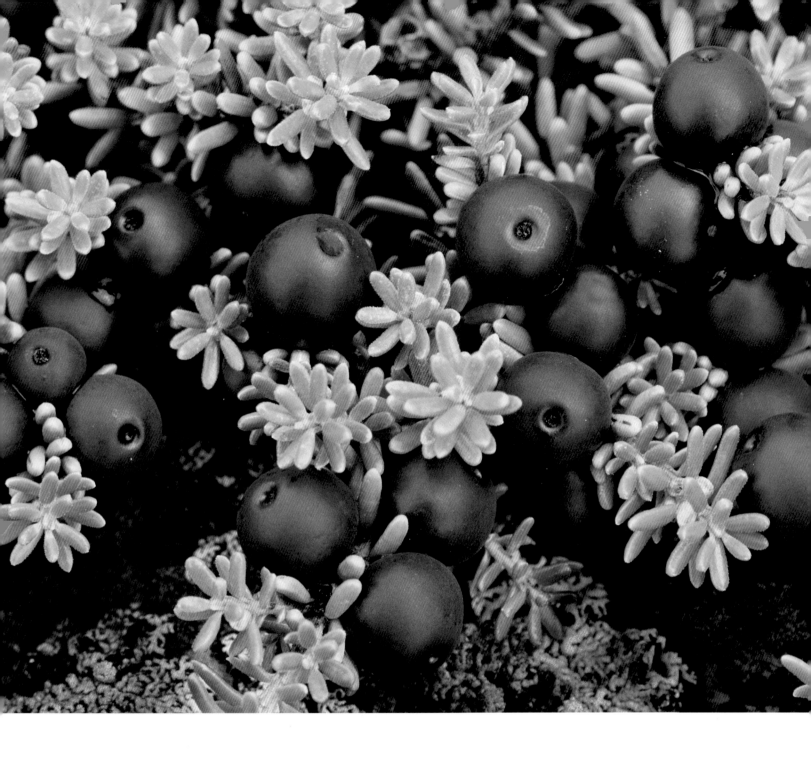

The crowberry (*Empetrum nigrum*) is a tough evergreen
shrub that grows as a thick ground-hugging mat and thrives
in sandy soil. A plant of the lower latitudes of the Arctic,
it is rarely found in the Arctic islands. Crowberries are still
eaten with enthusiasm by Inuit living on the land; tradition-
ally, the berries are preserved in seal oil as a winter food.
Along the western shoreline of Hudson Bay, polar bears have
been known to eat so many crowberries that their facial fur
becomes stained.

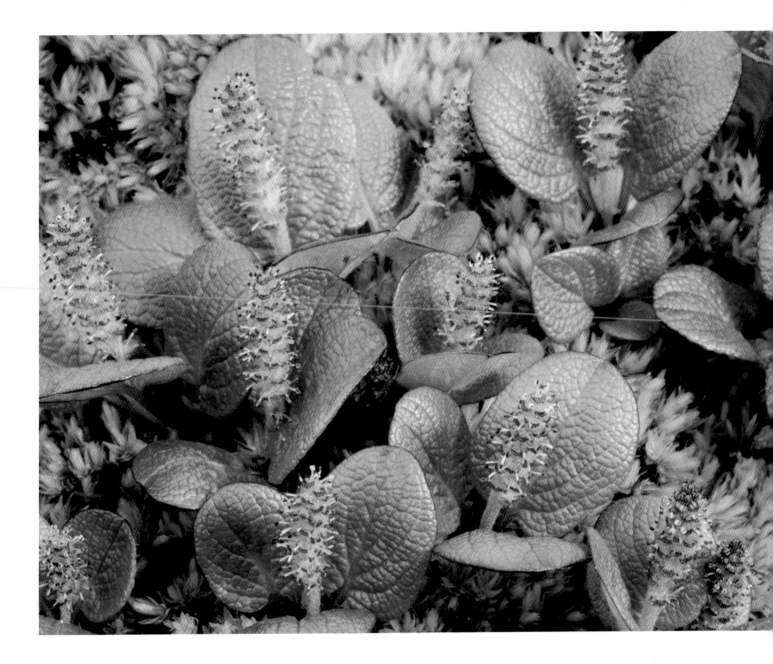

Left: In autumn, the deeply veined leaves of the bearberry (*Arctostaphylos* sp.) provide a crimson background for the smaller leaves and berries of the mountain cranberry (*Vaccinium* sp.). Many arctic berries do not ripen until after the first frosts and remain on the plant throughout the winter under the snow. To my taste buds, bearberries at any time of the year are rather mealy and insipid, but they are eaten with gusto by early spring migrants, such as geese, snow buntings and lapland longspurs, before insects are available.

Above: The leaves of the net-veined willow (*Salix reticulata*) are covered with a shiny waxy coating that restricts the amount of moisture the plant loses to the dry arctic air. The willow's leaves and bark are a rich source of vitamin C and were eaten historically by First Nations people and Inuit. On Banks Island in Canada's Northwest Territories, I was intrigued to watch Inuvialuit children strip the outer bark off larger willow branches and scrap away the white cambium layer with their teeth. The children said they were eating "the fat of the willow," which tastes slightly sweet.

Above: The purple saxifrage is the most northerly ranging wildflower on the planet. Its habitat extends to the tip of northern Greenland – the very limit of land in the Northern Hemisphere. I photographed these particular flowers on Devon Island, Nunavut, in the second week of July. A three-inch (8 cm) snowfall the day before had completely covered the plants, but within 12 hours, the snow had melted away and the flowers recovered.

Right: Overnight, frost had formed on the chilled body of this arctic bumblebee (*Bombus polaris*), suspended beneath a fireweed blossom. The frost had melted by mid-morning, and after several minutes of shivering its large muscles, the bee had increased its body temperature enough to fly away. In this fashion, a bumblebee can raise its body temperature up to 60 Fahrenheit degrees (33 C degrees) above the air temperature. Thus when a queen bumblebee first emerges in early summer and is gathering nectar and pollen, her hot-blooded body is already "incubating" the eggs inside her, even before she lays them.

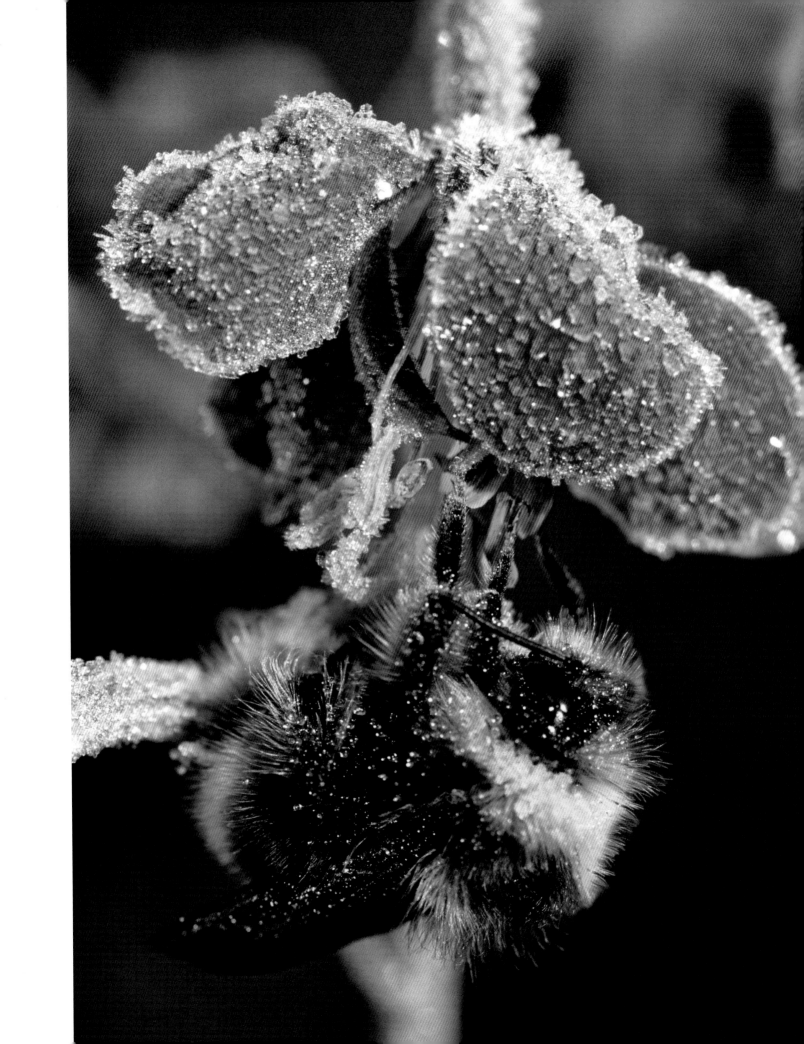

BIRDS OF THE

MIDNIGHT SUN

After watching birds and mammals at play on many different occasions, I find it difficult to believe that they don't sometimes do so for the sheer enjoyment of it – or for what we call fun. Some of the most playful birds belong to the Corvid family, which includes ravens, crows, magpies, jays and nutcrackers. Among corvids, the common raven (*Corvus corax*), in particular, is known for its complex play. The big, black, shiny birds will at times even play with other species.

One summer in Inuvik, Northwest Territories, I watched a solitary raven that could easily have been auditioning for the circus. When I first noticed the bird, it was quietly perched on a telephone wire. Suddenly, it spun forward and dangled upside down on the wire with its wings outstretched. After a moment or so, it let go – first with one foot, then with the other – and flew away.

I've watched ravens ride and roll repeatedly in the updrafts along the sides of mountains. In a study of the birds' aerial antics, one researcher observed that typically, the birds do a half roll, wherein they fold their wings, flip upside down for a second or two, then open their wings and roll upright again. They might roll over and over, as often as 19 times in a row, sometimes rolling left, sometimes right. A small percentage of times, the ravens do a full roll; in a few instances, they perform a double roll.

One winter, a British researcher spied a raven engaged in a different sort of play. The bird was on a hillside, and it was fluttering in the snow as if it were bathing. It rolled onto its side and then onto its back. Because of the steepness of the slope, the bird began to slide headfirst down the hill, its feet sticking straight up in the air. After gliding about 10 feet (3 m), it stopped,

hopped back up the hill and tobogganed down the snowy slope three more times. Later, the bird's mate, perched nearby, flew over, joined in on the snow bath and then likewise slid down the hill once on its back. Another observer watched with amusement as four northern ravens took turns sliding down a snowbank feet first, riding on their tail feathers.

Ravens are one of the few animals known to play with other species. Veteran wolf researcher Dr. David Mech described watching a gang of ravens at play with wolves in his classic book, *The Wolf*:

> As the pack traveled across a harbor, a few wolves lingered to rest, and four or five accompanying ravens began to pester them. The birds would dive at the wolf's head or tail, and the wolf would duck and then leap at them. Sometimes the ravens chased the wolves, flying just above their heads, and once, a raven waddled to a resting wolf, pecked its tail, and jumped aside as the wolf snapped at it. When the wolf retaliated by stalking the raven, the bird allowed it within a foot before arising. Then it landed a few feet beyond the wolf and repeated the prank.

Ravens have also been observed playing with brown bears. Young bears will chase just about any bird bold enough to land near them, but only ravens actually invite play. After a bear cub has chased a raven and forced it into flight, the bird frequently circles around and lands again nearby, taunting the bear into another round of chase-and-fly.

Why are ravens so playful? No one is quite certain, but part of the answer may lie in this bird's superior

intelligence and ability to learn. The famous animal behaviorist, Konrad Lorenz, called the raven a "specialized non-specialist." Because these birds are so clever and adaptable, they have managed to inhabit a great diversity of environments, ranging from arctic tundra to cactus deserts. The tendency for ravens to play may be simply another manifestation of their behavioral flexibility.

Living in the Arctic requires flexibility, especially in winter. Ravens and other birds of the midnight sun cope with the challenges of that season in one of three ways: they *fight* it, staring the season straight in the eye in the manner of the muskox, arctic hare and fox; they *hide* from it, either buried beneath an insulating mantle of snow as the lemming does, or curled deep inside a den hibernating, as the marmot and grizzly do; or they *flee,* using feathers, feet or fins. Most arctic birds adopt the third strategy, which is to escape to warmer climes. Some exceptions are the raven, ptarmigan, snowy owl and gyrfalcon, many of which tough it out, tenaciously enduring the many months of numbing frigidity and darkness.

Worldwide, roughly 180 species of birds fly north to the Arctic each summer for sex in the midnight sun. Within two or three months, many are preparing to migrate south again. Food is the issue, not the cold weather. Migrating birds leaving the Arctic may travel between roughly 60 miles (96 km) or 6,000 miles (9,600 km) – the destination and distance depends on where they can find food. Virtually every bird that breeds in the Arctic could theoretically remain there for the winter if they could only find enough food to keep their body furnaces roaring. Since food is scarce, they must migrate, and the getaway destinations they choose are not always a great deal warmer. Ptarmigan and redpolls, for example, may only move a short distance to the tree line, where the winters are just as long and cold as they are on the tundra. Arctic falcons, owls and hawks frequently escape no farther than the freezing, wind-swept prairies.

Nevertheless, most arctic migrants still overfly winter, and usually, they choose locales where they can revel in the warmth of the sun. In North America, arctic ducks, geese and swans overwinter in the southern United States (as do many sparrows and longspurs). In Eurasia and Greenland, these waterfowl spend the winter months foraging in England, Scotland and Wales and in the productive tidal flats along the European coastline. The shorebirds, however, are the real showoffs. Most of them travel to South America or Africa.

One year, I journeyed to the High Arctic and then to the subantarctic within a four-month period. On the first trip, I watched an adult white-rumped sandpiper (*Calidris fuscicollis*) brood its chick against a sudden summer squall on Devon Island in the Canadian Arctic. A few months later, I photographed a flock of these same birds probing a mudflat in the Falkland Islands, 11,870 miles (19,100 km) away. What makes the migration of the white-rumped sandpiper even more amazing is that it travels the distance in just a few nonstop flights, lasting up to 60 hours each and covering 2,500 miles (4,000 km) at a time. Not bad for a bird that weighs only 1½ ounces (45 g).

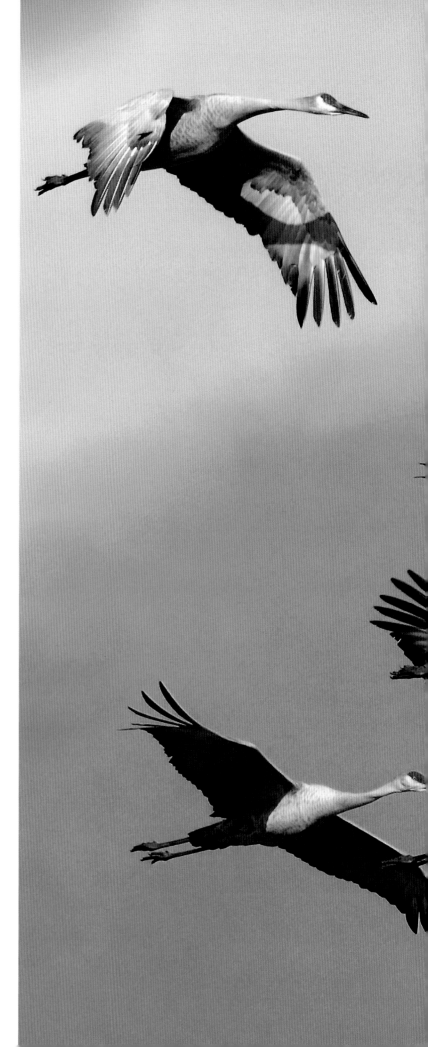

Chapter opening: It's a well-known fact that the arctic tern (*Sterna paradisea*) makes the longest migration of any creature on Earth, often traveling 18,500 to 30,000 miles (30,000–50,000 km) between its Arctic nesting grounds and its wintering ground in the Antarctic. A more interesting question for me is *why* the tern travels such a great distance. Scientists speculate that this arctic aeronaut continues to follow the same migration route that its ancestors did during the last glaciation, when much of the polar region was encased in ice. Since the tern's lengthy migration has not led to a lower survival rate, there has been no evolutionary incentive for the bird to revise its flight pattern.

Right: Like 95 percent of all arctic birds, the sandhill crane (*Grus canadensis*) flies north for a few months each summer to breed and then leaves again in early autumn. One September, I watched flock after flock of these long-necked buglers pass overhead for nearly two days as tens of thousands of them funneled from the vast tundra of the Yukon and Kuskokwim River deltas, heading for their distant wintering grounds in the wetlands of Texas and New Mexico. The sandhill crane's loud trumpetlike call is due to its unusually long trachea, which is coiled around the bird's breastbone.

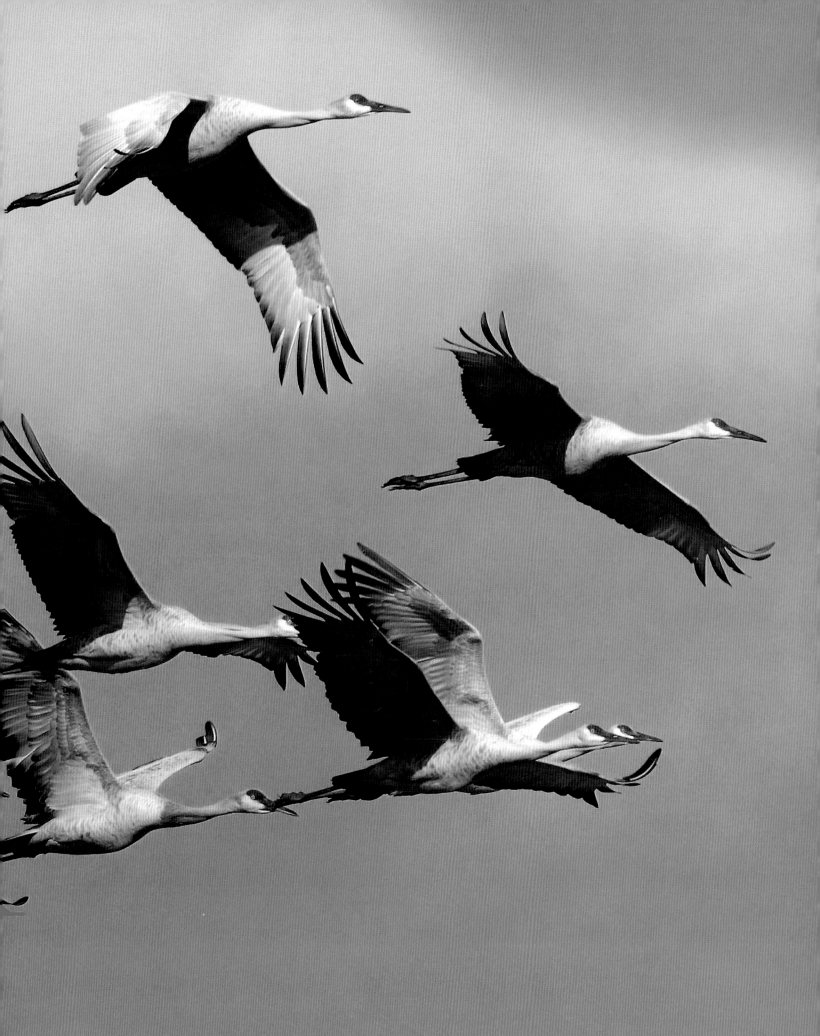

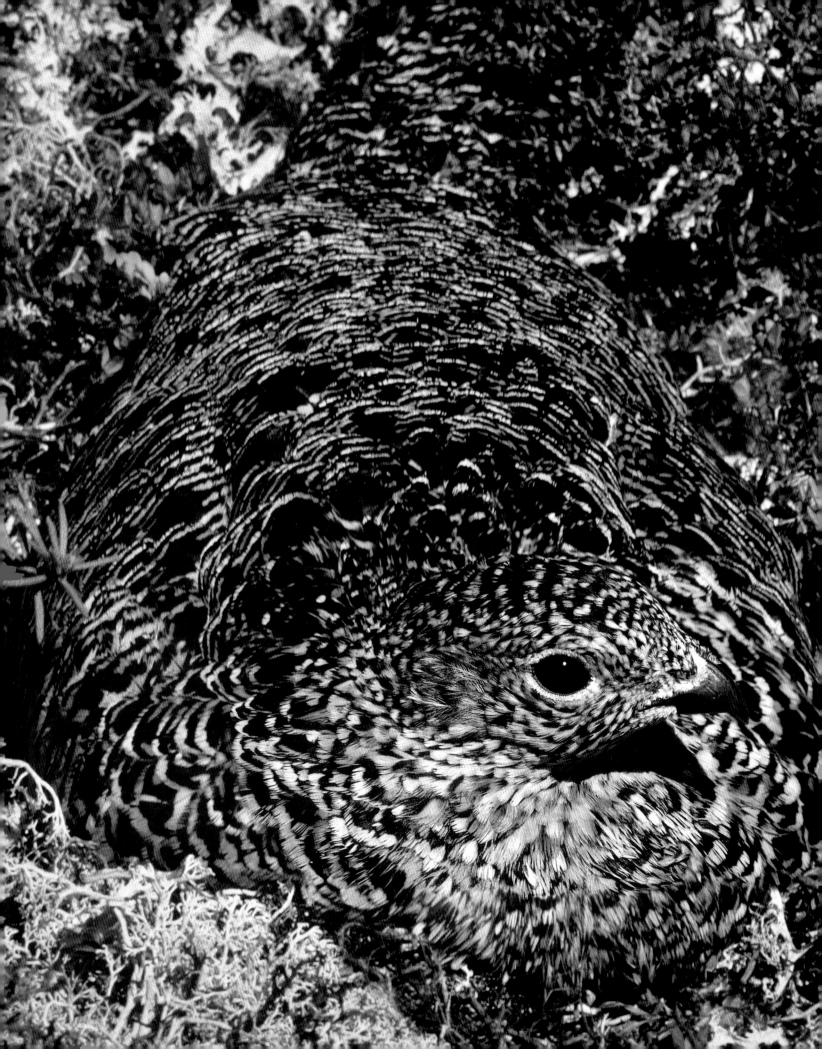

Previous spread: Variations in temperature, soil moisture and plant cover offer a variety of tundra habitats to arctic birds and contribute to their diversity. In valley bottoms, there are wet sedge meadows with growths of cottongrass as well as shrub tundra that is characterized by the presence of bushes, usually willows and dwarf birches. On the drier slopes and summits of the hills are the so-called "rock gardens," where a profusion of wild-flowers grows.

Left: This cryptically feathered female willow ptarmigan (*Lagopus lagopus*) was so confident in the effectiveness of her camouflage that I could have touched her as she sat incubating her clutch of eggs. When feeding conditions are ideal, a female willow ptarmigan may lay as many as 13 eggs – the largest clutch of any arctic bird. The average clutch, however, is usually seven to 10 eggs.

Many people think that snowfall is the signal for the ptarmigan to change its feather color from summer brown to winter white, but that isn't how it works. As autumn turns to winter, the hours of daylight grow shorter, and it is this decreasing number of daylight hours that signals the brain of the bird that it's time to shed its brown feathers and replace them with white ones. Surprisingly, neither the temperature nor the snowfall affects the timing of this transition, which explains why a ptarmigan sometimes turns white before it has snowed. Once the winter is over, the ptarmigan molts a second time, replacing most of its white feathers with camouflaged brown and gray ones. In spring, this change is triggered by increasing daylight hours.

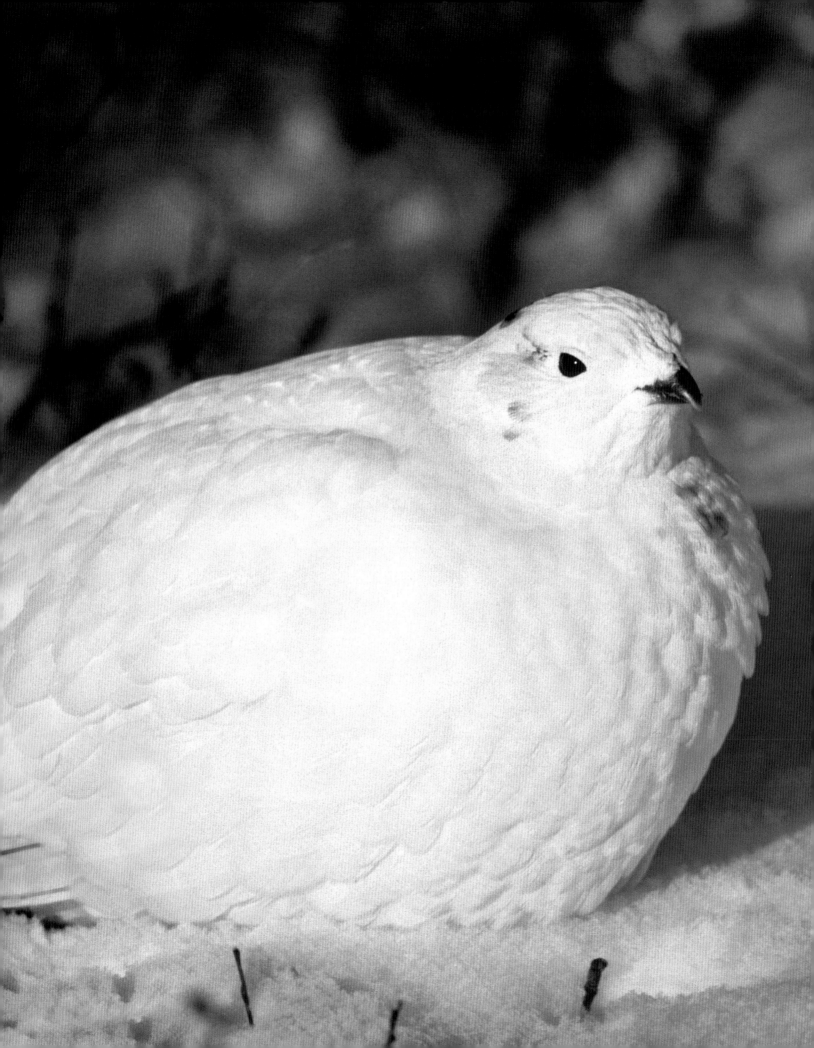

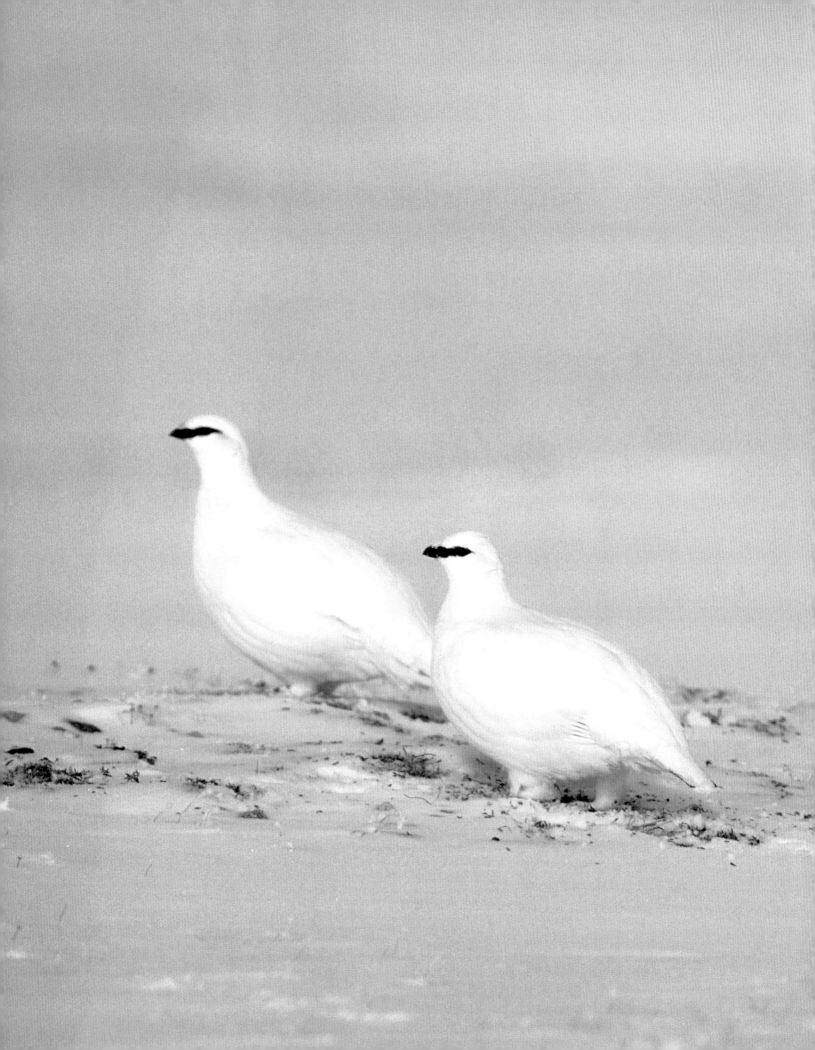

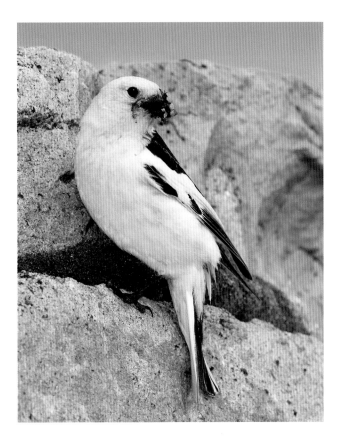

Above: A male snow bunting (*Plectrophenax nivalis*) in the Svalbard Archipelago fed insects and spiders to a brood of five chicks huddled in a nest in a rock crevice. The sheltered location of the nest protected it from the worst of the weather and from the keen eyesight of predators such as arctic foxes, jaegers and ravens. In many High Arctic communities, the return of snow buntings in May is a welcome sign that spring is on the way. Typically, the handsome black and white males arrive four to six weeks before the females, while snow still covers the ground.

Left: In winter, the rock ptarmigan (*Lagopus mutus*) feeds mostly on seeds, buds and twigs that grow above the snow, preferring windswept ridges and slopes where the snow cover is light. The birds pictured here had scratched through a thin covering of snow and were feeding on saxifrage seeds. Earlier in the day, I watched a small flock of ptarmigan searching for food in the abandoned feeding craters dug by muskoxen. Sometimes, these birds follow right behind the muskoxen as they feed.

The lapland longspur (*Calcarius lapponicus*) breeds throughout the circumpolar Arctic. The bird's common name is derived from the location where the first specimen was collected and described and from the unusually elongated claw on its hind toe, the purpose of which is still a mystery. Every five to 10 minutes, the male pictured here made feeding trips to its four chicks in a nest hidden in the grass nearby, offering them caterpillars, craneflies and spiders.

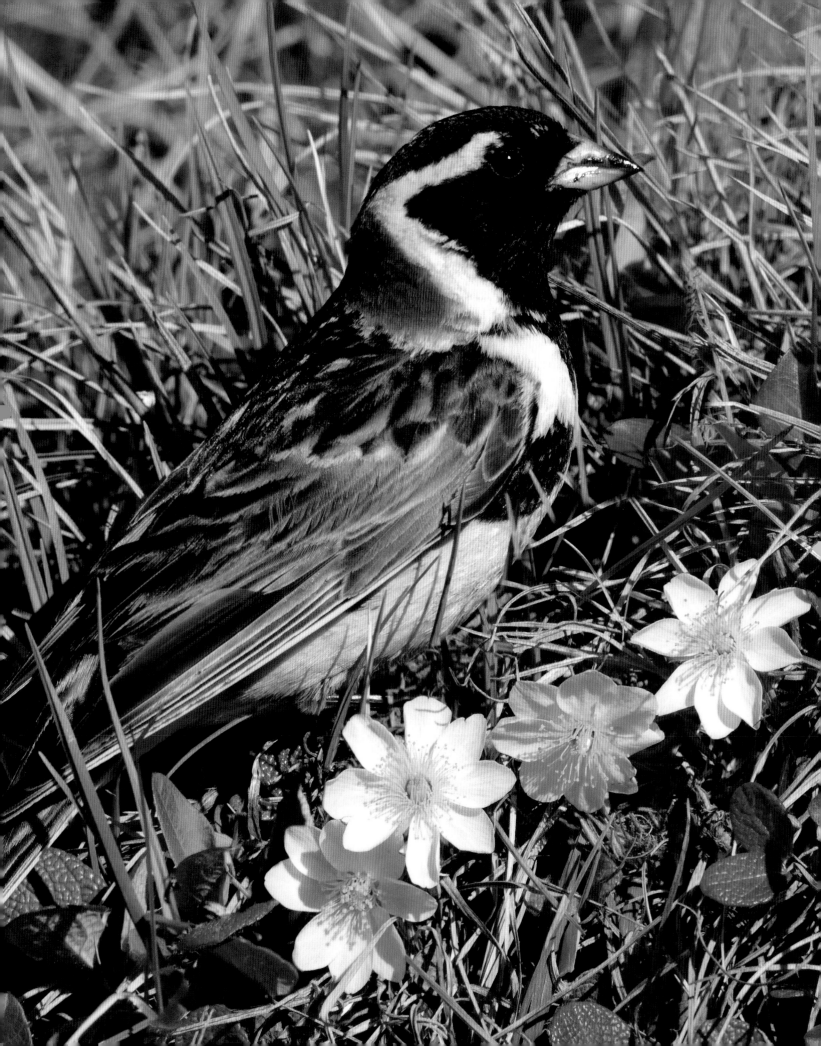

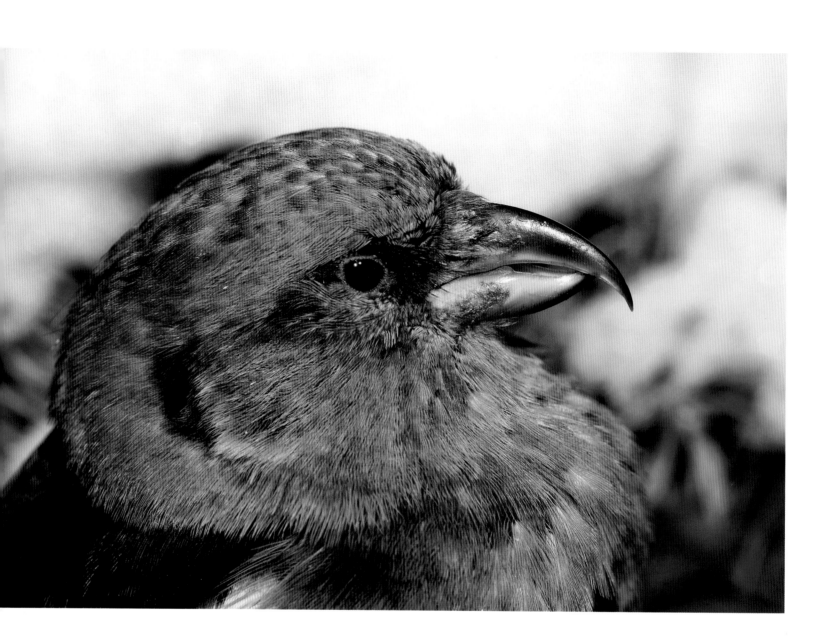

Above: On June 23, 2008, I was aboard a ship in the pack ice off the southeastern coastline of Spitzbergen in the Svalbard Archipelago, at 77 degrees north latitude. The day before, a severe storm with strong southerly winds had struck us. Around six o'clock, as I was having my morning coffee on the bridge, I was shocked to see three red crossbills (*Loxia curvirostra*), like the male pictured here, flying around the deck of the ship. The nearest coniferous forests, where these cone-eating songbirds would normally be found, was in northern Norway, over 500 miles (800 km) away. Storms winds drive many birds off course and into new habitats – unfortunately, most of these pioneers do not survive.

Right: Small mammals and birds, such as this hoary redpoll (*Carduelis hornemanni*), are especially vulnerable to cold and become chilled more quickly than larger species. When food is scarce and a redpoll's energy reserves are depleted, the resourceful bird has a strategy to help it survive a cold arctic night. It chills out, literally. Birds normally keep their body temperatures at a constant 104 degrees F (40°C), but it is expensive to keep the heat turned up that high. To save energy, the nighttime body temperature of a roosting redpoll may drop 18 Fahrenheit degrees (10 C degrees), earning the bird an energy saving of up to 30 percent.

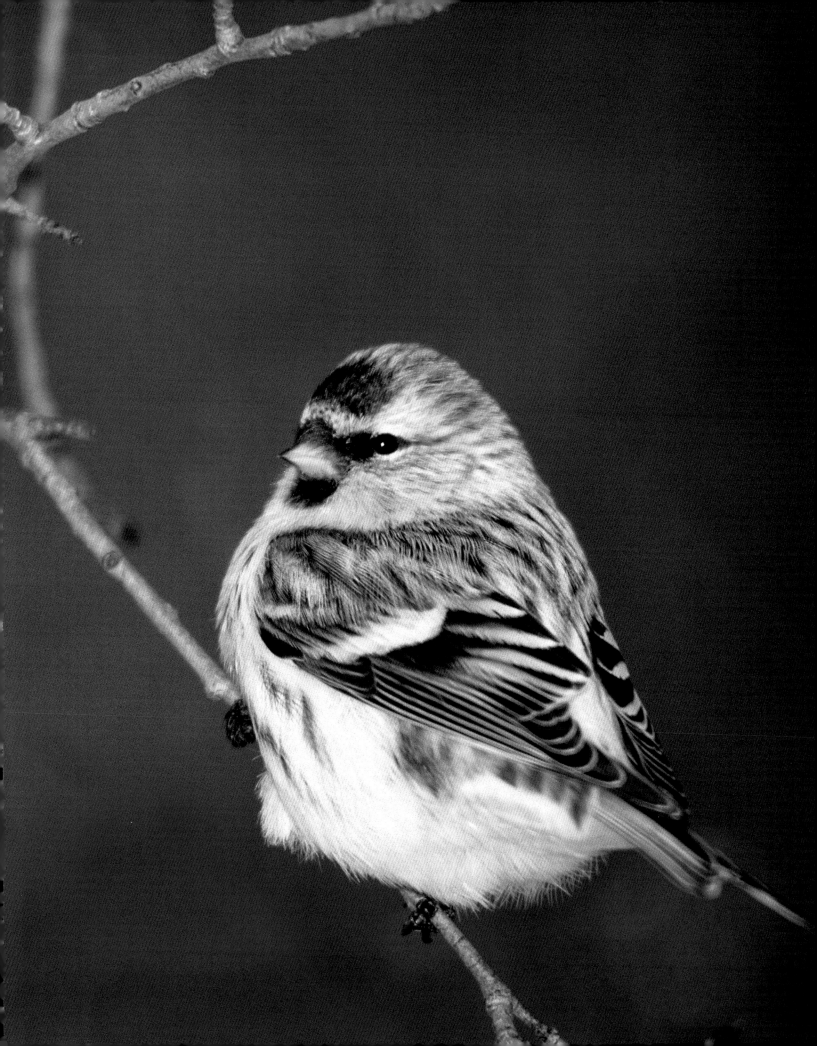

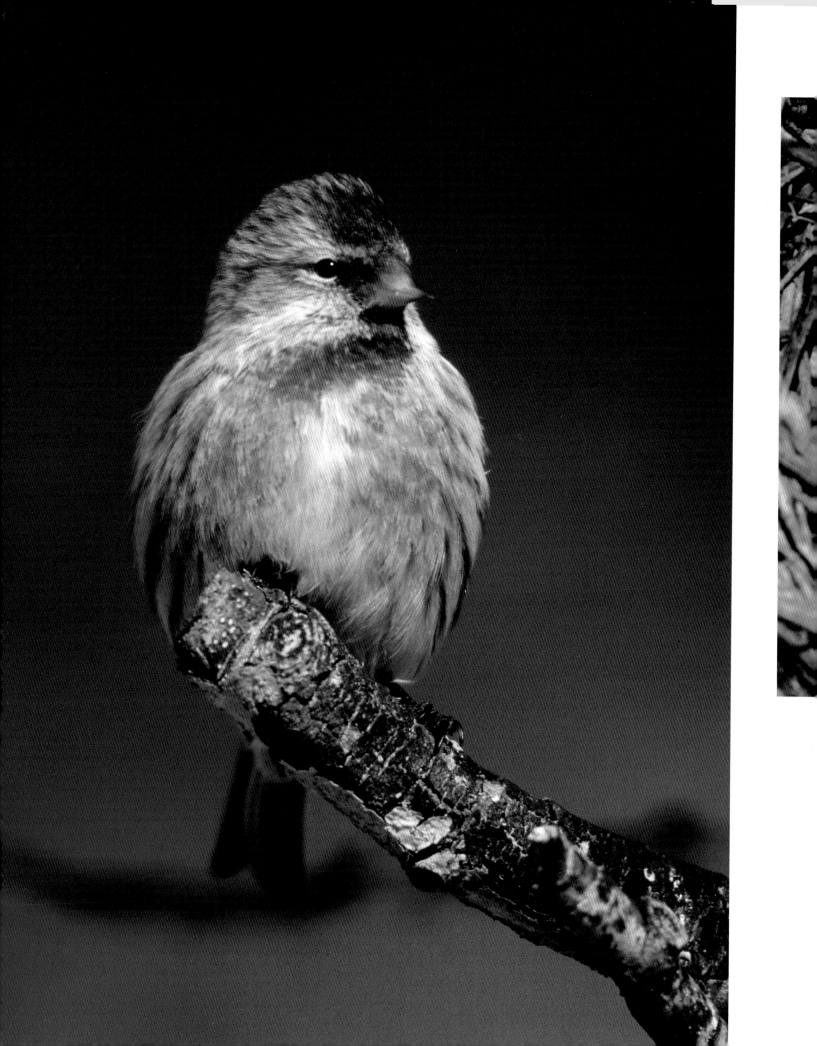

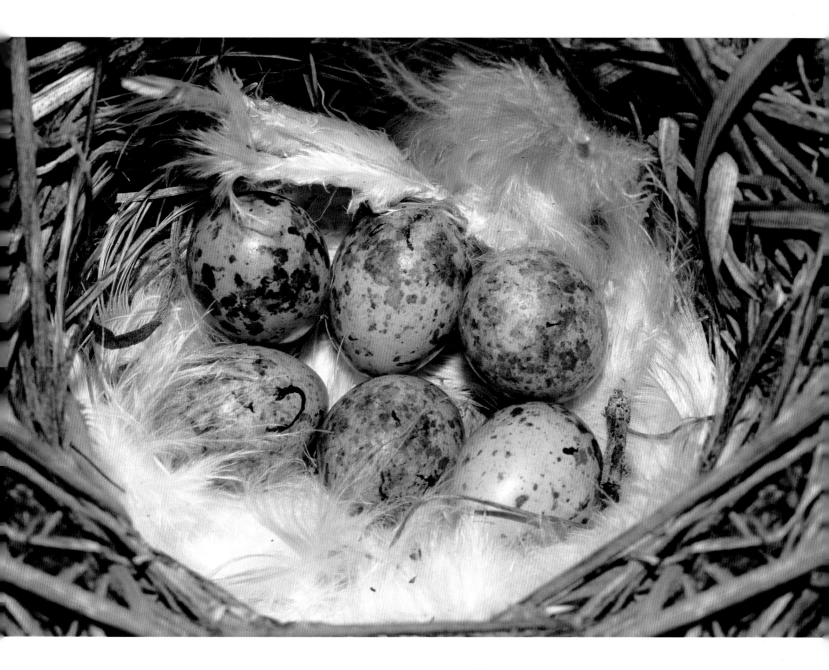

Left: If you were to pluck all the feathers from the body of a common redpoll (*Carduelis flammea*), the bird you'd be left with would be no larger than the end of your thumb. This diminutive songbird weighs a mere ½ to ¾ ounces (14–21 g), making it and its like-sized relative, the hoary redpoll, the smallest birds known to have overwintered in the Arctic. Russian researchers have found redpolls sheltering inside lemming tunnels beneath the snow in order to stay warm on cold winter nights. The birds sometimes stayed hidden for 16 hours at a time.

Above: In the Arctic, there may be snowfall any day of the year, so even summer-nesting birds need to insulate their eggs against unpredictable cold conditions. This is the nest of a common redpoll, which is frequently hidden in a low clump of willows, up off the ground. The small nest cup of fine twigs, grass and rootlets is generally lined with plant down from willows or cotton grass or from the molted hair of the caribou, fox or muskox. The eggs in this nest were swaddled in ptarmigan feathers.

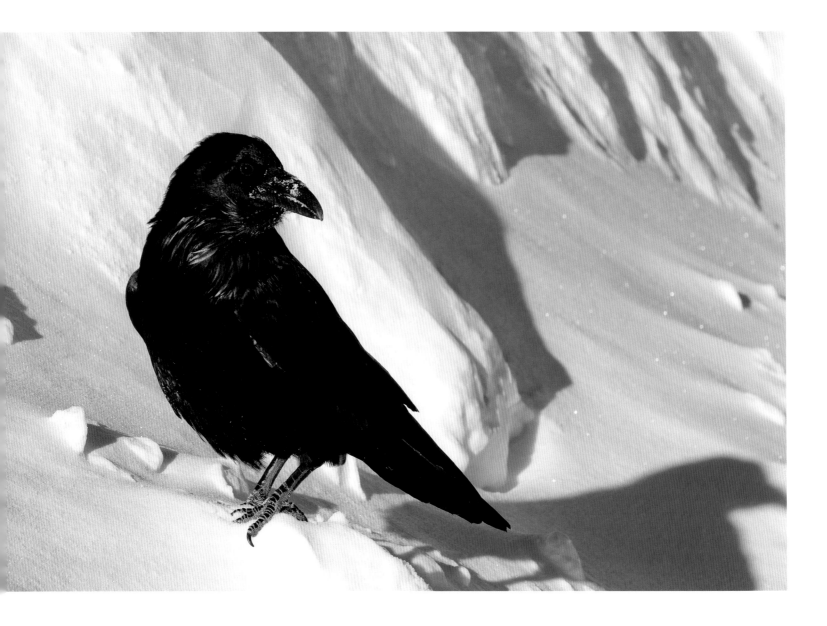

The common raven will eat almost anything but feeds mainly on the eggs and chicks of shorebirds and seabirds, the young of lemmings and arctic hares, and carrion. In one study on Alaska's North Slope, researchers stationed themselves near carcasses to see which scavengers would appear. Ravens showed up for a meal every time, and on three out of four occasions, these keen-sighted birds were the first on the scene. When a raven finds a large carcass, it will often cache any surplus meat it collects.

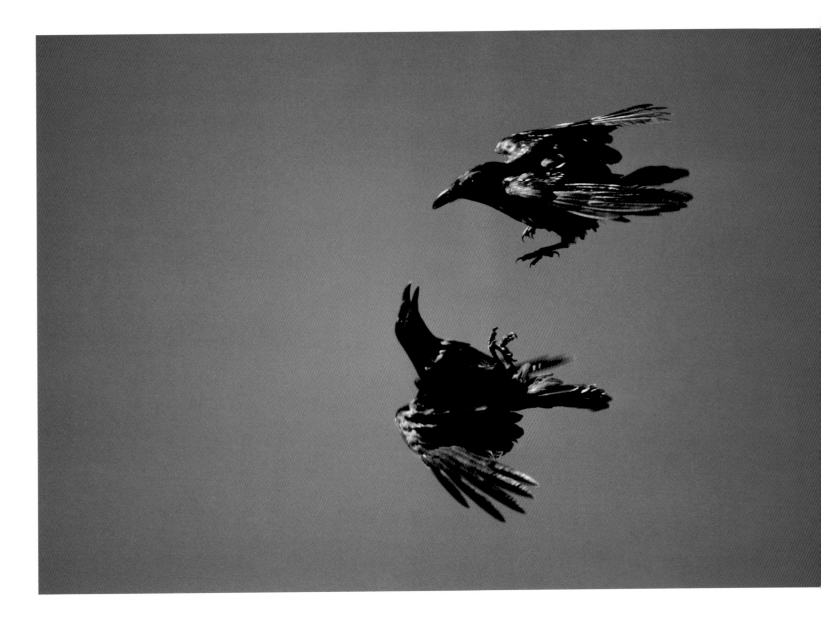

Ravens at play in the updrafts across the face of a cliff.
Occurring to the limit of land in Greenland and North
America, ravens may overwinter in the most northern areas,
but the majority migrate south in autumn, returning in very
early spring and laying eggs in mid-April. In Greenland, the
most northerly wandering birds are probably non-breeding;
breeding birds seem to require the presence of large
seabird colonies or human habitations to be successful
at rearing chicks.

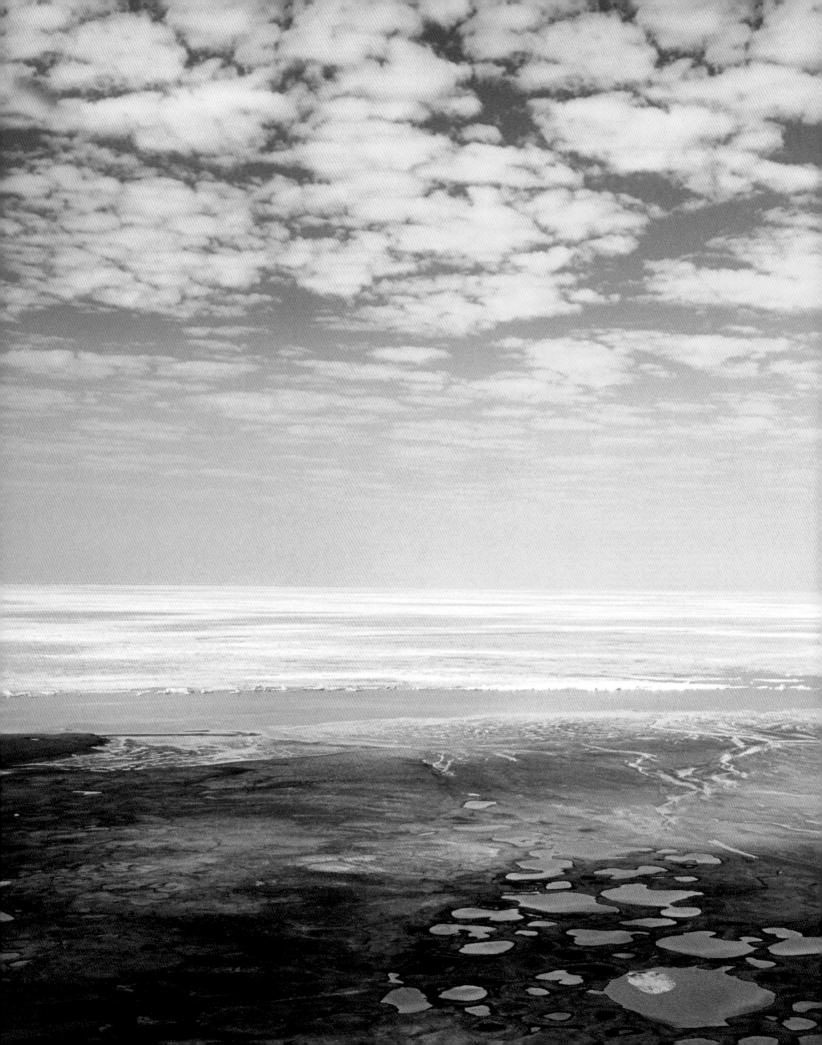

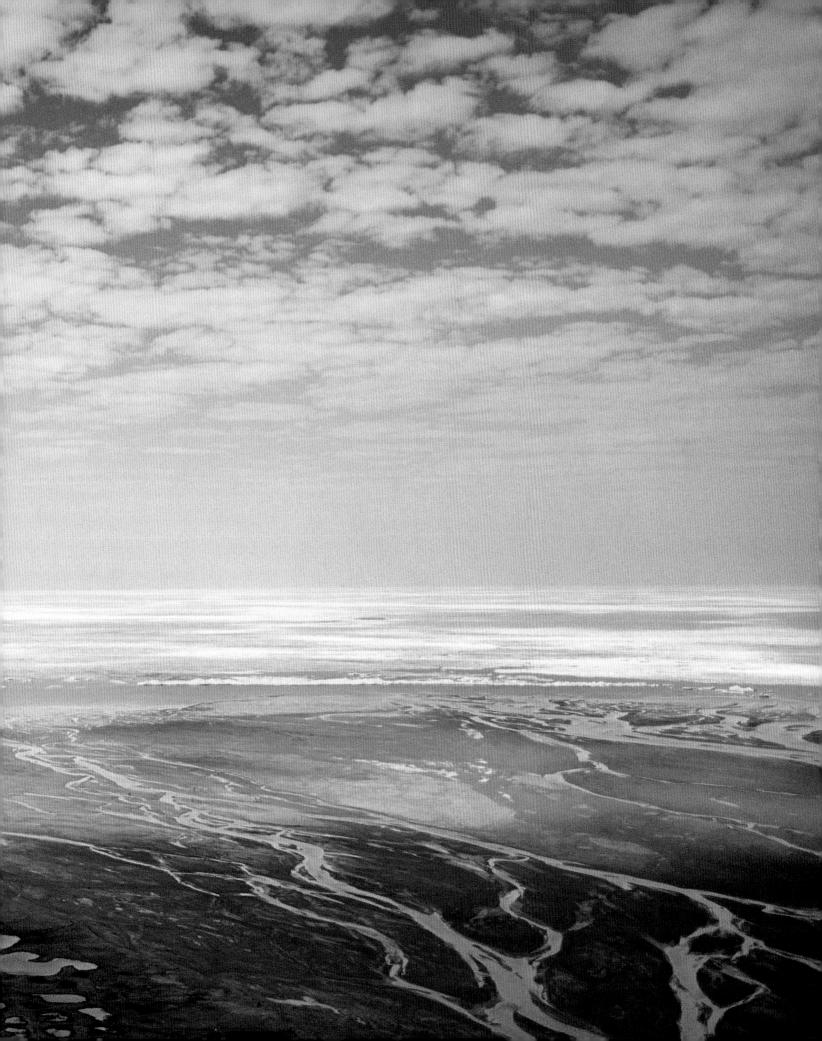

Previous spread: An aerial view of the Thomsen River draining into the ice-covered waters of McClure Strait, which shoulders the northern coast of Banks Island in the Canadian High Arctic. The braided river and multiple shallow ponds are excellent foraging habitat and provide nesting areas for innumerable shorebirds. As well, the rim of open water along the shoreline attracts rafts of eiders and scoters. With the relatively abundant bird life, the area is a good hunting grounds for the arctic fox, the most common predator of nesting arctic birds.

Right: The long-tailed jaeger (*Stercorarius longicaudus*) is a predatory bird that hunts shorebird and songbird hatchlings as well as lemmings. This fast-flying pirate also steals food from seabirds such as arctic terns as they return from foraging trips at sea. In the summer of 1996, I found a pair of jaegers nesting at the northern tip of Ellesmere Island. My position was latitude 83 degrees 05 minutes 35 seconds N, farther north than any jaeger nest that had ever been reported. We were just 483 miles (777 km) from the North Pole. Indeed, this nest was the most northerly nest site of any species ever reported on the planet.

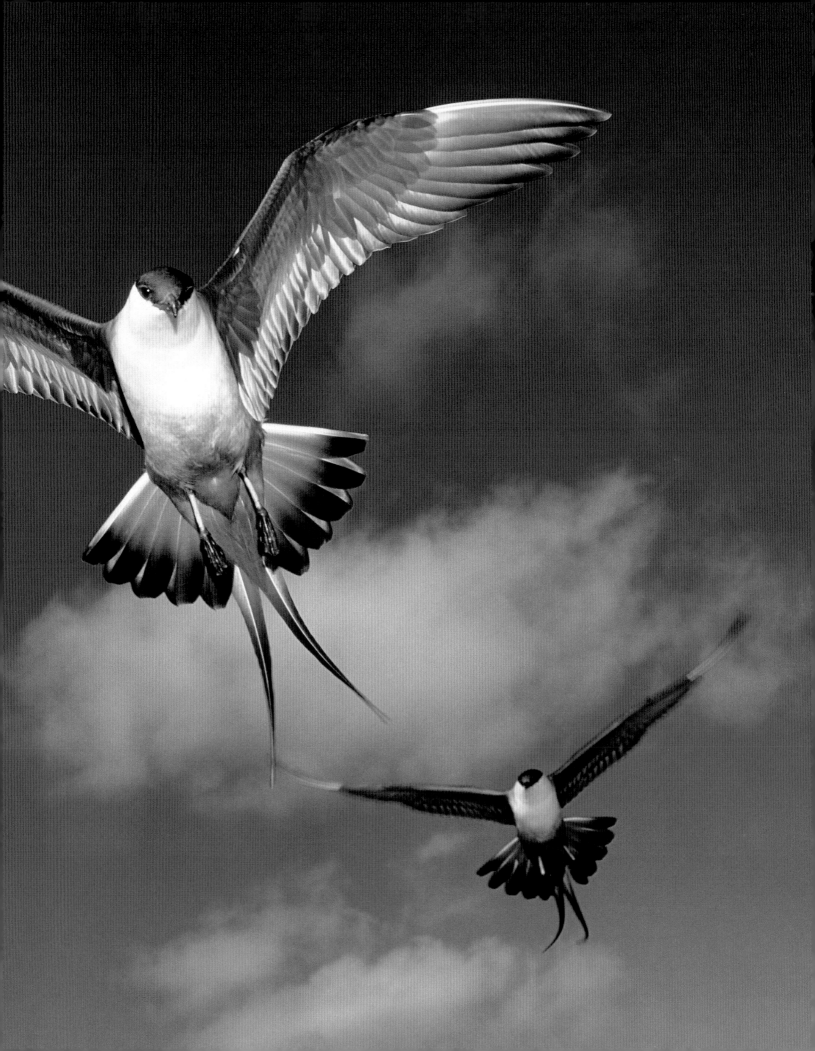

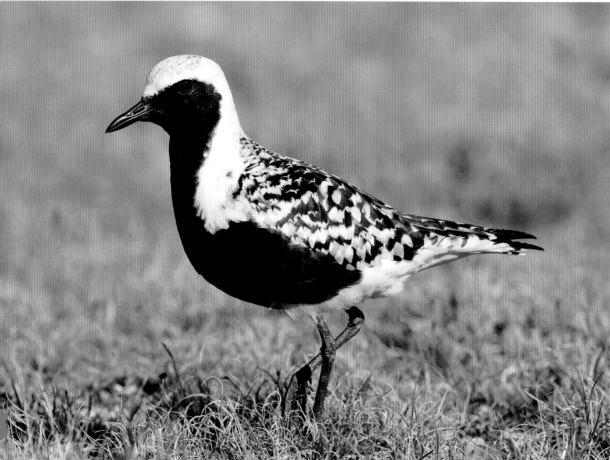

Nearly a third of all the birds breeding in the Arctic – roughly 60 species – belong to the so-called shorebird group, which includes, among others, a mix of sandpipers, godwits, phalaropes, curlews and plovers, such as this black-bellied plover (*Pluvialis squatarola*). Most shorebirds are rather plainly colored in blacks, buffs, grays and browns, and although they differ greatly in size, the most obvious difference between many of them can be seen in the shape and length of their bills. These different bills help to reduce competition for food when the birds are foraging on their wintering grounds away from the Arctic.

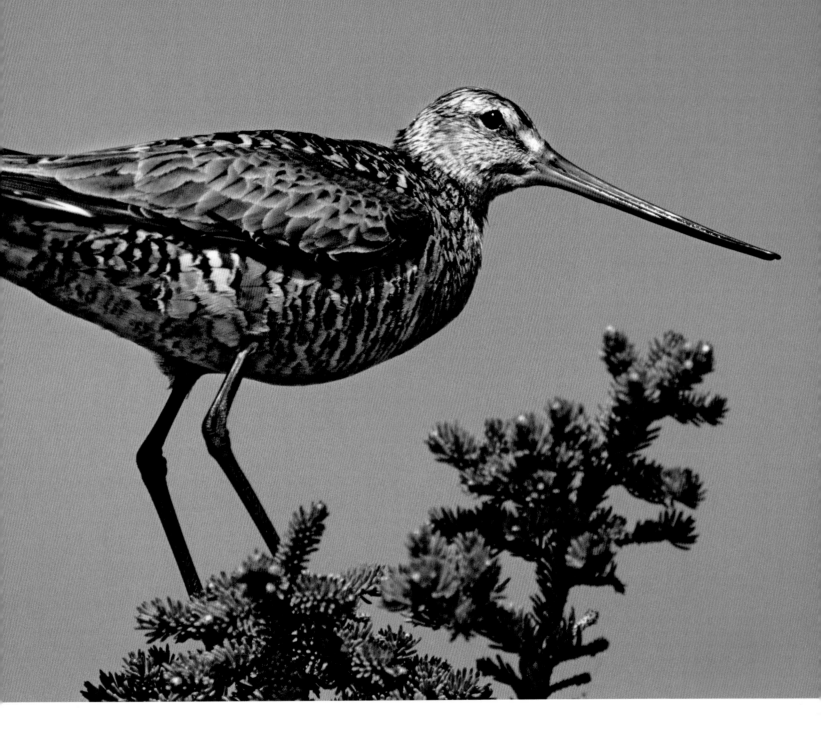

The long, up-turned beak of the Hudsonian godwit (*Limosa haemastica*) is one of the longer bills to be found on an arctic shorebird. In the Arctic, this bird feeds on the insects and spiders it catches in the thick grasses and sedges of the tundra. On its wintering grounds in the tropics, however, the godwit is able to probe deeply into the mud of intertidal flats. Since it can't see the lugworms, ragworms, clams and snails hidden in the mud, it "feels" its way around, using hundreds of sensitive touch receptors at the tip of its beak.

All shorebirds, including this semipalmated plover
(*Charadrius semipalmatus*), lay a clutch of four relatively
large eggs. The calcium required to provision the eggs
can be twice as much as the total amount of calcium in
the bird's entire skeleton. Where do these birds find
enough calcium? When scientists examined the stomachs
of many Arctic-nesting plovers and sandpipers, they
found the teeth and vertebrae of lemmings and voles.
Apparently, the birds scavenge from decomposed
carcasses and from the undigested pellets regurgitated
by owls, hawks and jaegers.

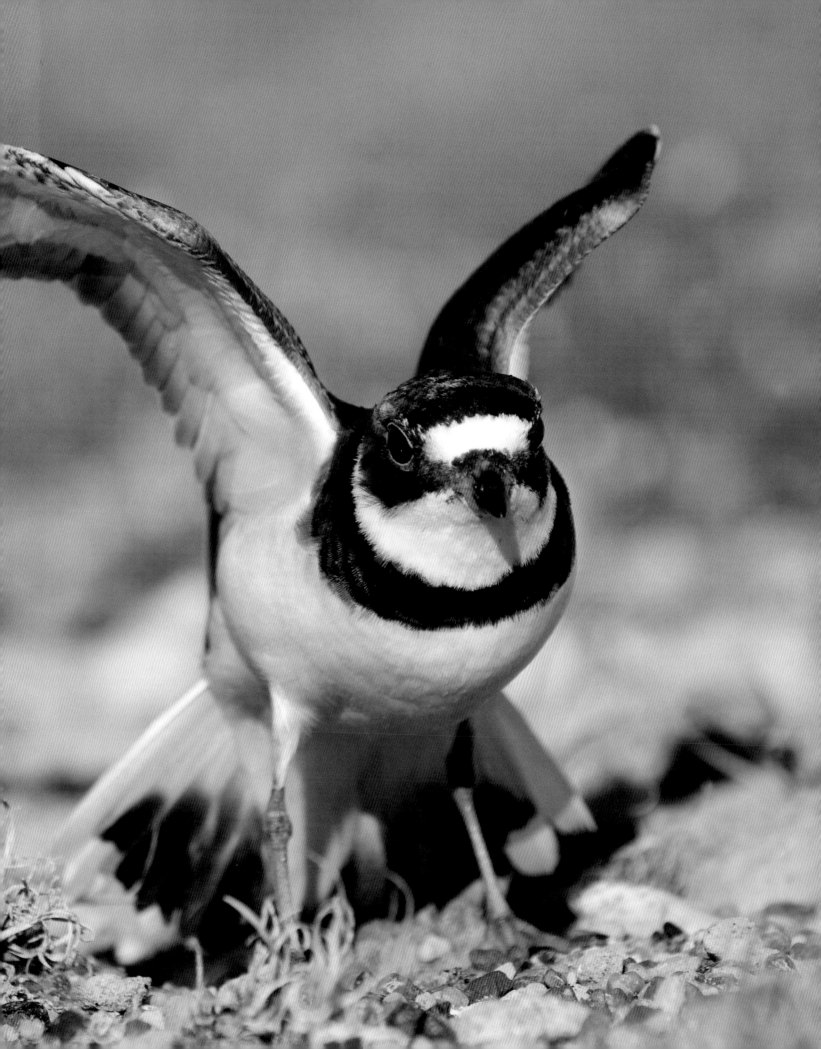

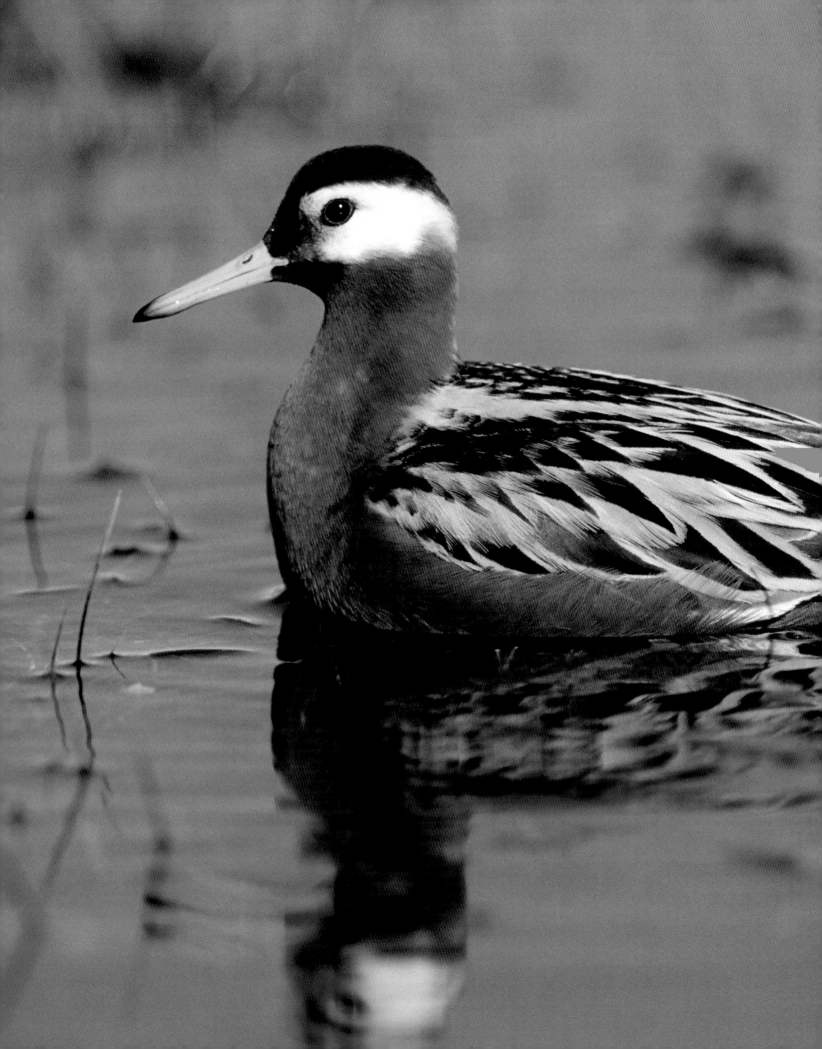

Left: In general, shorebirds practice the greatest variety of mating systems of any group of birds. A few are monogamous, but many are promiscuous. With some shorebirds, philandering males breed in succession with several females in a single season; with others, it's the female that raises several families, each fathered by a different male. In the case of the red phalarope (*Phalaropus fulicarius*), the female does the courting. She is also larger and more brightly feathered than her mate, which incubates their eggs and raises the chicks – one of the rare examples of complete role reversal in the world of birds.

Following spread: From a distance, the barren, tundra-cloaked hills and valleys of Northwest Fiord in East Greenland seem an unlikely home for bird life. Along the shoreline, however, I found barnacle geese, arctic terns and jaegers. Inland, there were northern wheatears (*Oenanthe oenanthe*), several species of shorebirds, as well as numerous newly fledged snow buntings chasing wolf spiders on the gravel-strewn slopes. At one point, I accidentally came between a mother rock ptarmigan and her half-grown chicks. The female of this species is quite attentive to her young, and when I disturbed the family, she uttered a throaty *krrrr* and tried to lure me away with conspicuous flapping.

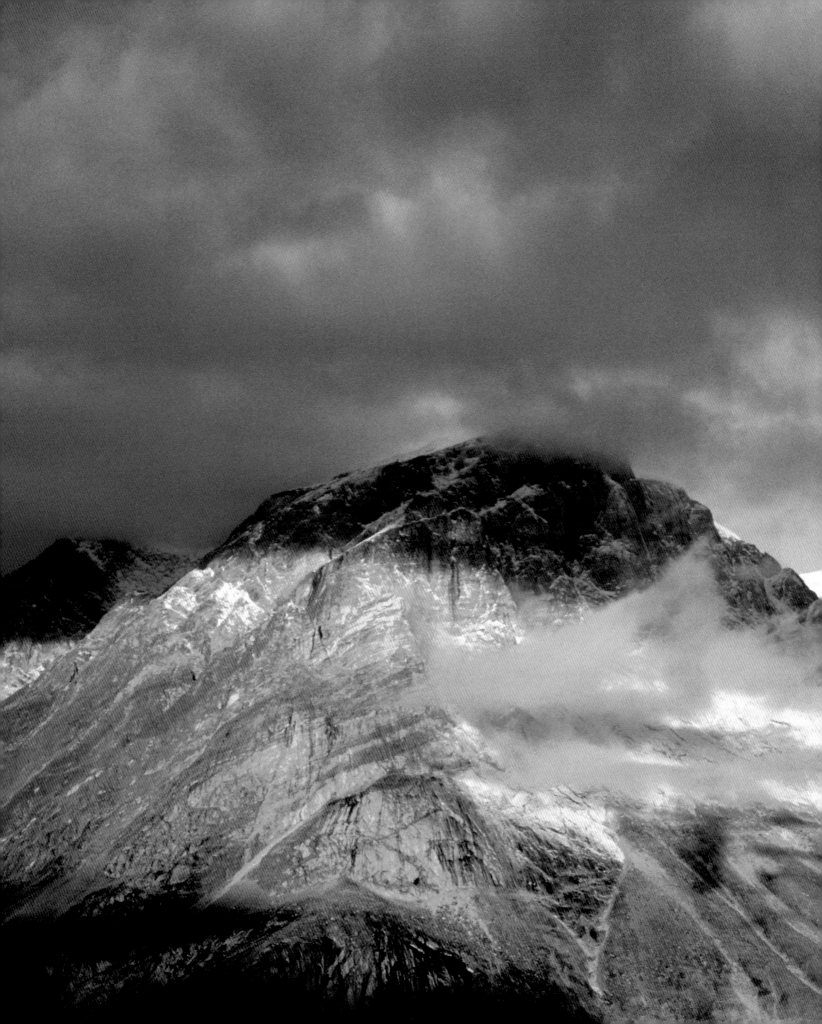

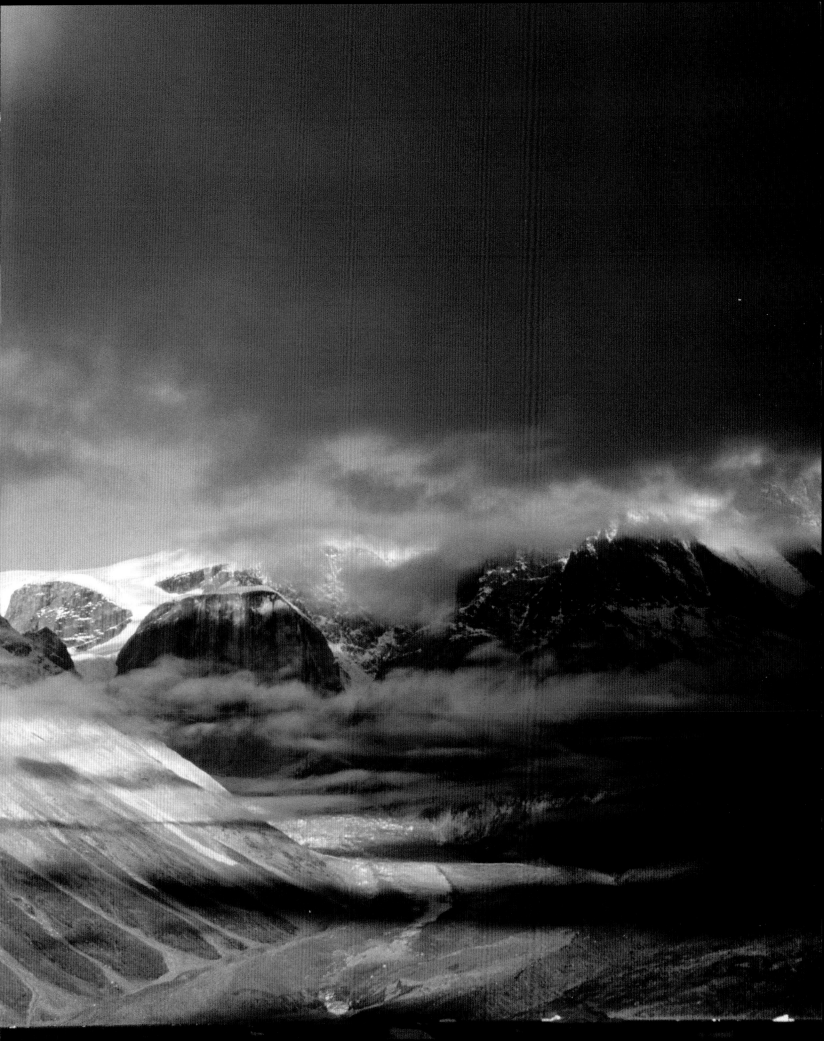

THE HUNTERS
AND

THE HUNTED

As a scientist, I'm patient. As a wildlife photographer, I am stubbornly patient. After spending hours of cramped and uninspired tedium inside a photo blind, I sometimes struggle with the temptation to give up and call it a day. Only the hope that waiting just another five minutes may yield a great photograph or a spectacular sighting gives me the discipline to persevere.

It's a strategy that has been successful for me time and time again. Once, as I was watching an incubating snowy owl on Prince of Wales Island in the Canadian Arctic, I wrote in my journal:

> I've been inside the blind for nearly five hours now. It's almost midnight and the landscape is bathed in soft amber light. The female owl is facing into the sun, her eyes shielded behind black squinting lids. Five mosquitoes are clinging to the feathers along the side of her beak. In the past hour, she has barely budged. I busy myself listening to the familiar sounds of the tundra world around me: the melodious babble of a courting long-tailed duck, the raspy rattle of a red-throated loon flying overhead, and the faint bugle of a distant sandhill crane, accompanied by the delicate tinkle of candle ice collapsing in the summer heat. Through the rear of the blind, I can see the male owl resting on the ice of a nearby lake, perhaps to cool himself and escape the hordes of blood-thirsty mosquitoes, many of which seem trapped inside the blind with me.
>
> Suddenly, the female leaves the nest and flies over to the male, who has now landed on the tundra with a collared lemming in his beak. The male arches his wings and rocks back and forth, strutting in one place

and holding the lemming high in the air. His brilliantine white plumage glares in the golden sunshine. He drops the rodent and the female quickly retrieves it and gulps it down. Without further fanfare, she silently glides back to the nest and covers the six white eggs with her feathery bulk.

The whole incident took less than a couple of minutes, and I was unable to capture any of it on film because the distance between me and my subjects was too great. Nonetheless, I was thrilled by what I had seen. Witnessing such a precious moment of animal behavior was ample reward for the wait.

Wherever you look in nature, there is always one group of creatures evolving new strategies of attack or defense and an opposing group inventing ingenious counter measures to thwart those intentions. Thus when two groups compete – for example, those that eat and those that get eaten – there will always be an arms race.

Let's start with plants, which occupy the bottom level of the arctic food chain. In the beginning, arctic plants may have evolved simply to survive the environment's climatic extremes. But the arctic environment includes a legion of hungry nibblers: muskoxen, caribou, grizzlies, hares, voles, lemmings and ground squirrels, all of which love to chew on buds, stems and leaves. The plant solution? Fill woody branches with hard-to-digest lignin and cellulose, flood stems with abrasive silica crystals, and pump distasteful poisonous chemicals into juicy leaves.

Not to be outdone, the nibblers responded. Poisonous chemicals were detoxified by enzyme systems in the

liver, beneficial digestive microbes were welcomed into sizable stomachs, and teeth grew larger, harder and more resistant to abrasion.

But the nibblers have always waged war with more than one foe. On the one hand, they battle with the foods they eat; on the other, there are hungry hunters intent on eating them. The arctic hunters are legendary and lethal: wolves, foxes, weasels, wolverines, bears, eagles, owls, hawks and falcons. As the predators evolved tactical intelligence, cunning approaches, lethal weaponry and forward-facing eyes that enhance their depth perception, the nibblers countered with camouflage coloration, bulging eyes with wide-angle vision, split-second reactions and speedy flight.

The warfare between the hunters and the hunted is the oldest tournament on the planet, and the battles continue daily in the untamed Arctic. Both contestants must constantly evolve new strategies to outmaneuver the other side. Enhanced defenses developed by the hunted may work for a time – until the hunters acquire improved techniques to foil those defenses. The contest only ends if one side evolves a fail-safe strategy that the other can't match; the losing side may then become extinct.

It's an uncommon treat to see the arms race in action, but I witnessed it once on the tundra slopes of Alaska when a pair of wolves waged war with a trio of caribou. It was early September, and the tundra was splashed with the appealing golds and reds of autumn. I had been resting on a slope that overlooked a wide valley and was observing three caribou bulls through binoculars as they slowly moved and fed. I was suddenly surprised to see two wolves creeping up a slope that concealed their approach from the feeding caribou. From my vantage point, it looked as though the wolves could not yet see the caribou, and I assumed the predators were targeting their prey by scent alone. The wolves were about 300 feet (91 m) apart as they reached the crest of the hill. On sighting the bulls, one of the wolves raced toward them; moments later, the second one joined in the chase. The bulls split up, two circling around and the third racing straight ahead. The hopeful wolves followed the single animal, but it was soon apparent that the now lone caribou would not be caught, for its flight was swift and steady. After a few hundred yards of high-speed pursuit, the wolves put an end to the chase. They stood around for a minute or two, as if considering their next tactic.

Now, however, the two caribou bulls that had fled together were separated from the wolves by yet another small hill. Once again, the two parties – the chased and the chasers – were out of eyeshot of one another. I suspect that the wolves could still smell the caribou, because they then reprised the same ploy that had failed mere moments before – keeping out of sight, they crept to the top of the hill and then ran like hell toward their startled prey.

Julius Caesar famously said, "Veni, vidi, vici" (I came, I saw, I conquered), but for the wolves that afternoon, it was more like, "We came, we saw, we chased, and we failed a second time." At that point, I was chuckling delightedly to myself. In a matter of a few minutes, I had seen the wiliness of wolves, the vigilance and strength of caribou and the mismanaged execution of a chase. The arms race was still in motion, and the outcome was as uncertain as ever.

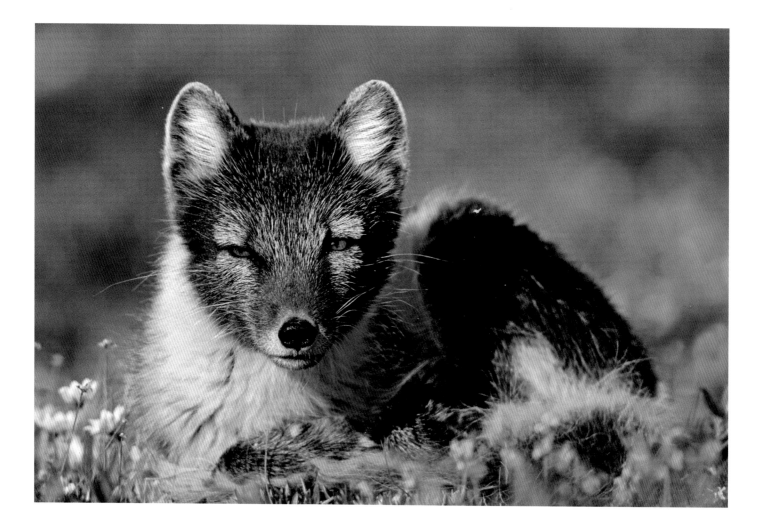

Chapter opening: Although the arctic fox (*Alopex lagopus*) dens and hunts on land during the summer months, many foxes that live near the coast actually move onto the sea ice during the winter. There, they follow the movements of polar bears, scavenging scraps from seal kills. But the arctic fox is a capable predator in its own right. In March, vulnerable ringed seal (*Phoca hispida*) pups are born in snow caves on the surface of the ice. A study undertaken in the Beaufort Sea reports that up to 45 percent of these newborn pups were sniffed and snuffed out by keen-nosed arctic foxes.

Above: No predator has influenced the nesting strategy of the arctic seabird to a greater extent than the arctic fox. The predatory ways of this cunning canid are the main reason that most arctic seabirds nest on cliffs. The agile arctic fox will tackle even the most precipitous of locations. In the Svalbard Archipelago, I watched a daredevil fox raid a cliff-nesting colony of thick-billed murres and black-legged kittiwakes – as it jumped effortlessly from ledge to ledge, it was often able to snatch an egg or chick. In the same spot, however, I came across the carcass of a less sure-footed fox that had been killed in a fall.

Right: In the late 1800s, biologist Joel Allen noticed that among the mammals and birds that lived in cold climates, body extremities – noses, ears, tails, snouts, beaks and legs – were shorter than on those that lived in warmer ones. Today, this pattern is known as Allen's rule, and it is recognized as nature's way of conserving body heat. When compared with that of its relative the red fox, which typically lives in a warmer climate, the physique of the polar-adapted arctic fox exemplifies this trend perfectly.

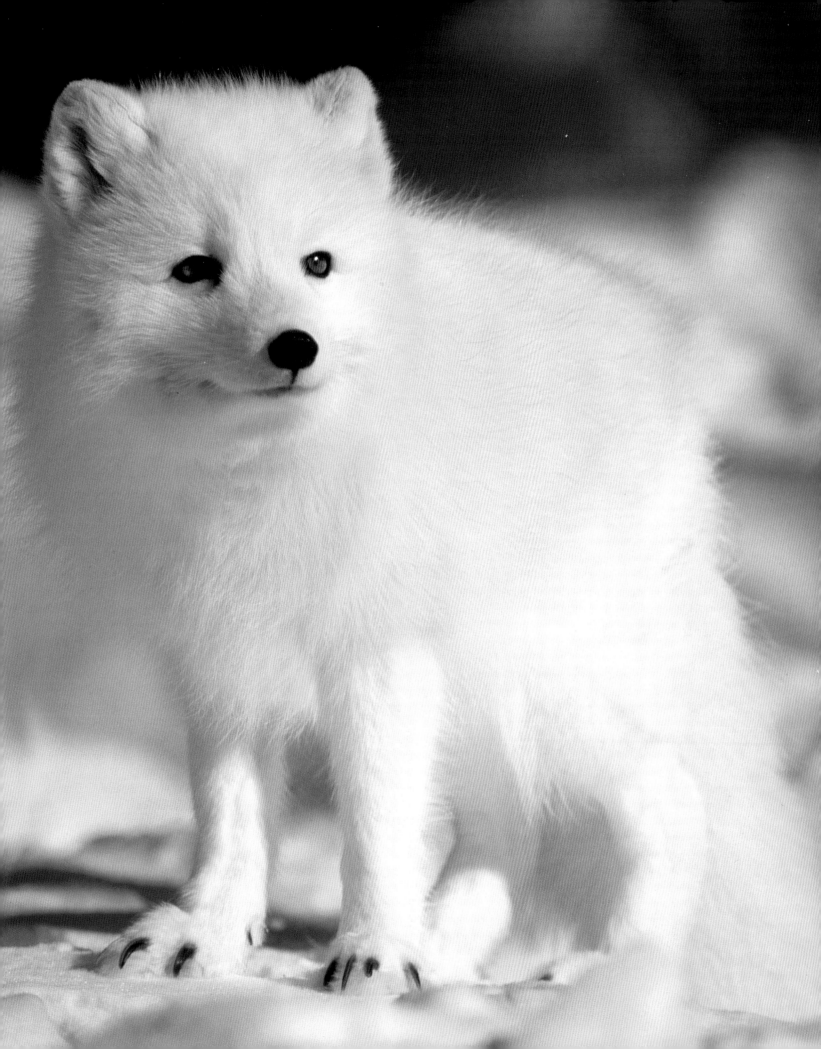

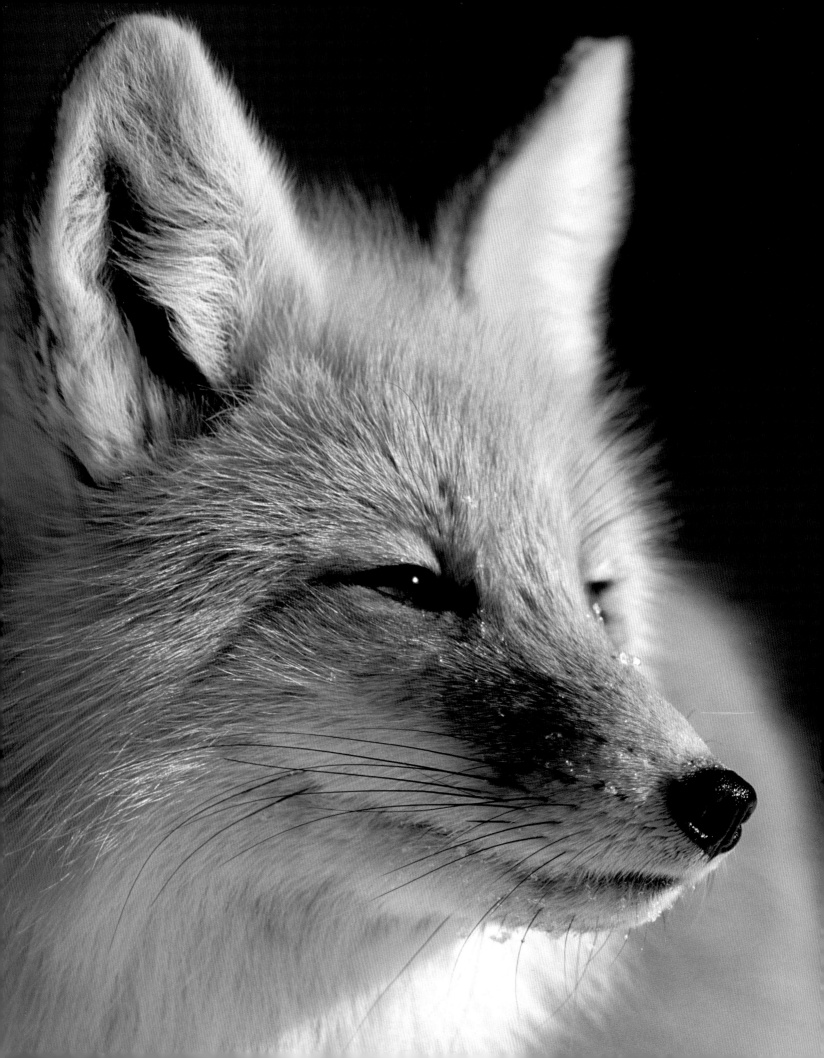

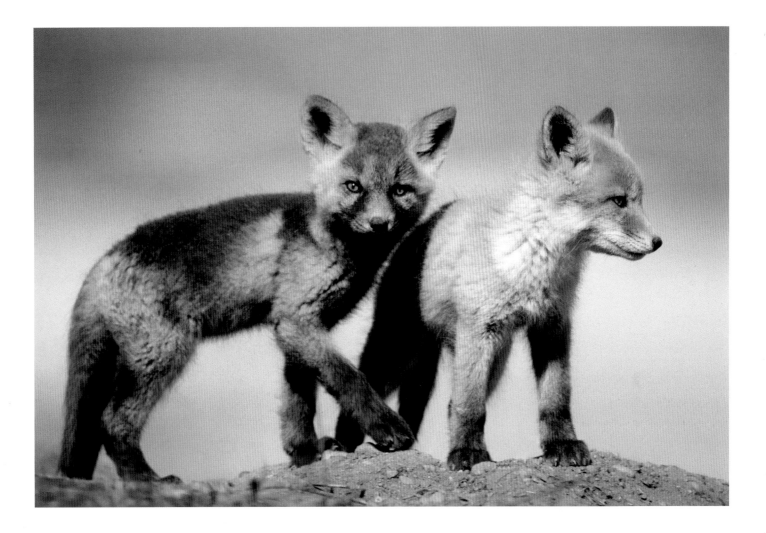

Left: Generally, the red fox (*Vulpes vulpes*) lives in forests. In the past century, however, the red fox in North America and Russia has slowly moved beyond the tree line, penetrating farther and farther into the tundra of the Arctic. It is now a year-round resident on the Barrenlands, lives on Baffin Island and has even been sighted along the southern end of Elles-mere Island, 650 miles (1,050 km) north of the Arctic Circle and 930 miles (1,500 km) from the nearest forest.

Above: A serious pecking order develops between young red foxes when they are roughly a month in age, and the skirmishes are unexpectedly vicious. In a vivid description of what happens to fox pups between three and four weeks of age, fox researcher Dr. J. David Henry writes that, "Fox pups do not act like cute cuddly puppies, such as those of the domestic dog; rather, they have always seemed to me to have a slightly demonic character. They are tough month-old thugs, little street fighters, who initiate fights and establish a strict dominance hierarchy during the following 10 days."

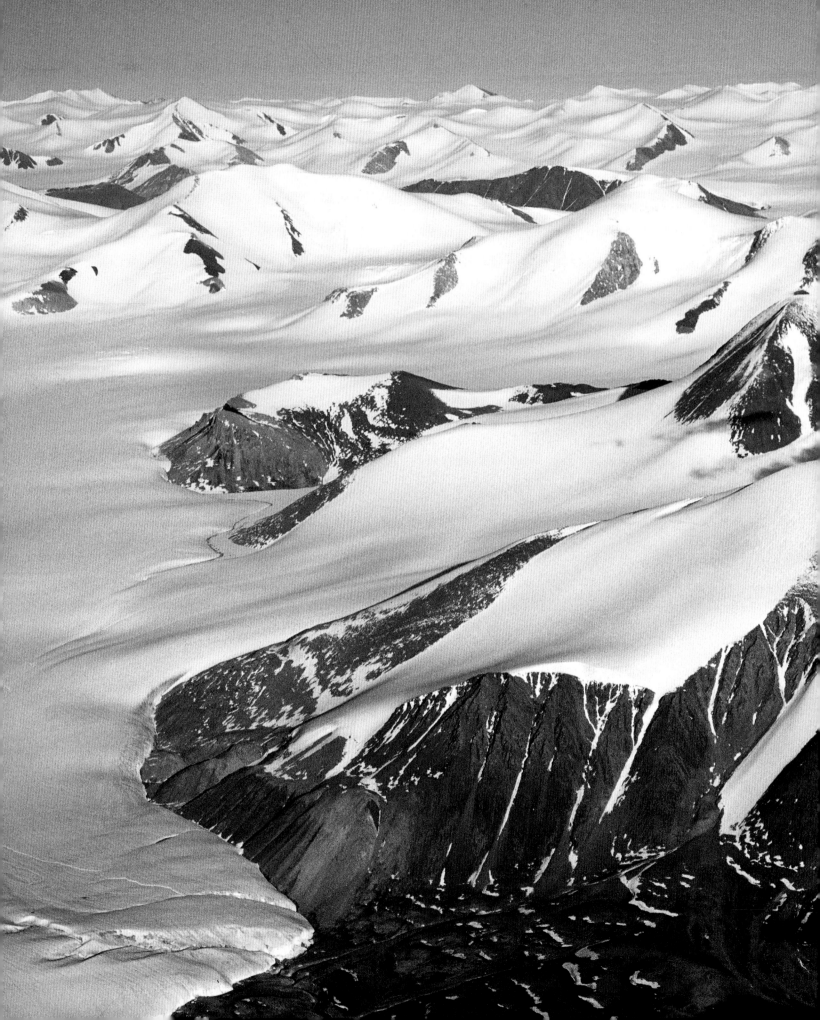

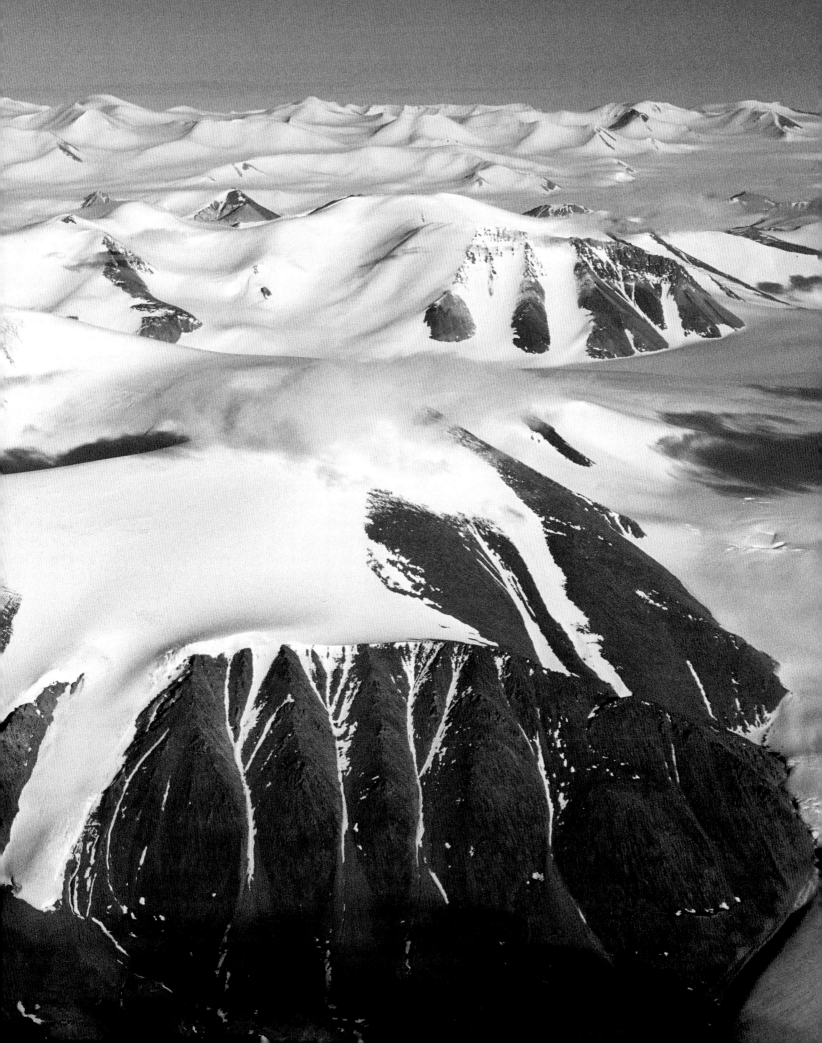

Previous spread: This tract of tundra at 80 degrees north latitude on Ellesmere Island in the Canadian High Arctic is surrounded on three sides by glaciers. Although seemingly inhospitable to wildlife, when I visited, the area was home to a pair of white gyrfalcons and a family of arctic foxes. For the most part, the falcons hunted arctic hares and rock ptarmigan, while the foxes scavenged winter-killed muskoxen and caribou and preyed on nesting birds.

Right: Although the accepted common name of the wolf (*Canis lupus*) is the gray wolf, the animal's fur coloration is highly variable and ranges from pure white to charcoal black. In fact, the most common color of the gray wolf is light tan or cream mixed with brown, black and white. In general, the fur of a wolf is much longer and darker in northern populations, and its coloration is not distinctive for any specific geographic location.

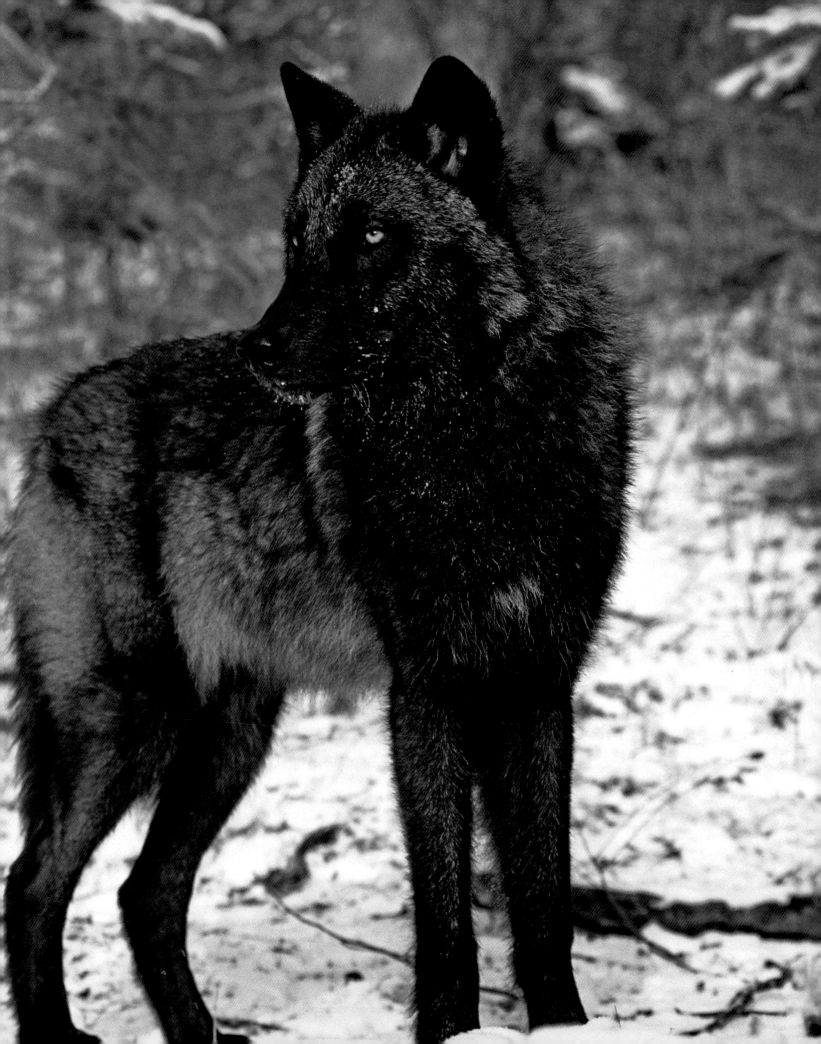

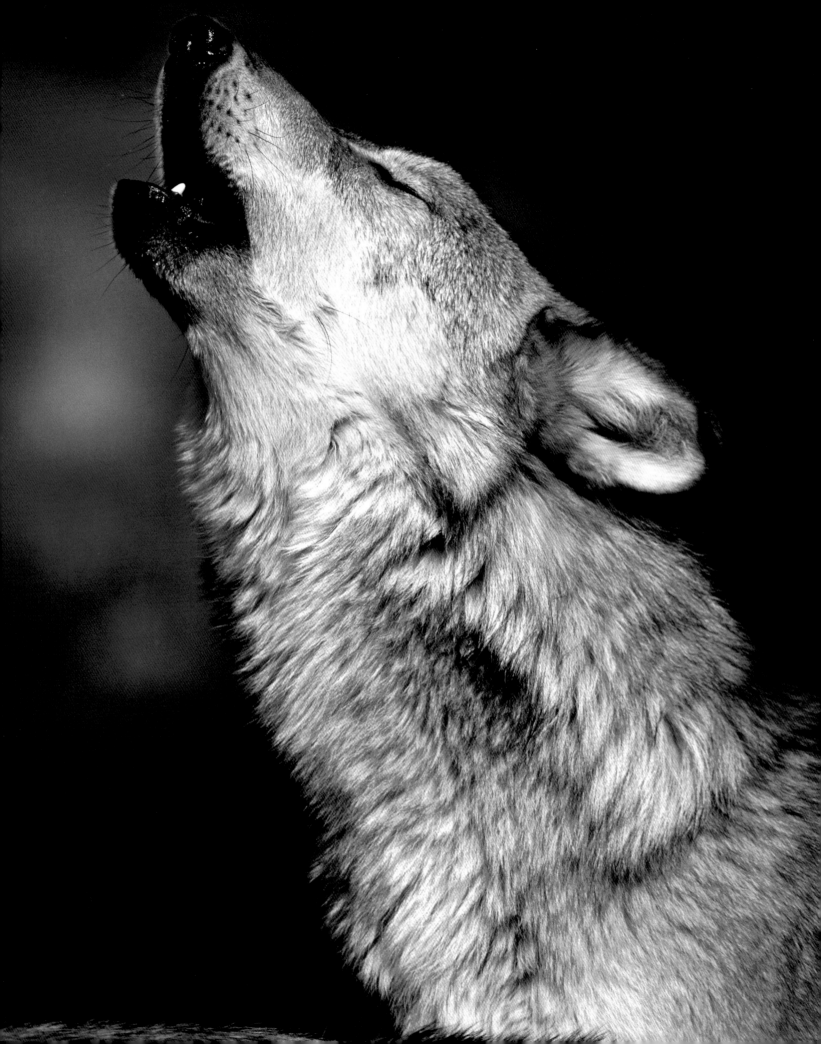

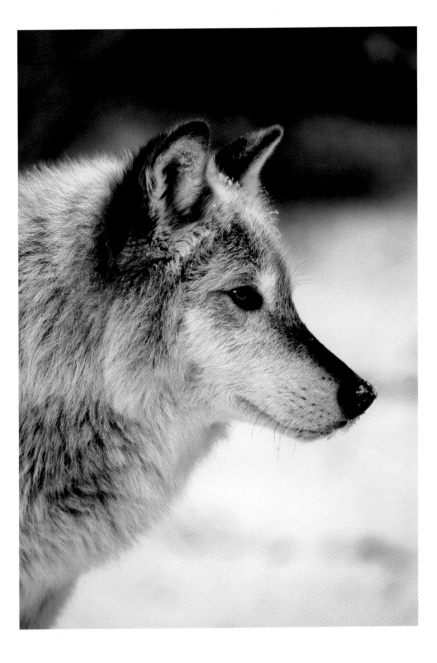

Left: On a cold, windless night when the conditions are ideal, it's possible to hear the howl of a wolf from several miles away. One researcher estimated that a solitary howling wolf might be heard over an area of 50 square miles (130 sq km). The rate of howling depends upon the time of year and social circumstances. For instance, howling increases during the late-winter breeding season and during summer pup-rearing. Wolves also frequently howl when they are feeding on a carcass, and the rate of howling increases with the amount of food left at the kill.

Above: A predator's diet is dictated largely by its body size. The muscular gray wolf, whose weight can range from 44 to 176 pounds (20–80 kg), hunts the large hoofed mammals of the Arctic: caribou, muskoxen and mountain sheep, some of which may weigh five to 10 times as much as the wolf does. To increase its rate of success, the wolf works as a member of a pack and hunts in groups. But the adaptable wolf also hunts hares, ground squirrels and birds on its own. Arctic wolves will even venture onto the sea ice and scavenge the remains of seals killed by polar bears.

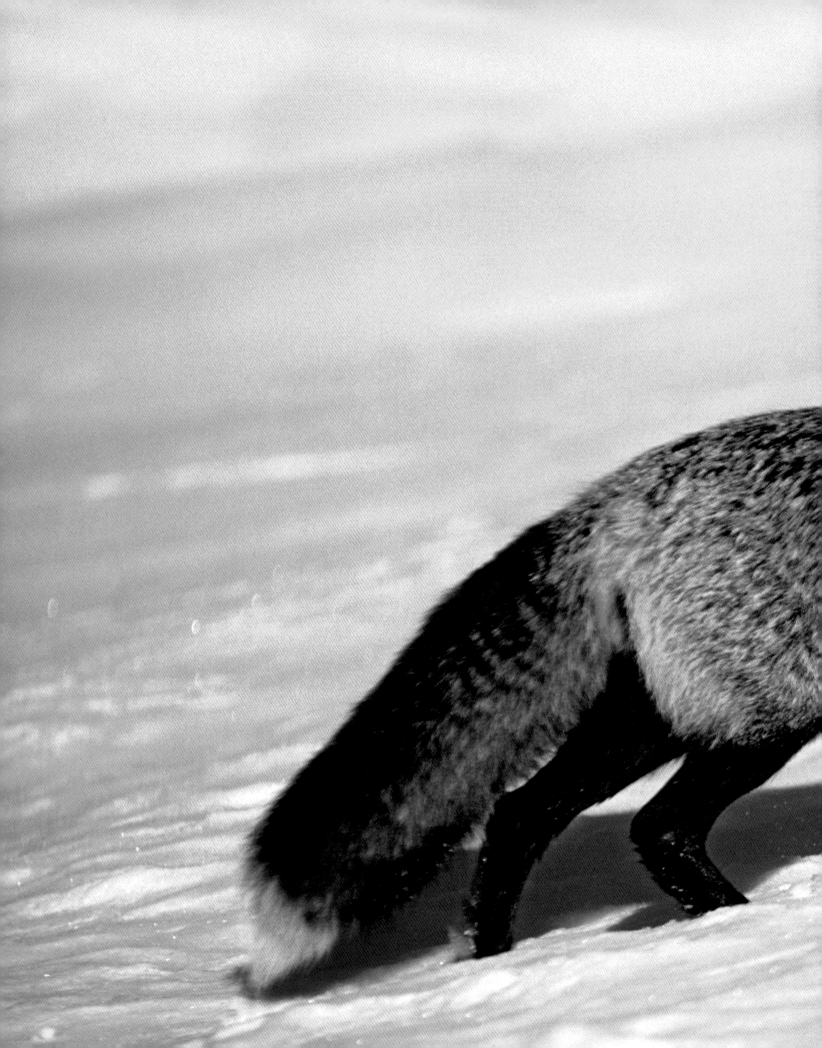

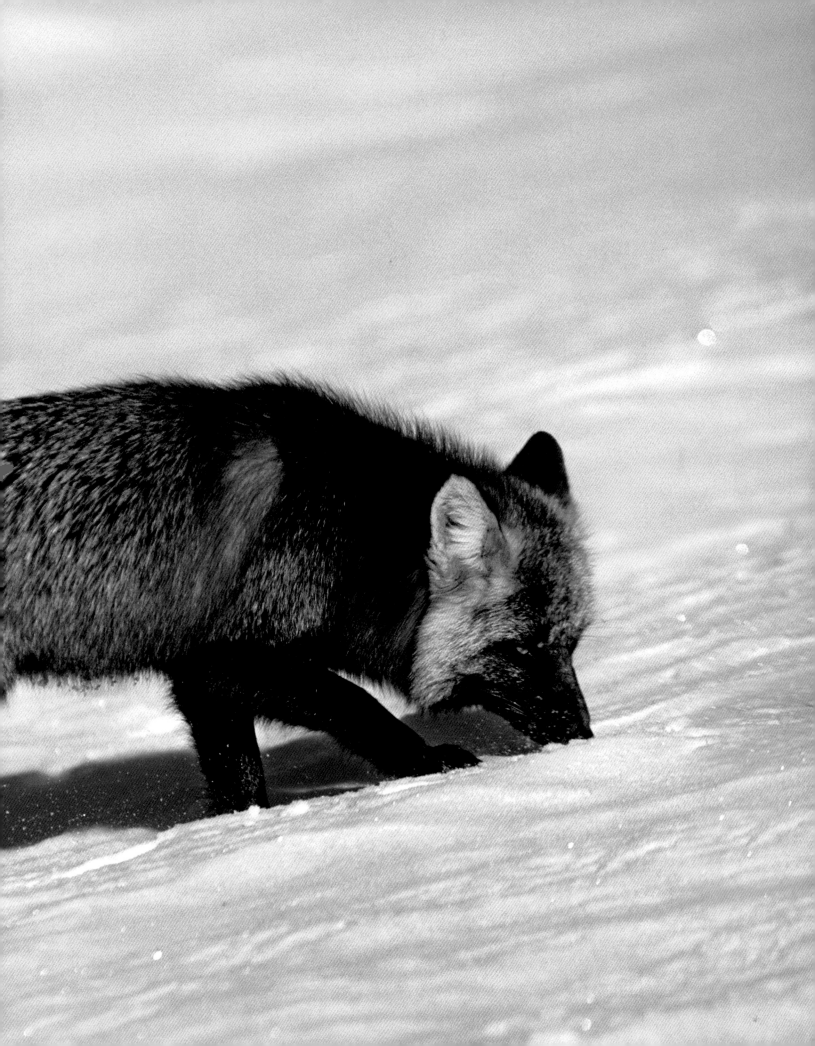

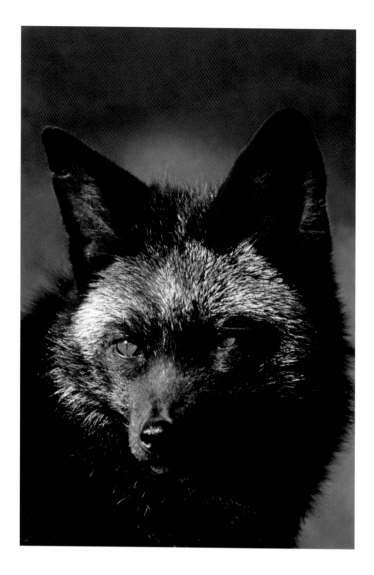

Previous spread: In northern Canada, the majority of red foxes have fur that is red in color. However, up to one quarter of all red foxes have either black fur tipped with white (called silver foxes) or reddish brown fur with buff-colored patches on the hips and shoulders and a distinct "cross" of dark fur across the shoulders. These are called cross foxes. The fox shown here is a mix between the two.

Above: This red fox exhibits the silver fox color variation. Color variations in red foxes are not a temporary condition and persist throughout the animal's life. A traditionally colored red fox may mate with a silver fox or a cross fox and produce all red pups or pups that are a mixture of red, silver and cross. The red fox is one of the most widely distributed carnivores in the world, occurring in North America, Eurasia and North Africa; all of the red foxes living outside of North America are red in color.

Right: The animal pictured is a cross fox, a northern color variation of the red fox. Wherever the Arctic hunting range of the red fox and arctic fox overlap, the red fox is always dominant over the compact arctic fox. The reds, which may be up to 60 percent heavier, commonly chase the white foxes whenever the two meet, ousting them from their dens when homesites are in short supply and killing their pups. When competition is intense, they may even kill the adults.

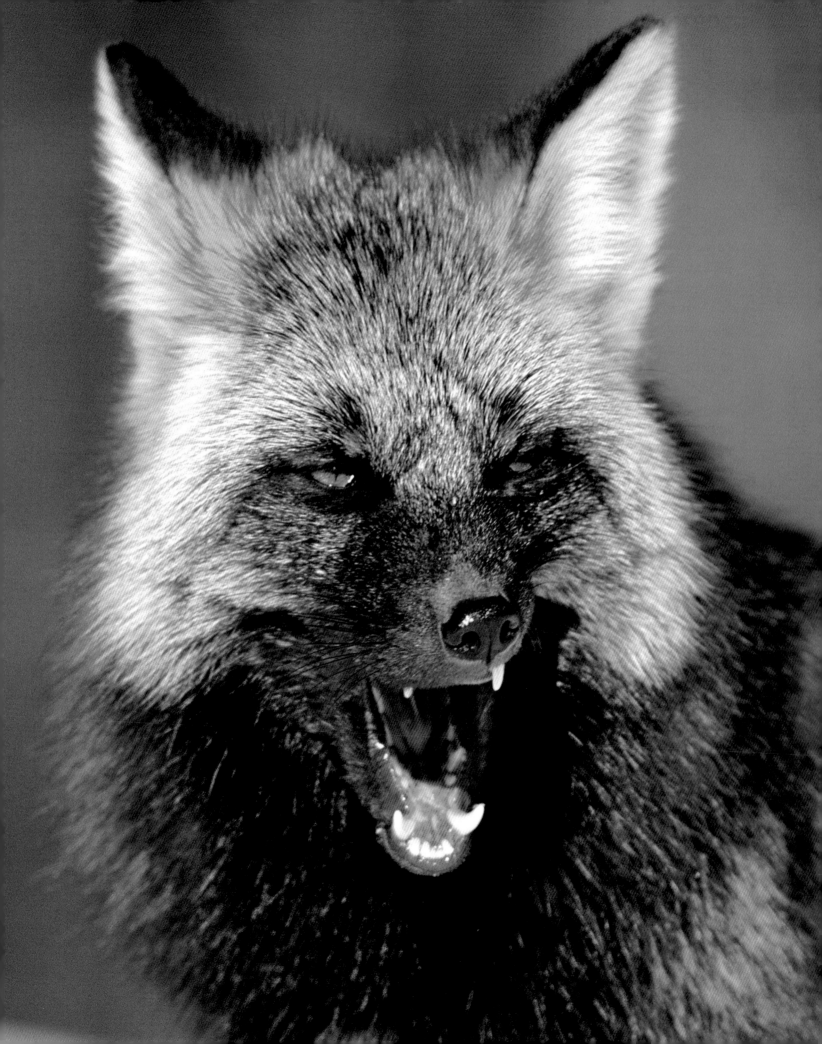

The ermine, or short-tailed weasel (*Mustela erminea*), is the tiny terror of the tundra. This 2½-ounce (70 g) light-weight hunts lemmings, mice and ground squirrels with the ferocity of a grizzly bear, dispatching its victims with a single bite to the back of the neck. The kill is made when the ermine's needle-sharp upper canines penetrate the rodent's spine or skull. Death for the hapless victim is instantaneous. A thick blanket of snow usually protects rodents from most arctic predators – but not from the ermine. With its long slender body, the ermine can tunnel beneath the snow and chase its prey along their own runways.

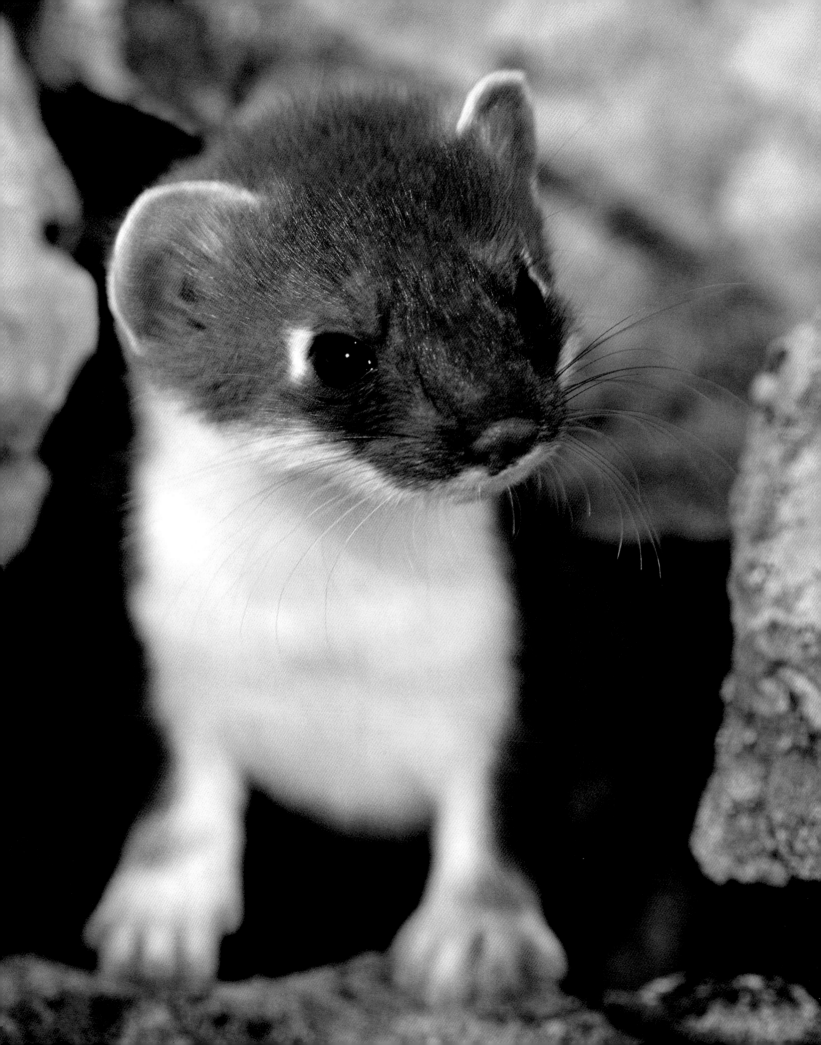

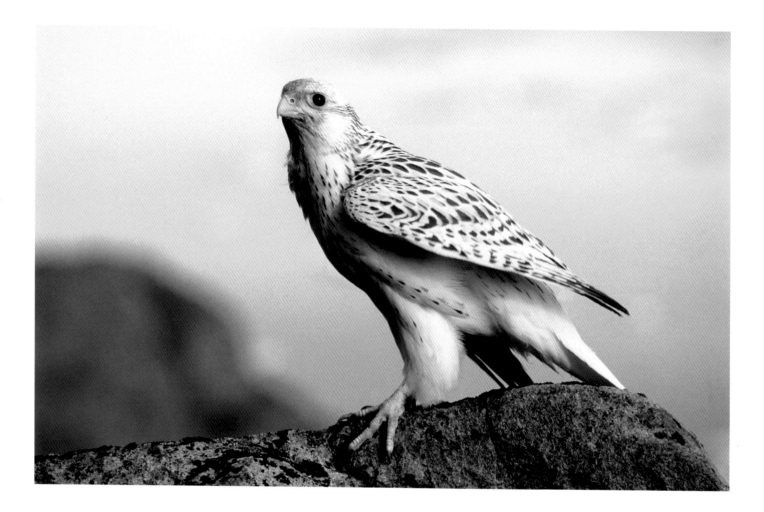

Above: The gyrfalcon (*Falco rusticolus*), or simply gyr (pronounced jeer), is the largest and most northern falcon in the world, nesting to the very edge of all the lands bordering the Arctic. It varies in color from all white, with some scattered darkish markings on its back, to an overall dark gray. The magnificent gyr is on the top 10 list of birds that most bird watchers hope to see in their lifetime. Among gyrfalcons and other birds of prey, the females are larger and quite a bit heavier than the males – the female gyrfalcon weighs on average 40 percent more than her mate, and her wingspan is three to four inches (7-10 cm) longer.

Right: The rough-legged hawk (*Buteo lagopus*), known as the rough-legged buzzard in Russia, is probably the most common bird of prey in the Arctic. Like so many predators, including owls, weasels, arctic foxes and jaegers, the success of the hawk is closely tied to the lemming cycle. In years when lemming numbers are high, a hawk can feed many chicks and is able to raise a large family. I've counted as many as seven chicks in a nest. However, in years when the lemming population crashes, a hawk may be unable to raise even a single chick.

Following spread: This young gyrfalcon was one of three chicks reared in a cliff-side nest on northern Ellesmere Island, overlooking the ice-littered waters of Alexandra Fiord. Ideal nest locations may be used by successive generations of falcons over decades, even centuries. Such prolonged use can result in a thick mound of food remains and excrement covering the nesting ledge. A nest along the Kolyma River in Russia consisted of droppings and willow ptarmigan bones that were 18 inches (45 cm) thick, while a longstanding two-foot-high (60 cm) nest found on Ellesmere Island's Fosheim Peninsula consisted almost entirely of arctic hare bones.

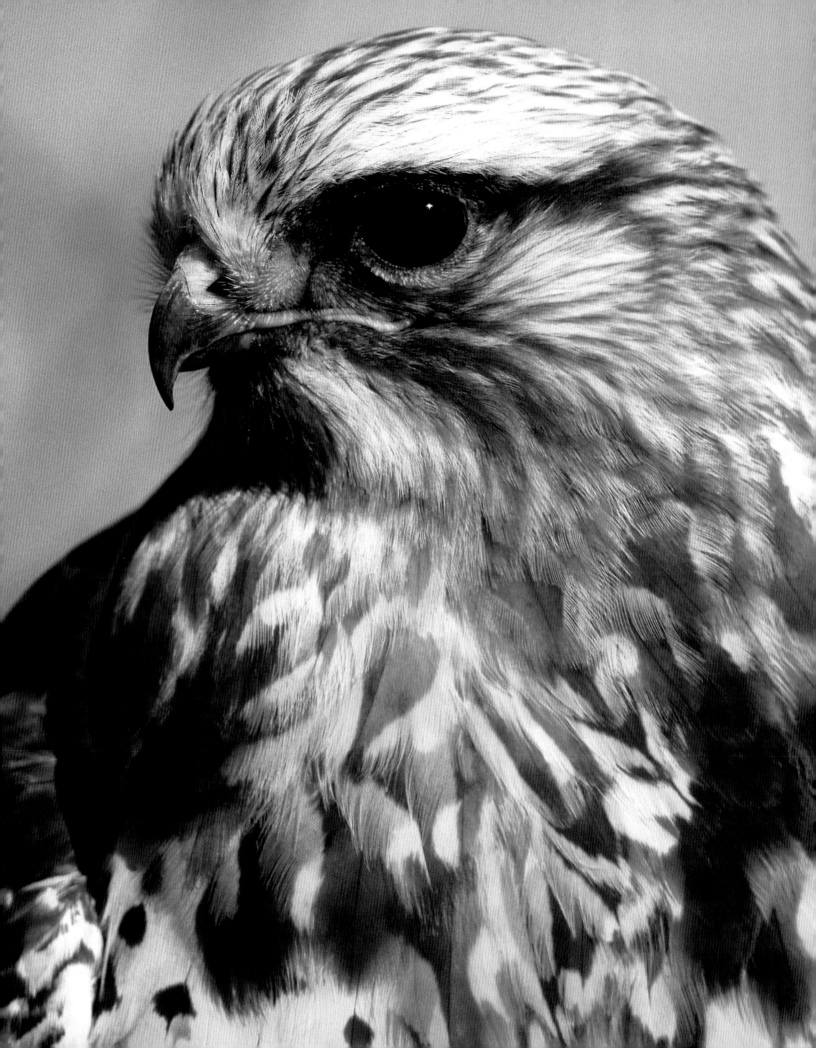

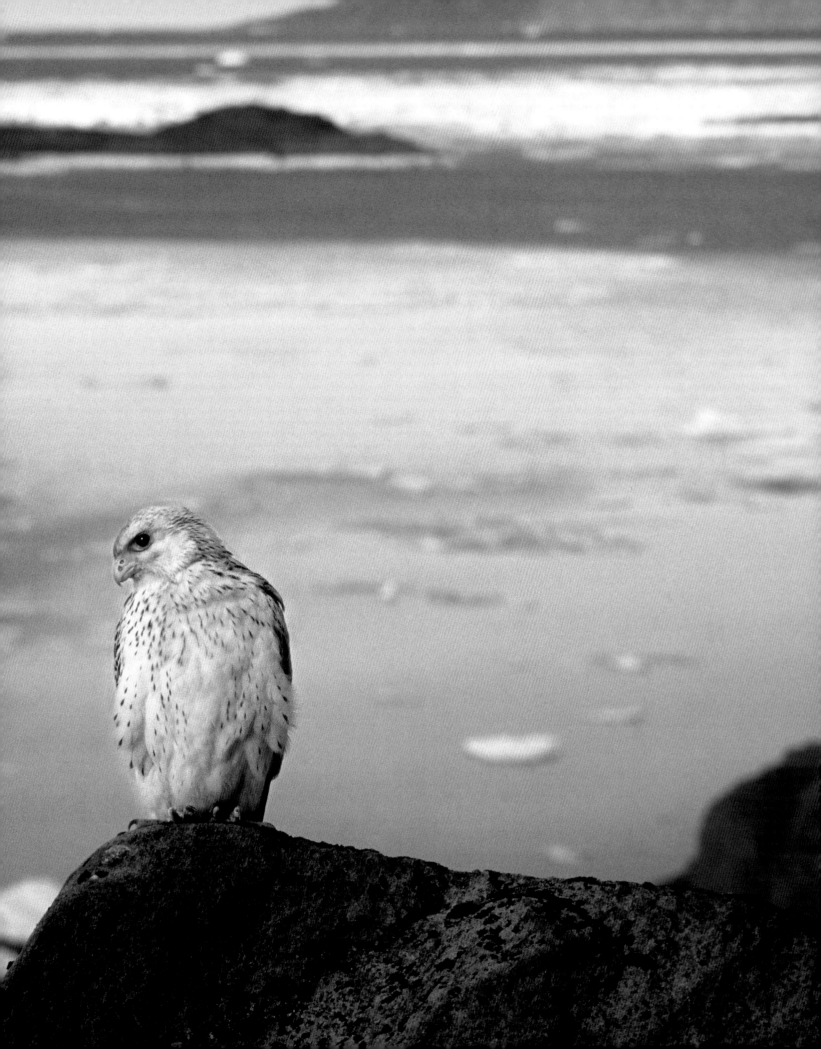

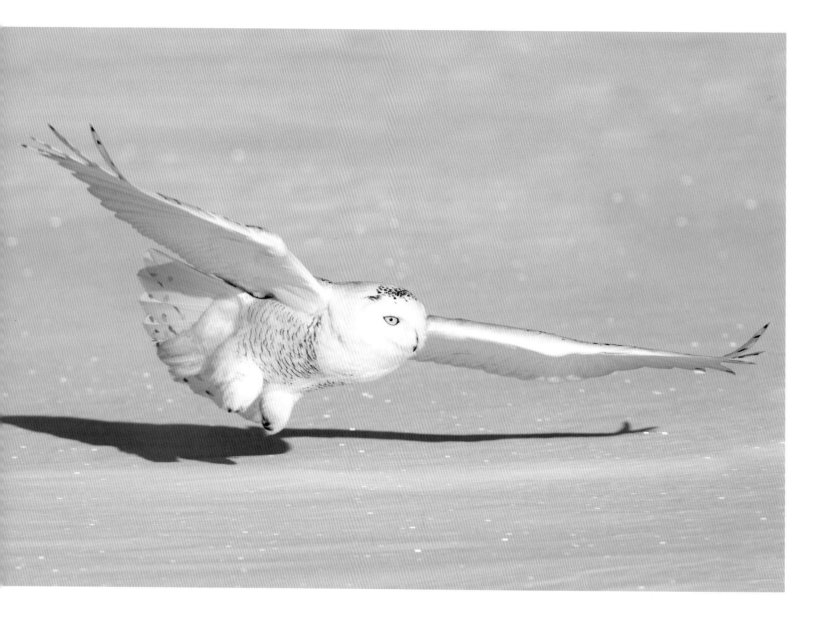

Above: The snowy owl (*Bubo scandiacus*), with an average weight of four pounds (1.8 kg), is one of the heaviest owls in the world. As is the case with most northern owls, the snowy owl's feathers weigh more than the bones in its skeleton. Predictably, the snowy owl also has large wings. Each wing is roughly the same size as two standard sheets of typing paper. Wings as large as these influence two aspects of the bird's flight: speed and sound. Large wings enable a bird to fly slowly without stalling. This allows the owl to spend a greater amount of time searching the ground from on high for prey. Flying slowly also reduces the noise that results from air flowing over the wings.

Right: The winter plumage of the snowy owl creates one of the warmest feather coats in the world of birds. To prove that the snowy owl could survive temperatures lower than any recorded in the Northern Hemisphere, a researcher subjected a captive owl to increasingly colder temperatures. First, he dropped the temperature to minus 67 degrees F (−55°C) and held it there for three hours. He followed that exposure with two hours at minus 106.6 degrees F (−77°C) and five hours at minus 135 degrees F (−93°C). Amazingly, the owl survived these potentially lethal temperatures without exhibiting any signs of frostbite.

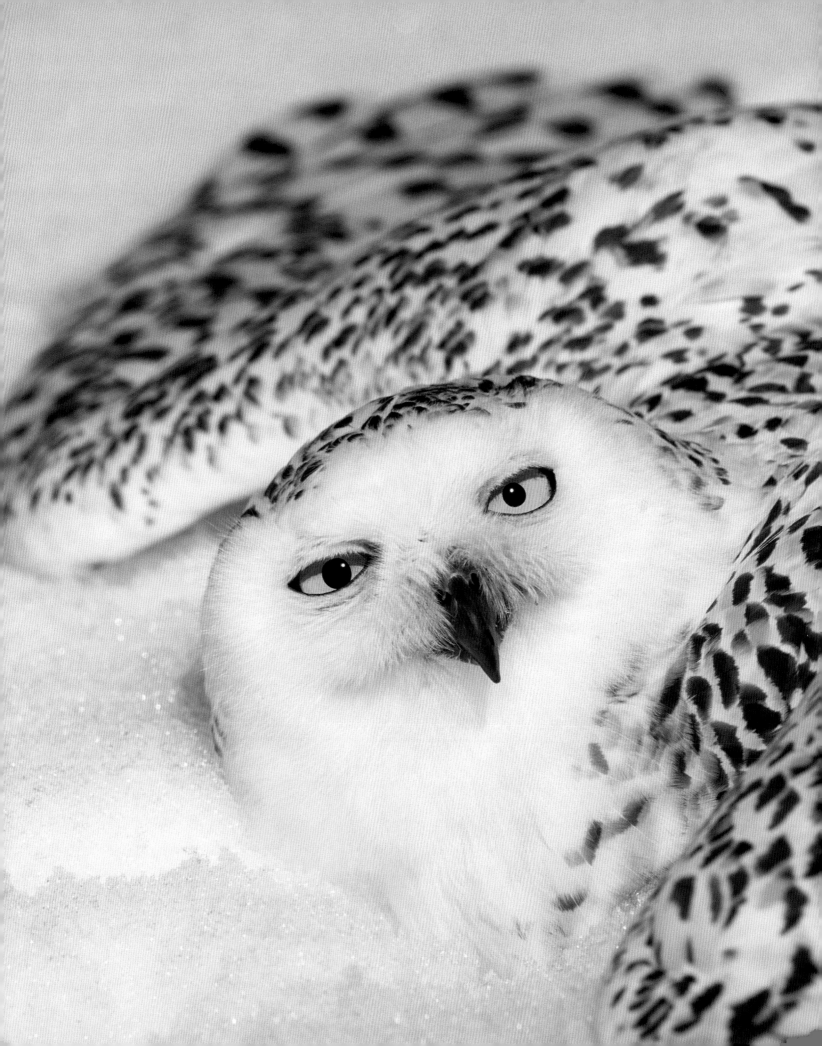

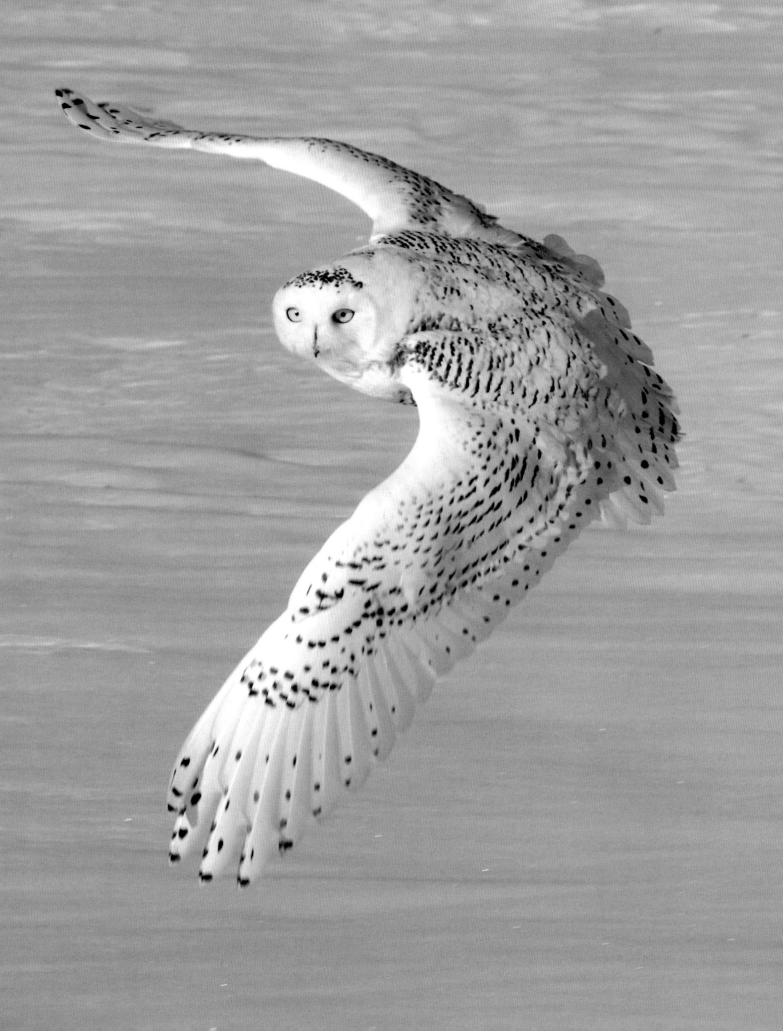

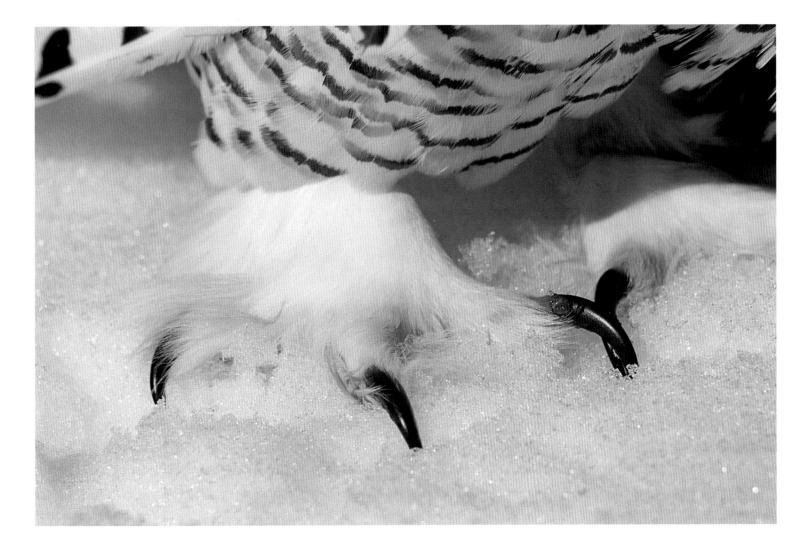

Left: The most common hunting strategy employed by the snowy owl is the sit-and-wait method, in which the bird monitors a stretch of tundra from an elevated vantage point, then launches an attack once it spots a vulnerable victim. In these kinds of hunts, vision is the owl's most important sense; it relies very little on hearing. A number of factors determine an owl's hunting success: weather conditions, the nature of the prey (mammals vs. birds vs. invertebrates) and the age of the owl. In one study, adult female snowy owls were successful in two-thirds of their attempts, whereas juveniles were successful only one-third of the time.

Above: The feet and talons of the snowy owl are its principal weapons of attack and capture. In summer, when the owl is mainly a predator of the lightweight lemming, its massive talons and powerful feet seem a little like overkill. But on the bird's wintering grounds on southern prairies and marshlands, its muscular feet are a great benefit. There, the owl hunts jackrabbits, grouse, ring-necked pheasants, ducks and grebes, and it's not above snatching an unsuspecting house cat.

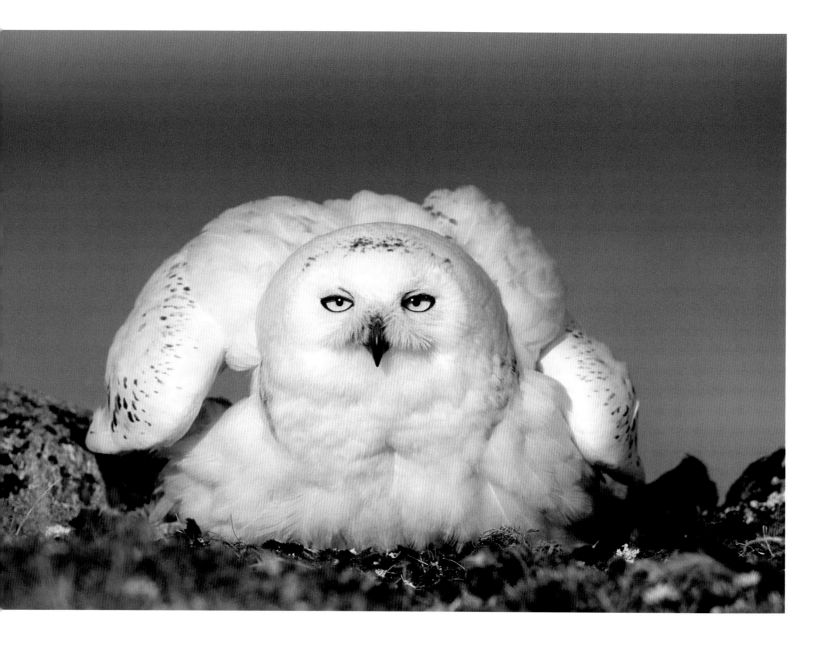

Before a mother owl lays her eggs, she sheds the feathers from a small area on her belly. This naked patch of skin, called the brood patch, then softens, thickens and becomes heavily vascularized to aid in the transfer of the mother's body heat to the eggs. The female snowy owl, as in all species of owls, is exclusively responsible for incubation, while her male partner hunts and provisions her with food. The first egg hatches after an incubation period of roughly 32 days.

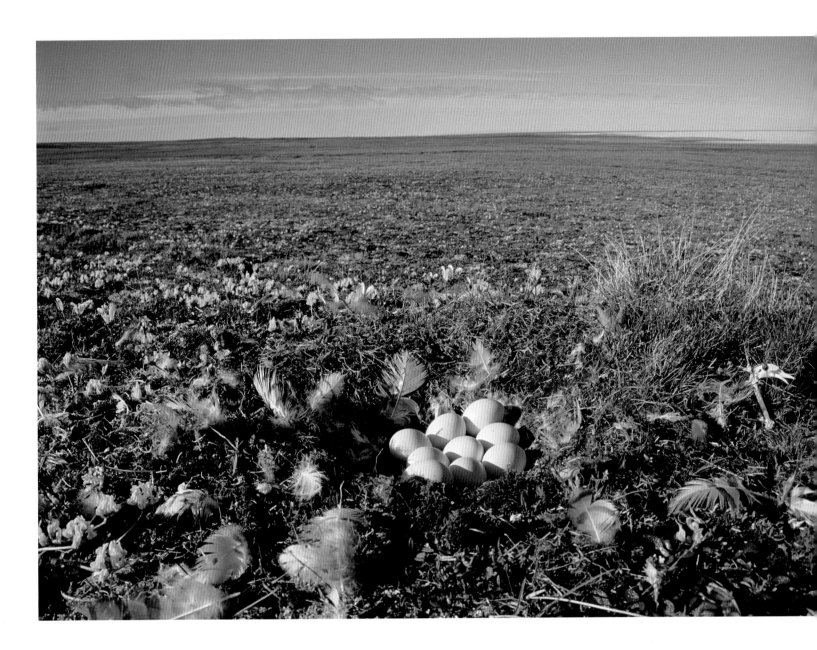

This snowy owl nest in the Canadian High Arctic is surrounded by feathers molted from the mother owl's brood patch. The number of eggs a female snowy owl lays can vary from one or two eggs to as many as 11. The number depends primarily upon the abundance of available prey, especially lemmings. A pair of snowy owls can raise its largest family when the lemming cycle is at its peak and the plump rodents are running everywhere on the tundra. When the lemming cycle crashes and the rodents are scarce, however, a female owl may not nest at all.

Following spread: Young snowy owls leave the nest and hide on the nearby tundra when they are just two to three weeks old. At this age, the young owls cannot fly and are still many weeks away from independence. Nevertheless, each chick spreads out over an area a little under half a square mile (1 sq km), hiding separately from its nest mates but always staying within their parents' defended territory. The chicks disperse in this fashion to lessen their chances of being detected by a hungry fox, wolf or bear. This chick was photographed on northern Ellesmere Island at 82 degrees north latitude.

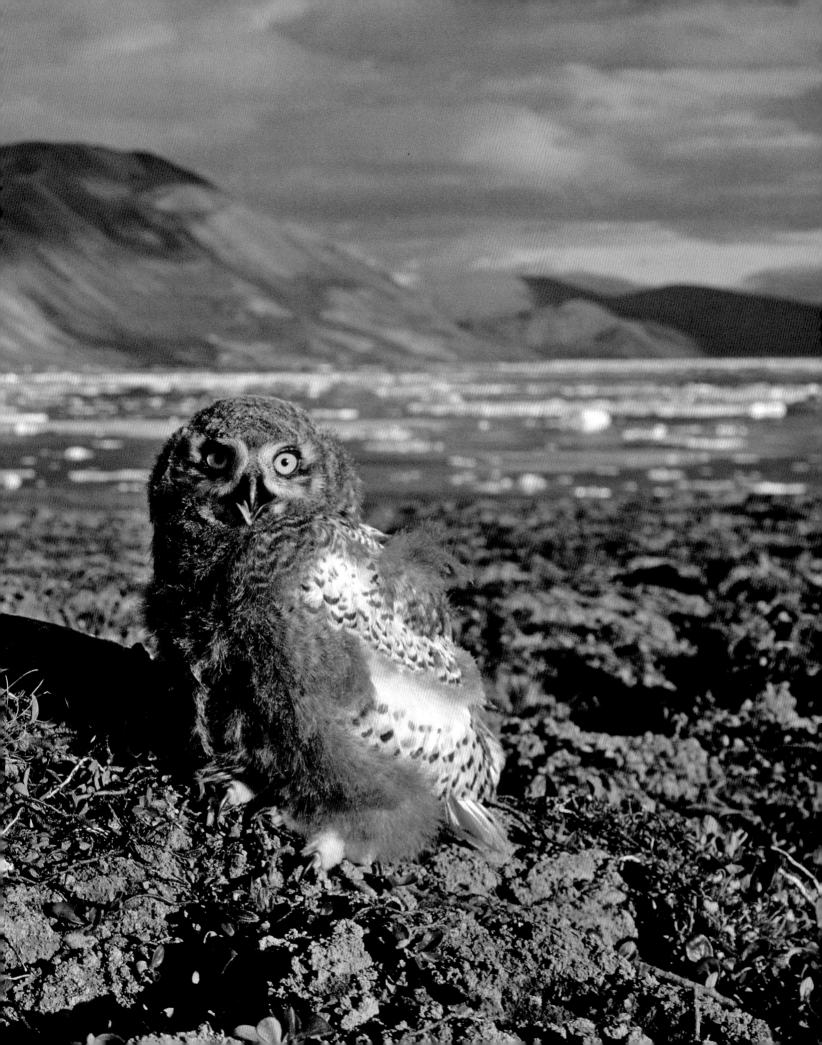

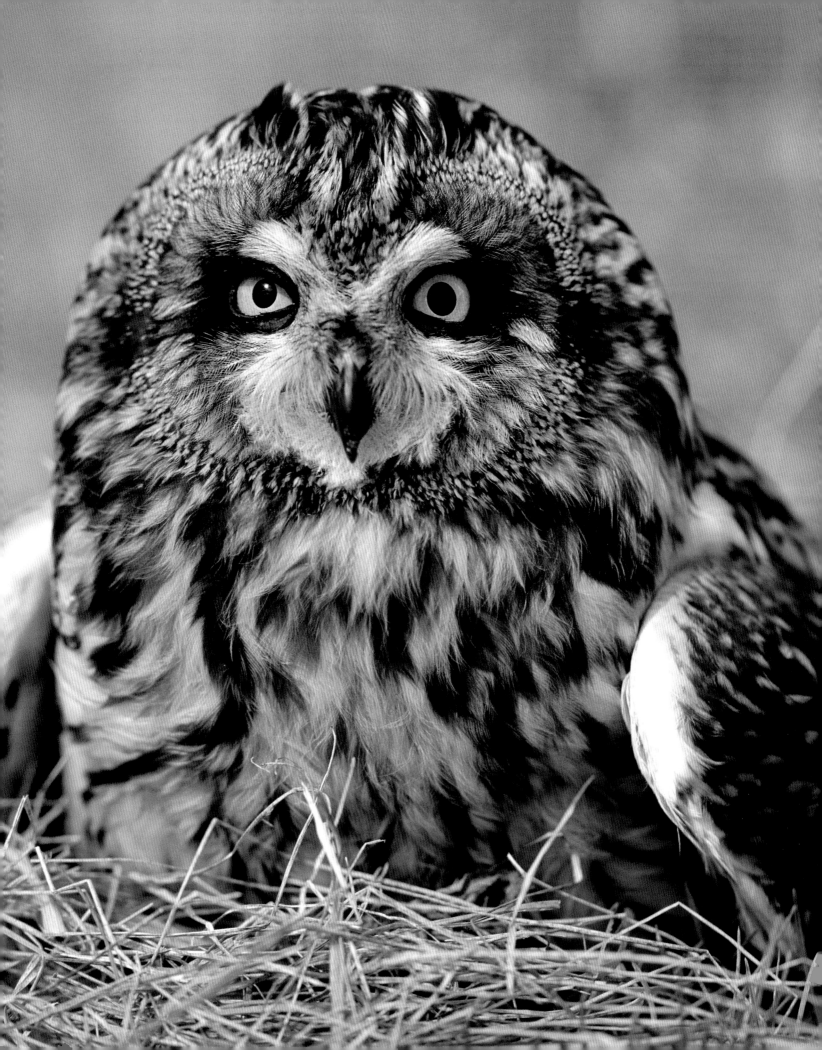

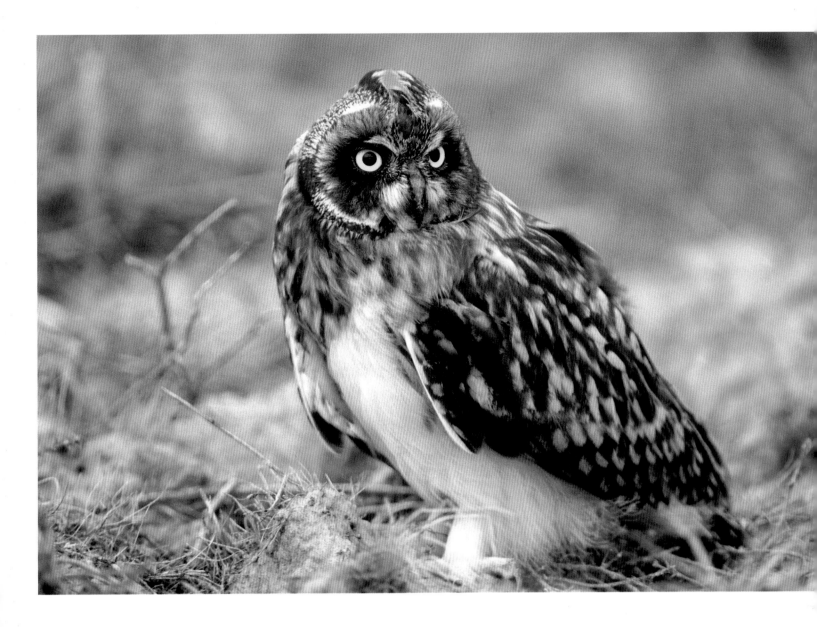

Left: A highly mobile species that specializes in hunting small mammals, the short-eared owl (*Asio flammeus*) is found only in the low latitudes of the Arctic and rarely strays into the Arctic islands. The voles (*Microtus* sp.) and lemmings (*Lemmus* sp. and *Dicrostonyx* sp.) that are the owl's principal prey typically follow population cycles of abundance and scarcity, and the owl relocates when numbers are high, moving on when those numbers decline.

Above: Feathered ear tufts, like those found in the short-eared owl, occur on roughly 40 percent of owls worldwide. Ear tufts have nothing to do with hearing. Biologists speculate that the feathered tufts evolved primarily as a way for owls to camouflage themselves by breaking up their outline and mimicking the ragged top of a broken branch. The tufts may also serve a communication function: when an owl is agitated or frightened, its tufts are flattened, and when the owl is alert or curious, they're raised.

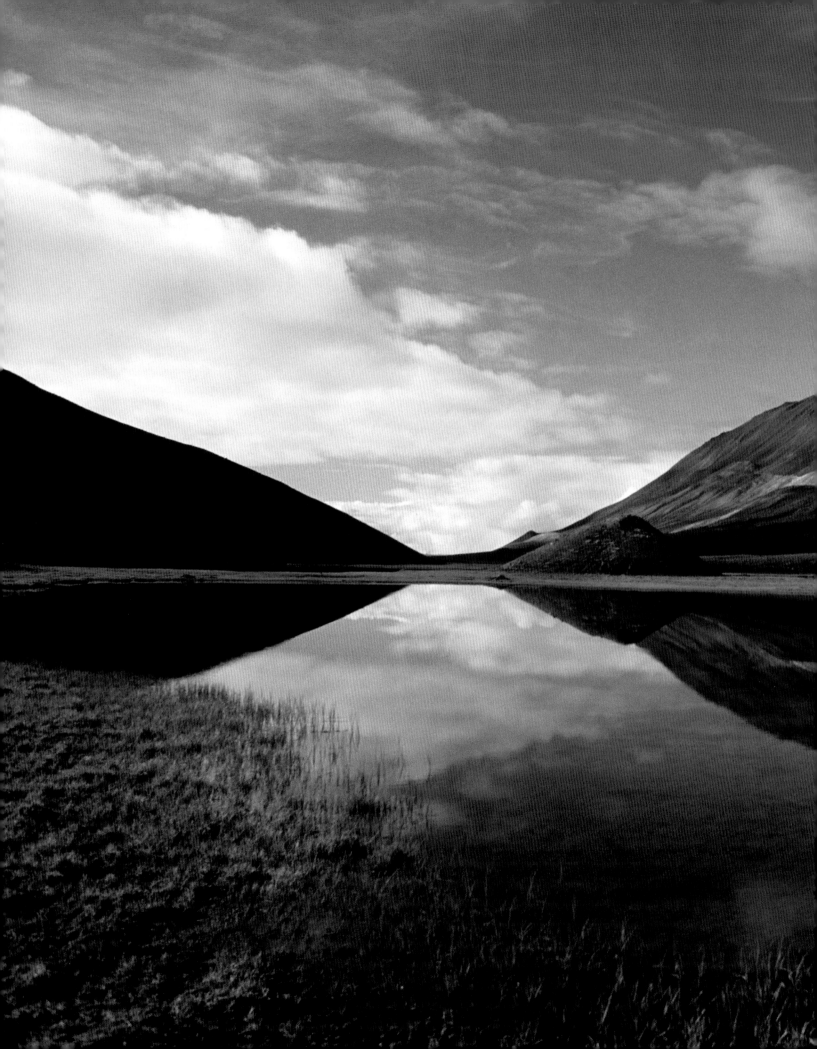

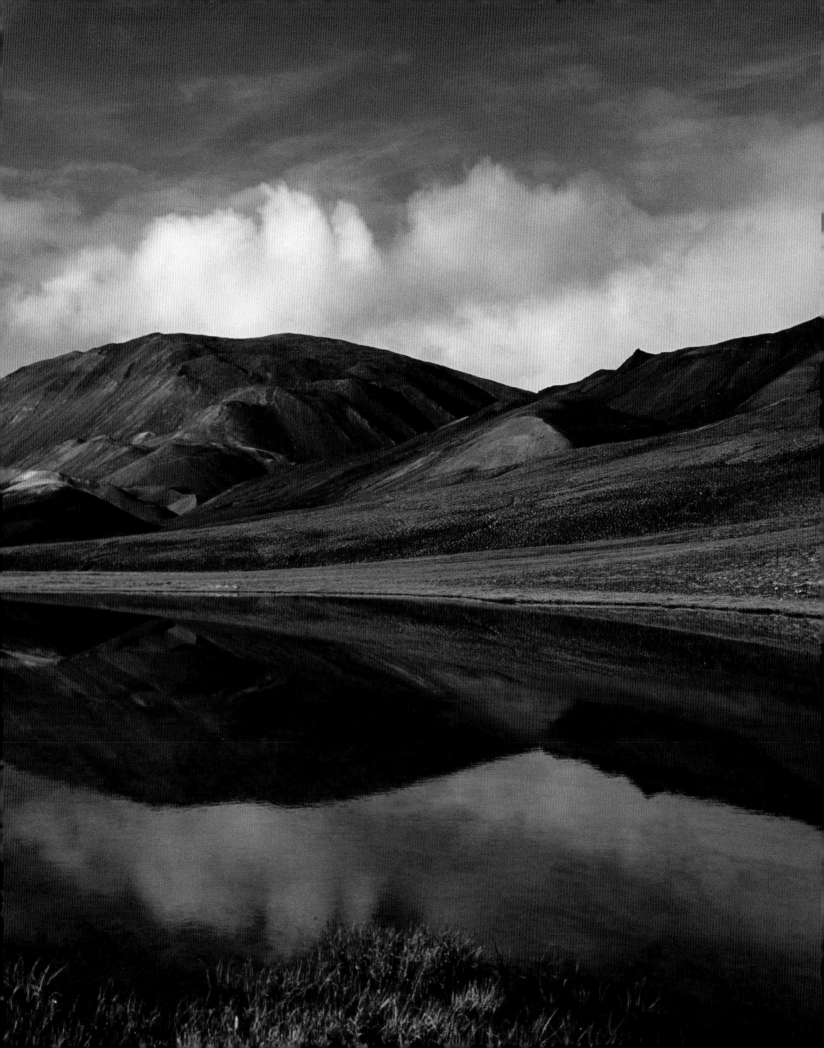

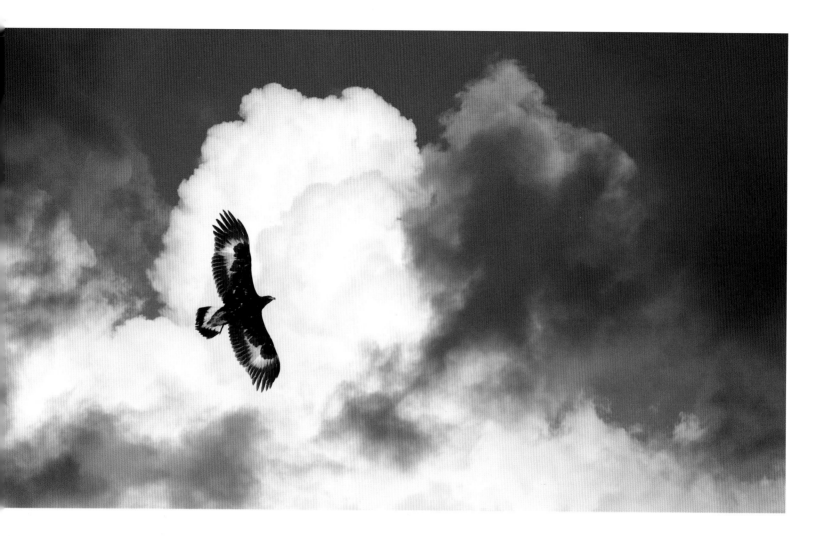

Previous spread: The summer I photographed Skeleton Lake on northern Ellesmere Island was a low year for lemmings, and I didn't sight a single snowy owl in the area, despite hiking a little over 200 miles (320 km) in the surrounding tundra. When lemmings are scarce, the owls may hunt ptarmigan and other nesting birds, but as often as not, the birds simply migrate to other territories where the tundra is more productive.

Above: The golden eagle (*Aquila chrysaetos*) has a limited Arctic range in North America, being restricted primarily to mountain chains in northern Yukon and Alaska. In the Arctic, the eagle hunts marmots, hares, ground squirrels and ptarmigan. Despite their reputation as tireless hunters, these "noble" birds will also scavenge every chance they can. In Alaska, I watched a golden eagle circle several times over a foraging grizzly bear. Eagles shadow bears in this way because they are sometimes able to grab a squirrel escaping out the back exit while the grizzly is busy digging up the rodent's front door.

Right: The large beak of a golden eagle is well designed to cut and dismember prey, but the bird does not use its beak to kill its meals. Instead, it relies on its talon-tipped feet for this task. The bare area of skin at the base of the bill, called the cere, is where the bird's nostrils are located. Biologists cannot fully explain why this area on the eagle's face is featherless. One reason might be improved ventilation, especially during high-velocity dives and strenuous takeoffs with heavy prey. Another benefit may be that the feather-free area makes it easier for an eagle to avoid soiling its facial feathers during feeding.

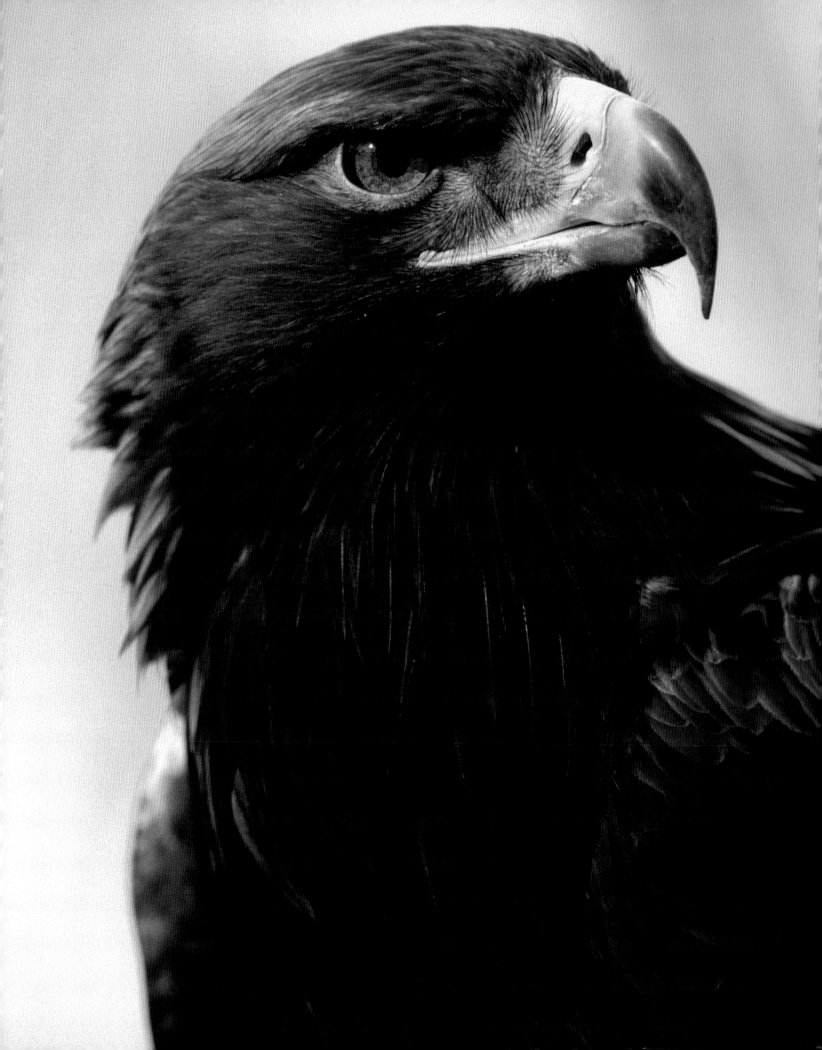

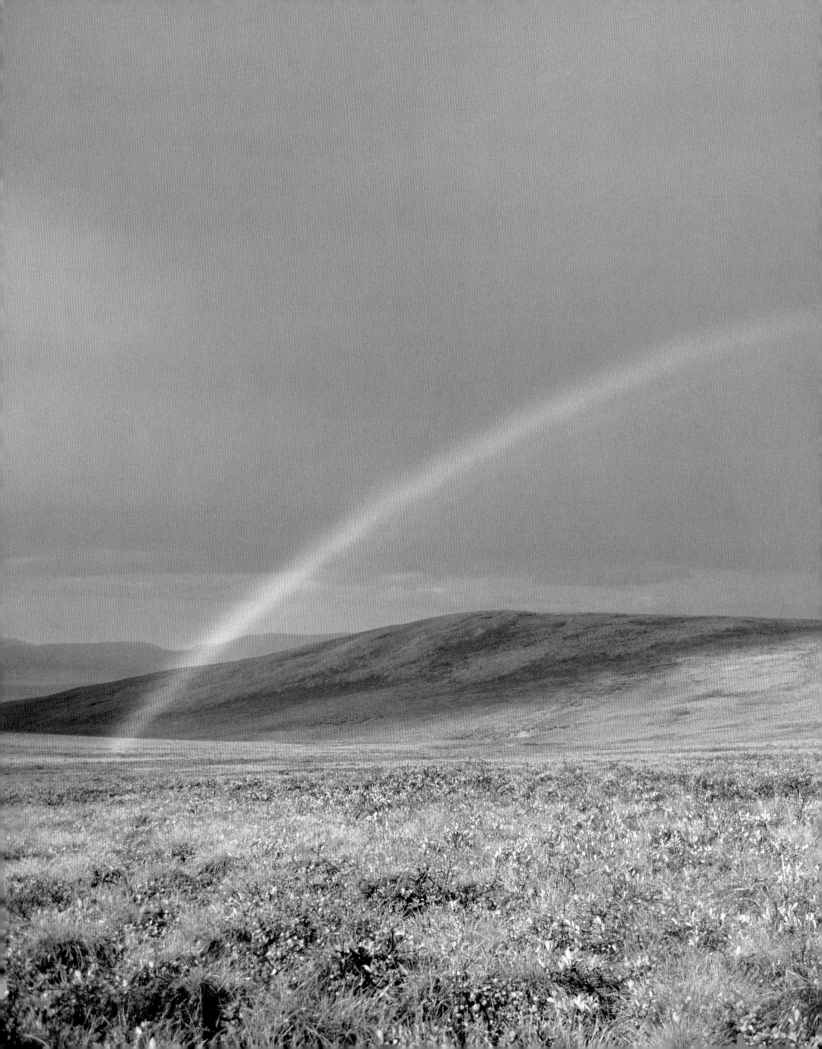

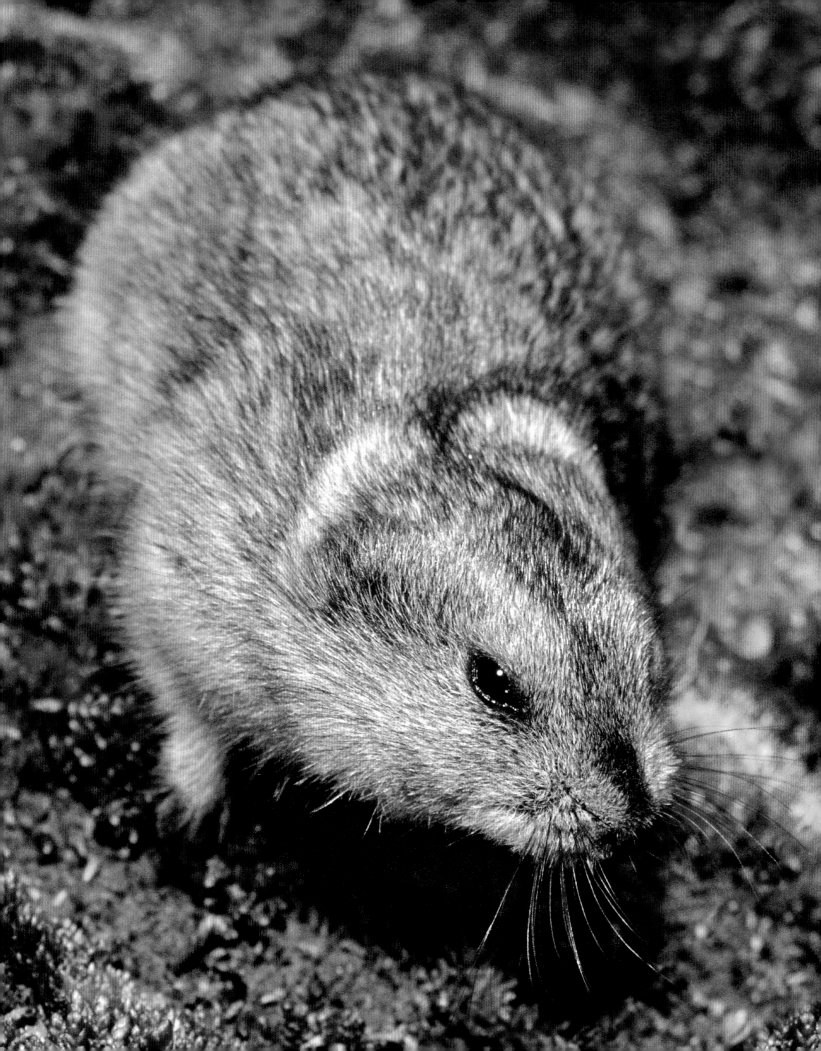

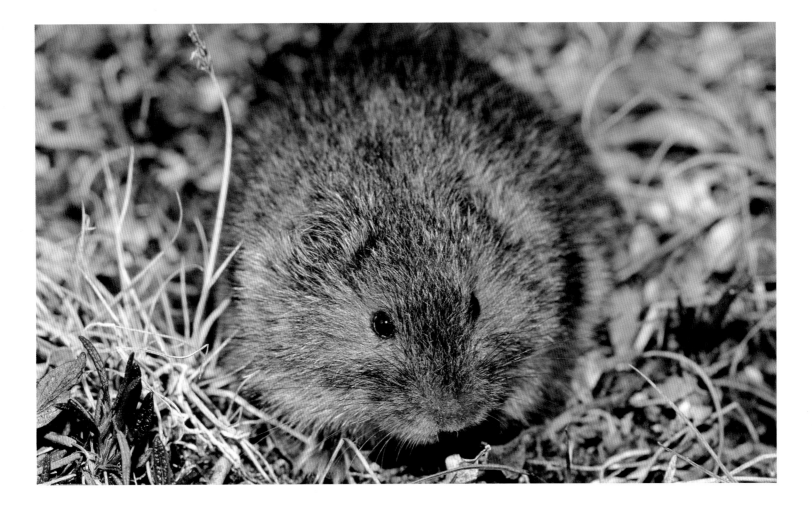

Previous spread: My wife and I were backpacking across this wet tundra area in northern Yukon when we were pelted with a heavy summer rainstorm. The downpour lasted just 20 minutes, and as the storm moved away, we were treated to this inspiring rainbow. It was mid-afternoon and we had been on the move all day and so were happy for any excuse to stop for a break. The beautiful rainbow convinced us that a cup of hot chocolate and some trail mix would boost our energy.

Left: The collared lemmings (*Dicrostonyx* sp.), of which there are three species, range to the most northern tundra regions of North America, Russia and Greenland. Lemmings do not hibernate. During the cold winter months, they occupy areas where the snowdrifts are deepest, excavating a network of tunnels to connect their winter nests with different feeding areas beneath the protective snow cover. Unlike any other rodent, the collared lemming turns white in winter. Ancient Inuit believed that the white lemmings fell from the sky with the first snowflakes of winter.

Above: The body shape most perfectly suited for heat conservation is the sphere, and the brown lemming (*Lemmus trimucronatus*) comes as close to having that shape as any mammal. Nothing sticks out from its fat rounded body. Its legs are short, its small ears are hidden in long fur, and it has next to nothing for a tail. Even with this ideal shape, however, the lemming still needs lots of insulation from the cold. It has long, bristly fur on the soles of its feet, and its winter coat is the densest of any rodent its size.

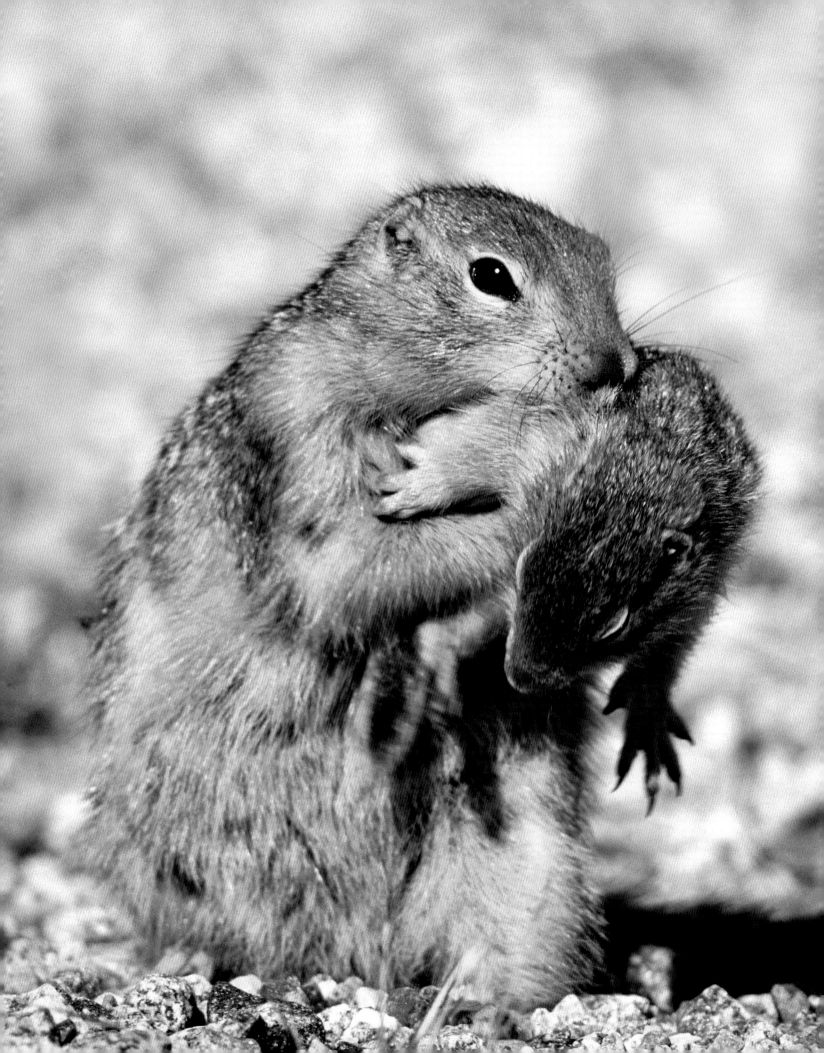

In just half an hour, this mother arctic ground squirrel (*Spermophilus parryii*) successfully transferred her four youngsters from one burrow to another one 150 feet (45 m) away, perhaps because the family home had become flea-ridden. This 1½-pound (0.7 kg) squirrel spends most of its life curled in a ball and hibernating deep inside a burrow. Called *sik-sik* by Inuit, the squirrel is active for just four months each year, but while it is out and about, everything with talons or fangs wants to eat it.

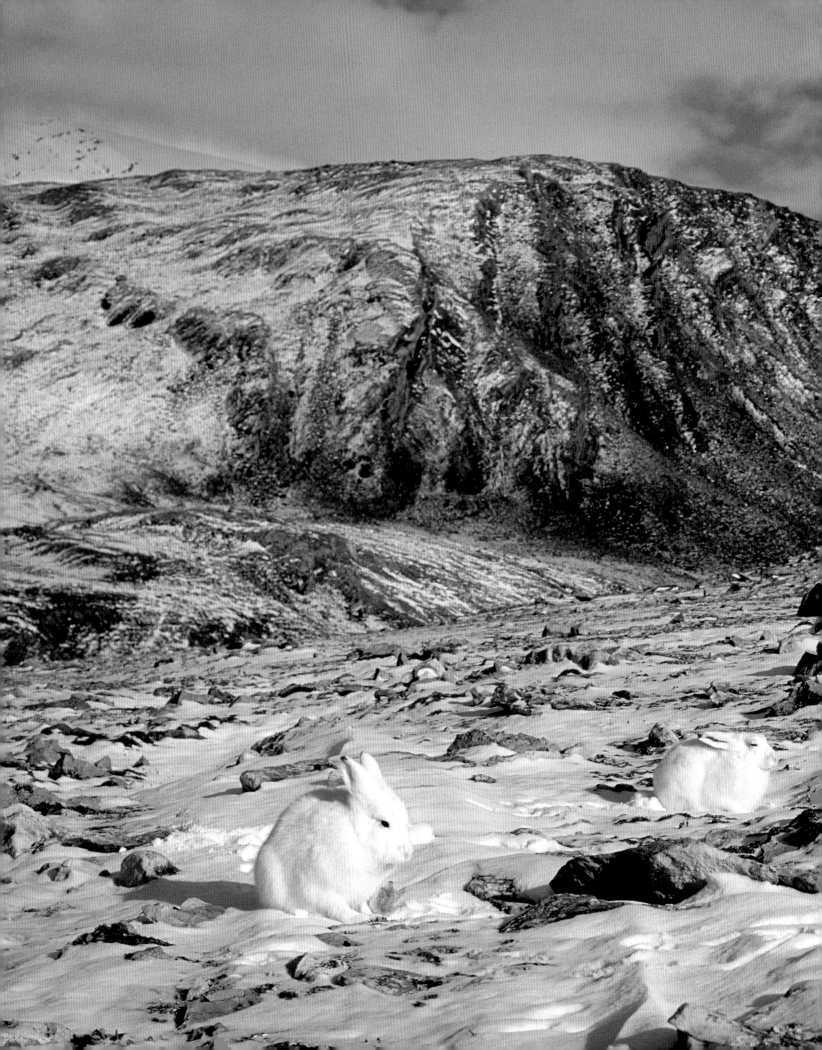

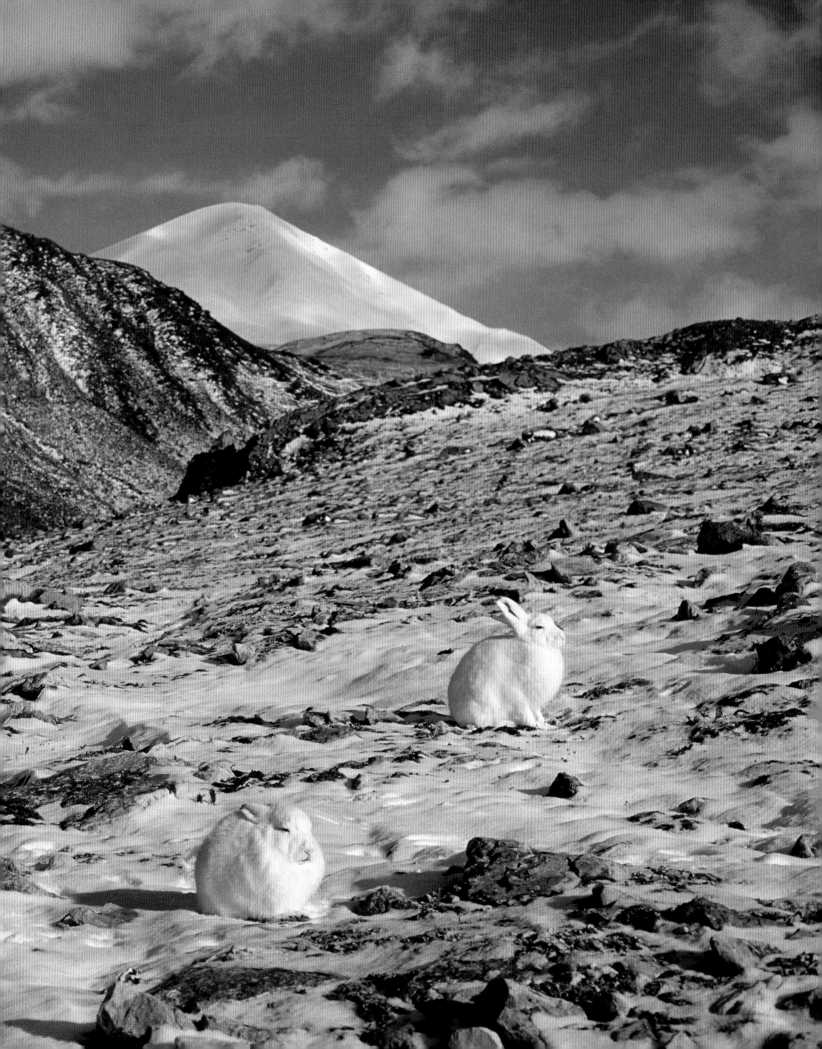

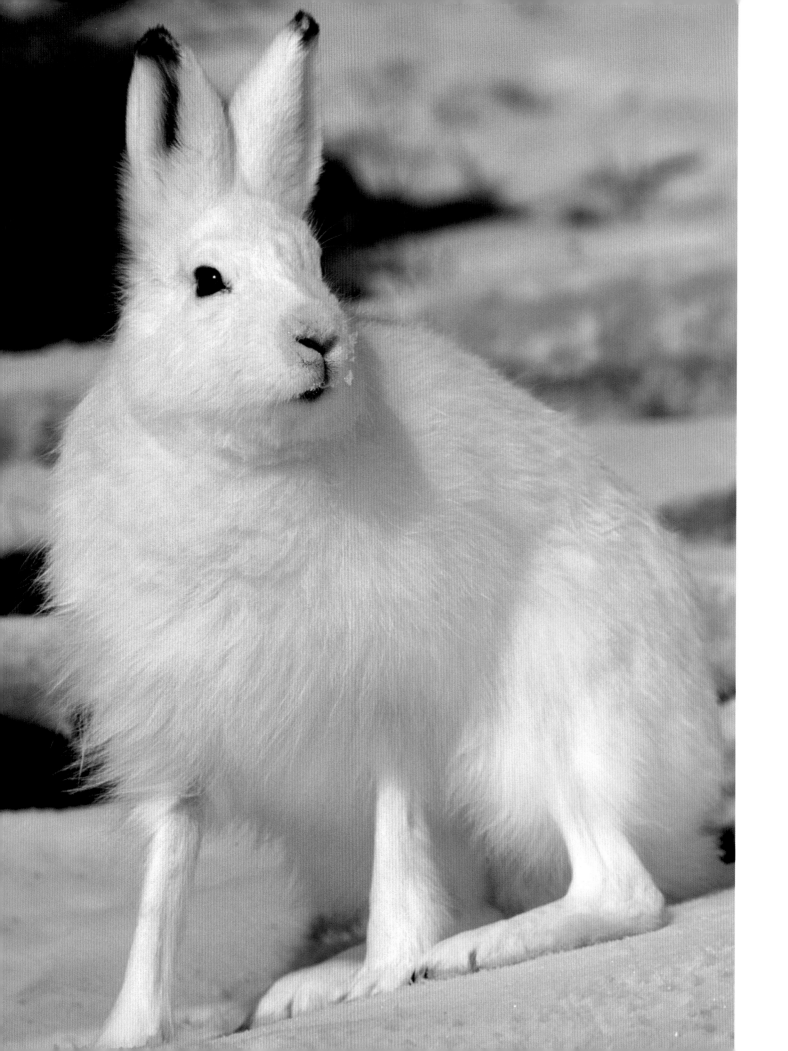

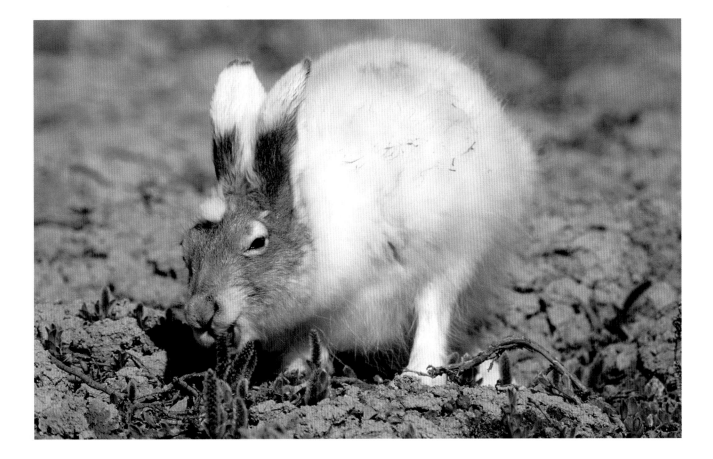

Previous spread: Most hares are solitary. Not so the arctic hare (*Lepus arcticus*), which in winter may gather together in herds of more than a hundred individuals. An Inuk hunter told me that when a group of hares that size hops across the snow, it looks as though the entire hillside is moving. The largest groups have been spotted on Ellesmere and Axel Heiberg Islands, Canada's most northern lands. One photograph taken from a plane flying over Axel Heiberg Island recorded 390 hares in one shot. A biologist flying over Ellesmere Island in 1971 reported arctic hares in herds of thousands. He estimated there were 25,000 hares in an area of tundra just five square miles (13 sq km) in size.

Left: The North American arctic hare pictured here and the Eurasian mountain hare (*L. timidus*) are the most northern members of their family and the heavyweights among hares. This burly bunny averages around 10 pounds (4.5 kg), almost three times the weight of its forest-dwelling relatives farther south. When alarmed, the hare doesn't bound away with the usual four-legged bunny hop. Instead, it may jump up on its hind legs, sometimes bouncing on its tiptoes. If it then decides to run off, it hops away on two legs, like a kangaroo with its front legs tucked tightly against its chest.

Above: The arctic hare in the southern part of its range molts into a coat of brown fur in summer, whereas the most northern hares stay white all year round. This particular hare was eating the energy-rich catkins of ground-hugging willows, and I followed it around for almost an hour as it hopped from one patch of food to the next. The arctic hare, like most mammals, molts in a predictable sequence: the face is the first place its summer fur appears. The animal's mottled fur during its molting phase may make it less conspicuous on the summer tundra where small patches of snow often persist.

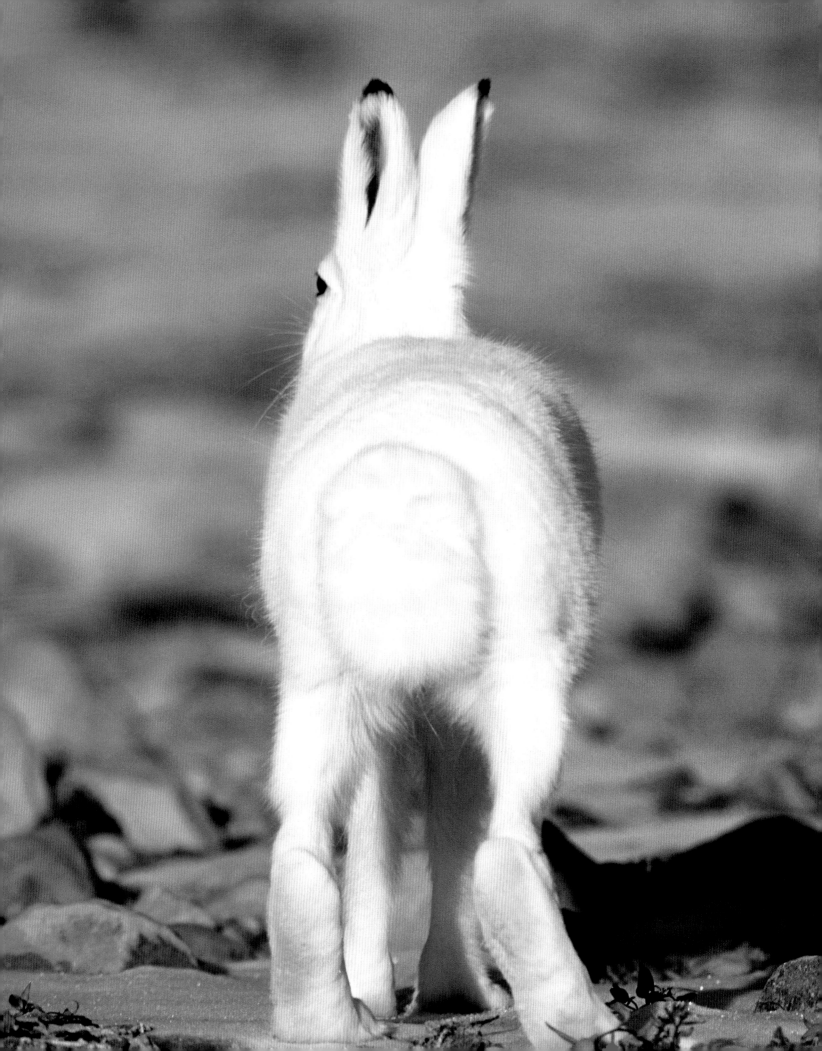

The arctic hare, like all hares, is built to run, and its body evolved to evade predators through the deployment of speed, rapid acceleration, quick changes in direction and lengthy bounds. Its hind legs and feet are much longer than its front ones, which gives it the appearance of a jacked-up street racer. The hare's hind-limb bones are especially dense and strong so it can push off forcefully without injuring itself; its collar bone is small and light-weight, as it is in other running animals.

POLAR

MARINERS

The walrus (*Odobenus rosmarus*) will never win a wildlife beauty contest. Still, I have a soft spot in my heart for this google-eyed, whiskered, wrinkle-faced beast, which has played a role in many of my most memorable Arctic adventures. Last summer, my fondness for the walrus grew even deeper when I discovered another side of its personality.

I was working at 80 degrees north latitude in Norway's Svalbard Archipelago, where walruses have not been hunted for more than 50 years; as a result, the animals are relatively unwary. On a gravel beach one day, I found over a hundred walruses hauled out and snoozing like bloated sunbathers. As I snuck along the shoreline, trying to get closer, half a dozen juvenile males surfaced about 75 yards (68 m) offshore. I knew they had probably seen me, so I decided to try to lure them closer. Wading into the shallows in my hip waders, I splashed around noisily to see how they would respond. To my surprise and great delight, the six walruses started to swim toward me. I squatted down at the water's edge in order to look less imposing, and then I waited. Within moments, one of the males swam straight at me and raised himself out of the water barely three feet (1 m) from my face. His less adventurous buddies stayed a short distance behind. I judged from the modest length of his tusks that the young male was a subadult, a teenager in the walrus world. At first, I didn't know whether to be frightened or thankful. After a moment or two, I cautiously stretched out my hand, and the walrus leaned closer, as if to sniff me.

After watching these creatures over the years, I knew how fast a walrus could wield its tusks, and I suddenly lost my nerve, withdrawing my hand before the walrus

had a chance to reach it. A minute or two passed as the animal tilted his head and examined me, first with one blood-shot eye and then with the other. I'm guessing that he realized the game was over, and he slowly backed into deeper water and swam away. I had known that walruses were powerful masses of muscle, superbly adapted to the demanding challenges of arctic life, but that summer day, I experienced a surprising side of the blubbery brute – an endearing sense of curiosity.

The marine waters of the Arctic are ice-covered for much of the year, which limits the amount of sunlight that reaches the water underneath. Without sunlight, there is no photosynthesis, and without photosynthesis, virtually no food chain on Earth can gain a foothold. In addition, the perpetual ice cover prevents winds from stirring up the surface and mixing the water so that nutrients can be replenished from the depths of the ocean. As a result, the waters of the Arctic are relatively unproductive. In fact, based on the amount of plant life the waters produce, the Arctic is one of the poorest aquatic regions in the world.

Poor or not, the ice-covered Arctic supports ample life. Remarkably, algae grow on the underside of the sea ice. The algae are grazed by a variety of invertebrates, which are then fed on by arctic cod, which in turn are hunted by ringed seals. Because of the community of plants and animals living on the underside of the ice, it is possible for ringed seals to occur almost anywhere, even in the cold, frozen center of the Arctic Ocean.

At the height of summer, during the open-water season, the waters of the Arctic can support large schools of arctic cod (*Boreogadus saida*). The schools vary greatly in size. The smallest contain a few hundred

fish, but the largest ever measured was an impressive 1,400 feet (425 m) long, 1,300 feet (400 m) wide and 30 to 65 feet (10-20 m) thick. Biologists estimated that the school contained approximately 400 million fish – that's 14,330 tons (13,000 tonnes) of potential food for predators. The ocean floor can also be a rich feeding ground. In many areas of the Arctic, the continental shelf is shallow, and the cold, oxygen-rich waters support rich beds of clams, worms, crabs and snails.

To harvest any of the ocean's riches, however, the animals of the Arctic must dive. Foraging walruses commonly make dives lasting six to nine minutes in water less than 260 feet (80 m) deep, although instrumented animals have been recorded at depths exceeding 820 feet (250 m). Very little sunlight penetrates deeper than 325 feet (100 m) underwater, yet feeding harp seals will dive to depths of 900 feet (275 m). Fish-eating belugas make very deep dives, swimming to the blackened seabed at depths up to 1,800 feet (550 m), where they stay submerged for up to 20 minutes. Even polar bears, which most ecologists regard as a marine mammal behaviorally (though their physiology is more like that of a terrestrial mammal), make dives of 10 to 13 feet (3–4 m) to dredge up tangles of seaweed to chew on.

To achieve such diving feats, marine mammals have evolved a number of ways to carry extra oxygen with them. Air-filled lungs behave like a pair of buoyant air bags, so most marine mammals empty theirs before a dive and rely instead on other reservoirs of oxygen to sustain them, namely those in their blood and muscles. Marine mammals commonly have twice as much blood volume as do like-sized land mammals, as well as extra red blood cells in each unit of their blood. Red blood cells carry the life-giving oxygen that every diving mammal needs, and with a greater volume of blood and more red blood cells, a seal can stay underwater longer than a land mammal can. Marine mammals also carry extra oxygen via a special protein called myoglobin, which is contained in their muscle cells. The more myoglobin there is in a muscle, the darker the muscle looks. The breast muscle on a barnyard turkey, for example, has virtually no myoglobin in it, and the muscle is pale white in color. By comparison, the muscle of a whale or seal, which is rich in myoglobin, is almost black in color.

The marine mammals of the Arctic are some of the region's most charismatic creatures. Who wouldn't laugh at the antics of a herd of blubbery walruses bellowing and burping on a gravel beach? Whose heart is not moved by the whine of a hungry harp seal pup? And who does not marvel at the beauty of a polar bear mother leading her cubs through a crystalline maze of pack ice? More impressive than the humor, emotionality and beauty of these creatures, however, are the wondrous ways they have evolved to exploit the hinterlands of the Arctic. For most of my adult life, I have pursued the exciting biology and behavior of wildlife, and this voyage of scientific discovery has enhanced my enjoyment of the Arctic and its creatures beyond my wildest dreams. My wish for you is that you also discover the satisfaction and value of such a journey.

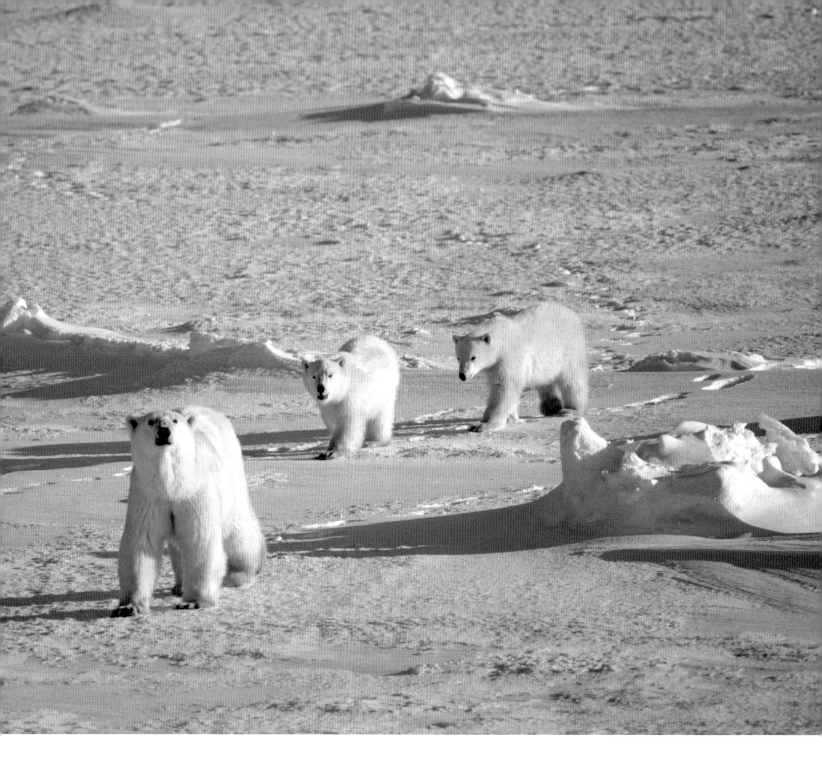

Chapter opening: A subadult polar bear (*Ursus maritimus*) hunting along the edge of the shorefast ice in the Svalbard Archipelago. The ice edge is a popular location for ringed and bearded seals to haul out and bask during their summer molting period. On warm, windless days, as many as 70 percent of the ringed seals in an area may be sprawled on the ice. Many seals haul out for 24 hours at a time, and some may stretch out for 50 hours straight.

Above: The cubs of this mother polar bear were roughly one and a half years old. At this age, cubs still derive considerable calories from their mother's fat-rich milk. Female polar bears usually have their first litter of cubs when they are five years old. After that, they give birth to a new set of cubs every three years, typically having one or two cubs at a time. A mother bear may raise up to 12 cubs in her lifetime.

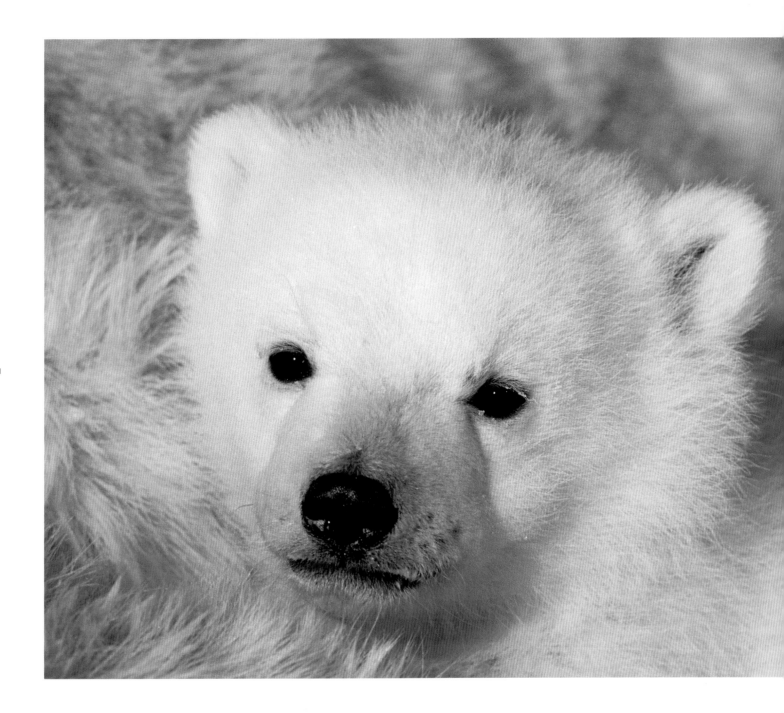

Although the pelt of the three-month-old cub pictured here is well developed, the youngster still has no subcutaneous fat and loses body heat more readily than an adult bear. To compensate, cubs have a higher metabolic rate, which is like turning up the thermostat on the furnace inside a house that is poorly insulated: the house stays warm, but it consumes more fuel. The higher metabolic rate of polar bear cubs is sustained by their mother's rich, fatty milk.

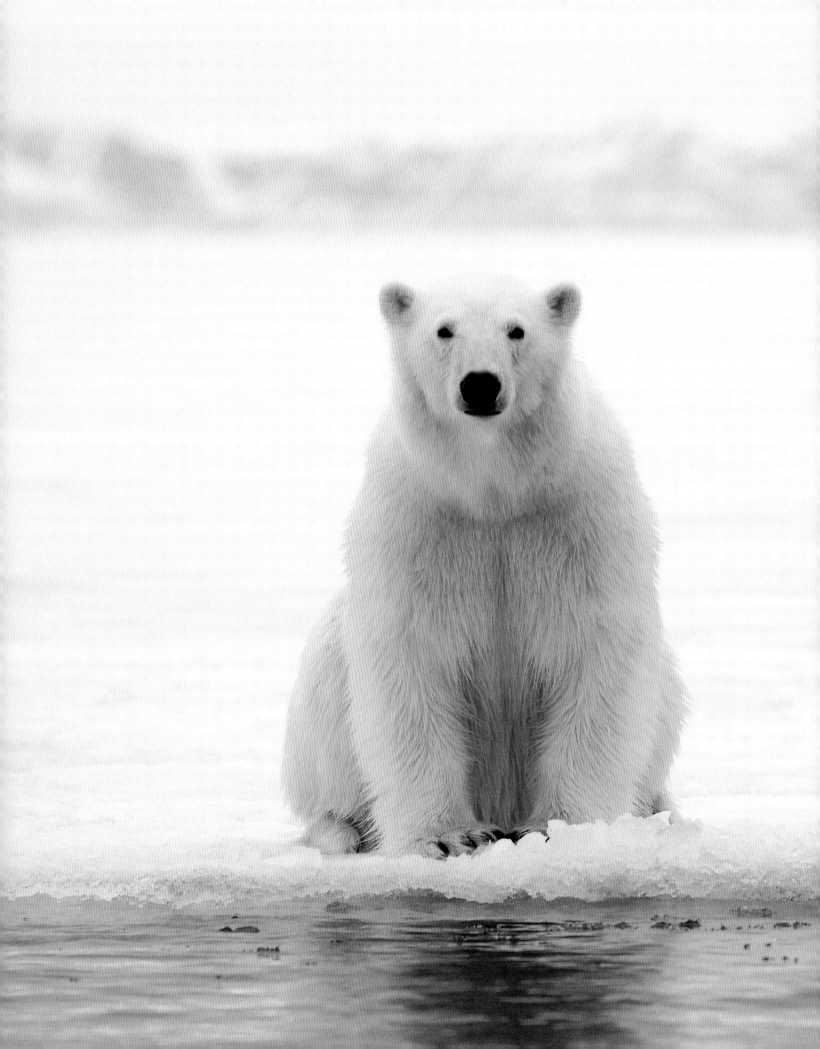

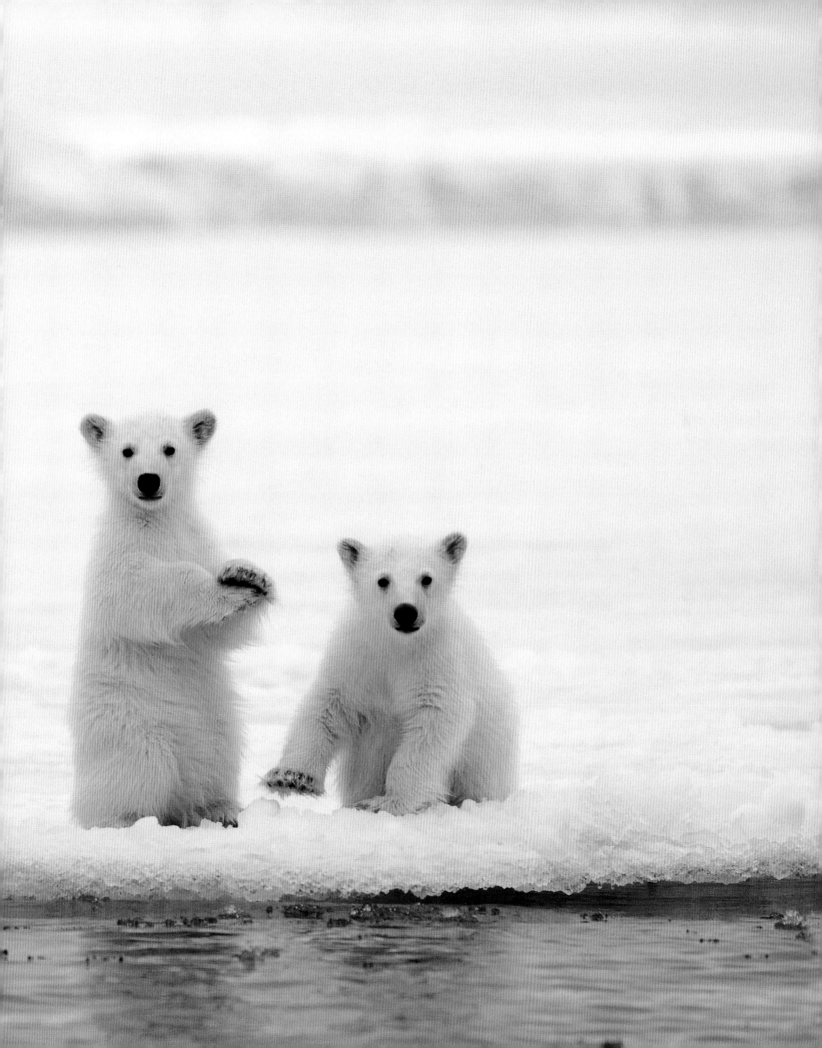

Previous spread: These six-month-old polar bear cubs were born in late December, after their mother excavated a den in a deep snowdrift along the shoreline of a remote island in Norway's Svalbard Archipelago. The family was searching for food along the edge of the pack ice, where seals frequently haul themselves out to warm up and molt. At this age, the cubs are old enough to eat small amounts of meat, and they eagerly share the ringed and bearded seals their mother kills. The young bears stay with their mother for two and a half years.

Above: The heavily furred bottoms of the polar bear's feet serve as insulation from the arctic ice and snow, while the small area of exposed bare skin is roughened like coarse sandpaper, allowing the bear to gain traction on slippery surfaces. When viewed under a microscope, this black skin is covered with thousands of tiny bumps, an anti-skid feature discovered when British scientists with the Ford Motor Company were researching slip-resistant footwear in order to reduce accidents in the workplace. Their findings in the natural world led them to develop a soft shoe soling covered with small conical projections, similar to those that appear on the pliable foot pads of a polar bear.

Right: Polar bears range in color from silvery white to a light yellow or straw color. The fur of newborn cubs is always pure white, but the fur of most adult bears, especially that of the males, turns yellow as they age. Some researchers believe that the color of a polar bear's fur changes with the seasons, with the fur at its whitest when the bears molt in the summer, gradually yellowing from oxidation by the sun. When I photographed this male bear, he was on his feet, watching another bear feeding on a seal carcass.

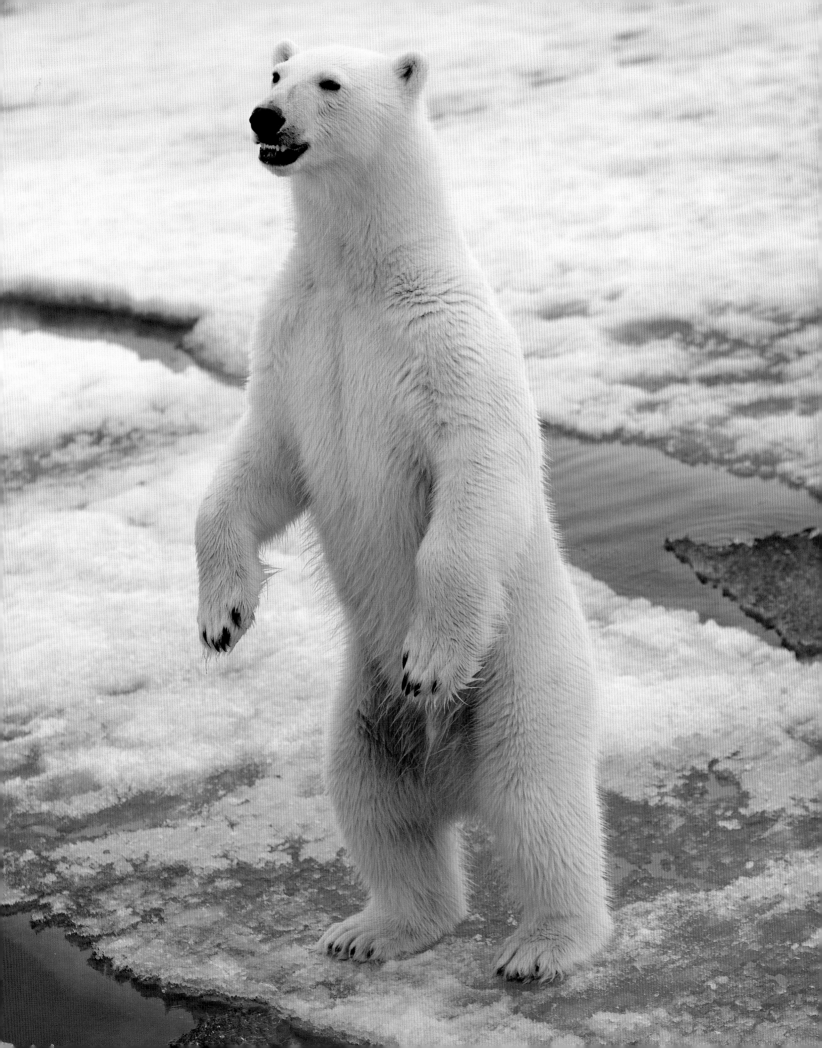

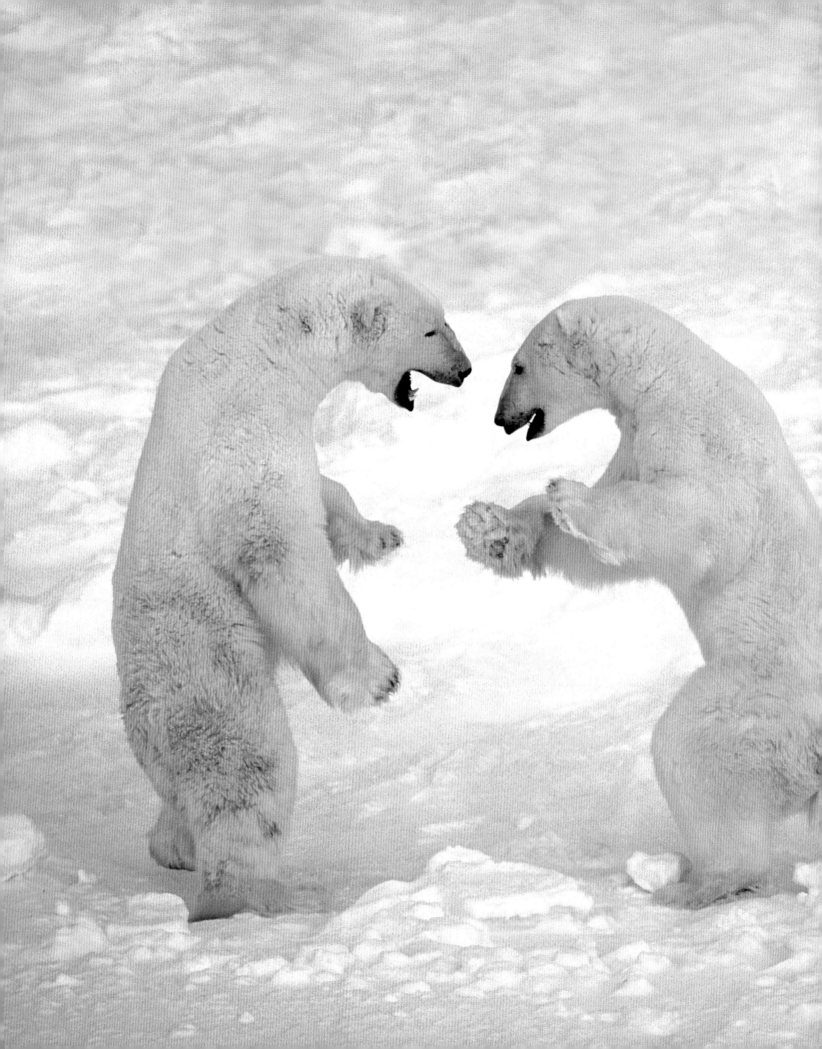

Wrestling is a play behavior that occurs mainly between polar bears of the same sex and age. These large adult males probably each weigh from 900 to 1,000 pounds (400–450 kg). Biologists speculate that play wrestling may be a way for the animals to refine social interactions, test opponents and gain experience in assessing size and strength and other cues of superiority. Then, during the spring mating season, when male bears fight one another in earnest, they are able to avoid dangerous confrontations with opponents against which they have no hope of winning.

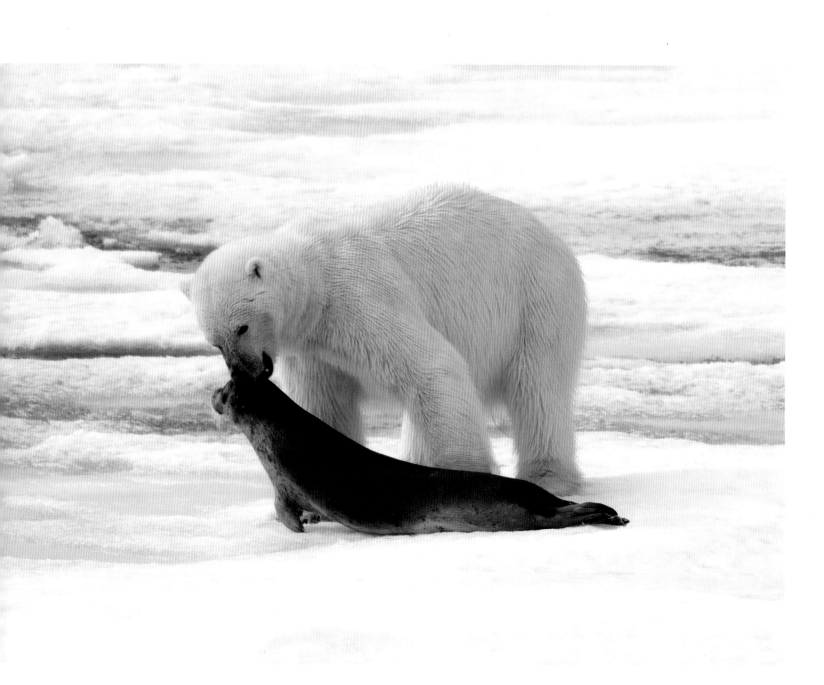

Above: The peak hunting period for polar bears is from March to July, during the seal-pup birthing season, when there is an abundance of naive young seals that are relatively easy to capture. Biologists estimate that during this period, a bear may consume 70 percent or more of its total energy for the entire year. This adult male bear has caught a young bearded seal (*Erignathus barbatus*). When the hunting is good, the bear may eat just the skin and underlying blubber of its kill, abandoning the remainder of the carcass to scavenging gulls and arctic foxes.

Right: The polar bear has the largest home range of all the bears, but its home range does not have a predictable shape or size – it is simply the area traversed by the animal as it goes about the normal activities of food gathering, denning, mating and caring for its young. As a result, a home range is dynamic, that is, its size and shape may vary from area to area. It may even vary from year to year in the same region. One of the largest home ranges measured was 104,101 square miles (269,600 sq km), a territory the size of Iceland.

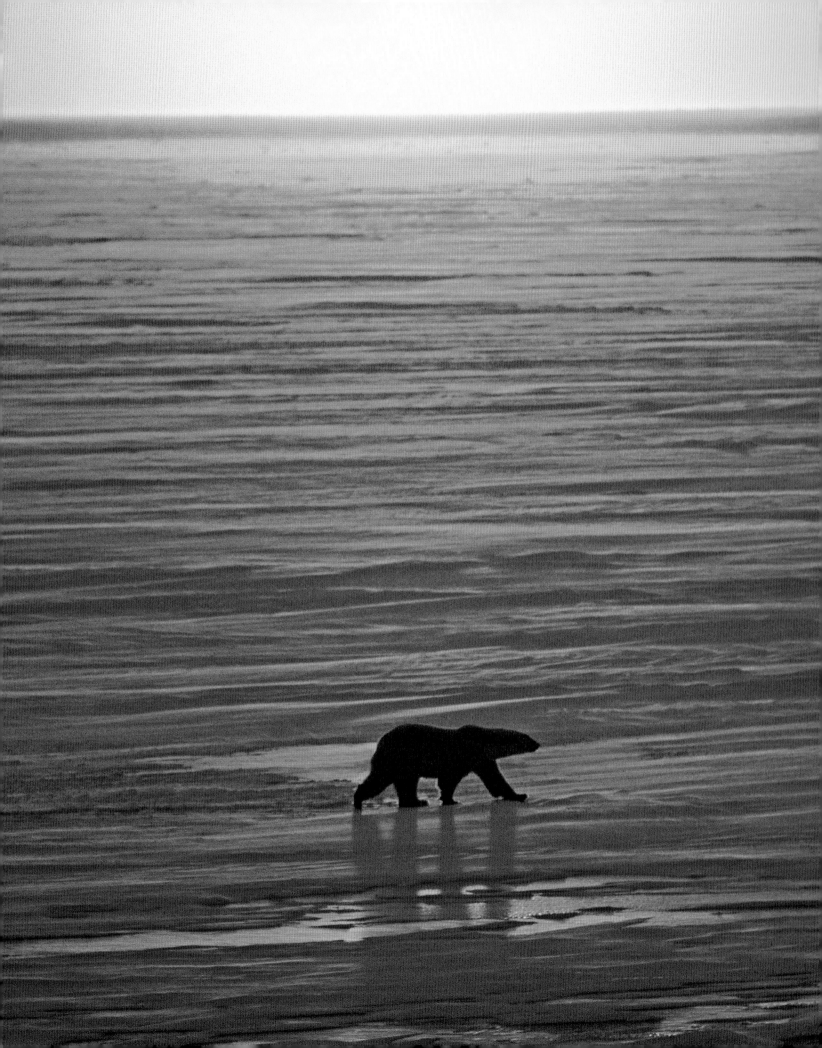

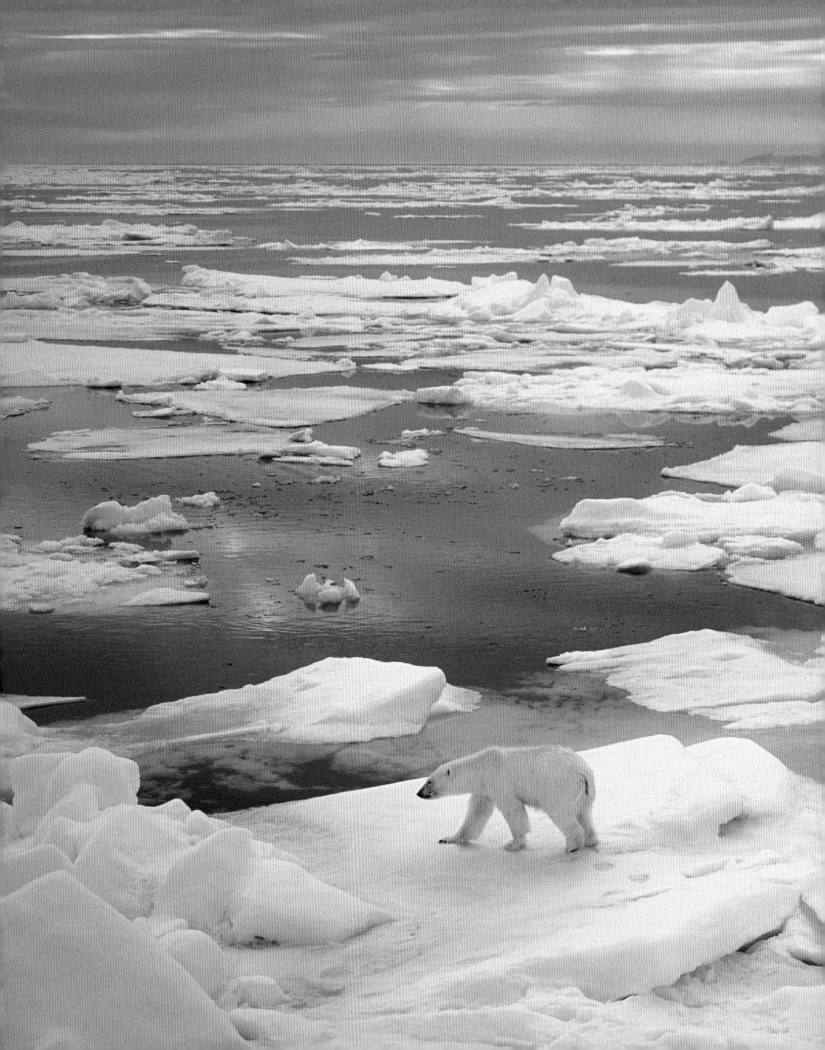

Left: The shifting pack ice is one of the polar bear's preferred sites for seal hunting, but in many polar areas, global warming has caused the summer pack ice to move farther and farther from the shoreline. Bears caught in this situation have two options: they can swim to land and spend the summer there, fasting and living off their fat reserves, or they can stay with the retreating pack ice. Those that choose to stay with the ice increasingly find themselves stranded at a great distance from solid ground, over deep, unproductive waters where few seals are found.

Following spread: Although the walrus's present distribution is restricted to distant ice fields in the Arctic, isolation in northern polar seas is not a requirement for this animal's survival. In neolithic times, Atlantic walruses ranged as far south as the Bay of Biscay off the coast of France and Spain; they persisted in the English Channel until 200 A.D. In the 1600s, when these marine mammals ranged as far south as Cape Cod, Massachusetts, half a million walruses may have hauled out on the sandy beaches of Canada's Gulf of St. Lawrence. The vast southern herds were ultimately systematically slaughtered for their valuable ivory, hides and fat.

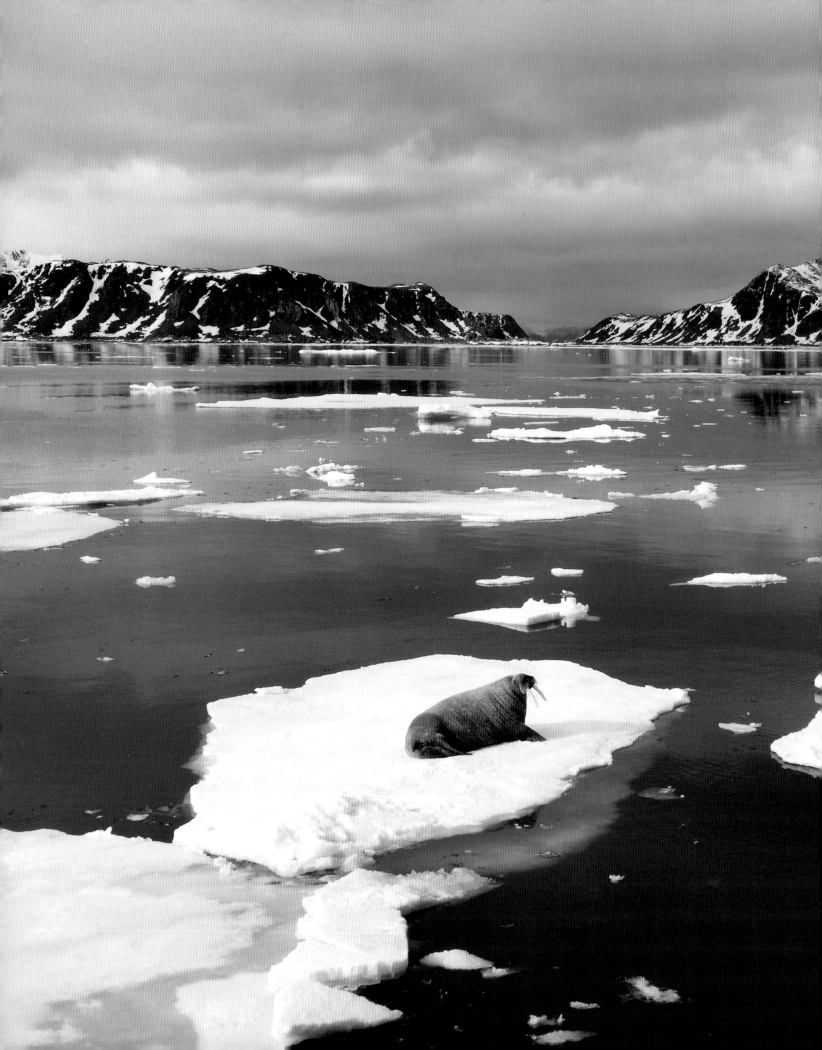

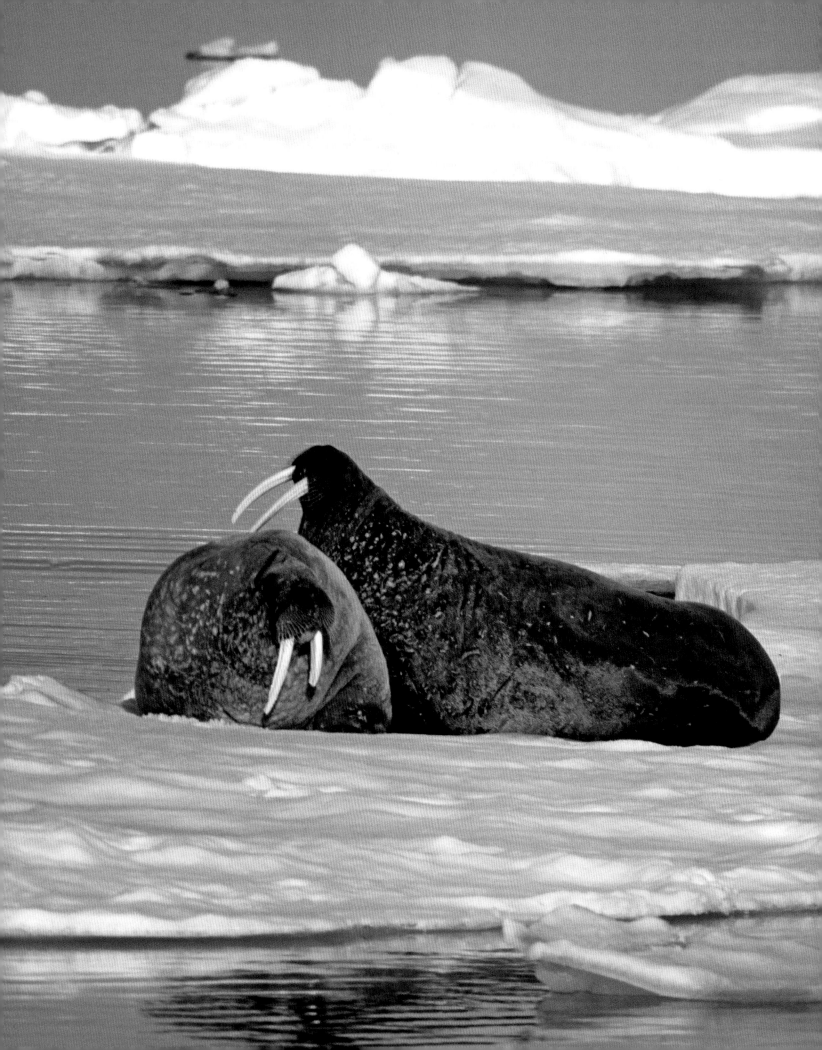

Left: Large bull walruses often haul out together and rest en masse. But because adult male walruses in crowded circumstances often jab and bludgeon each other with their tusks, the skin on their necks, shoulders and chests has thickened into a protective dermal shield. Their upper bodies are also covered with thick knobby warts that impart additional protection. The knobs and underlying skin may be almost three inches (7 cm) thick, which helps these animals avoid serious injury.

Following spread: The short tusks on this group of walruses identify them as subadult animals. At roughly four to six years of age, they're the walrus equivalent of a gang of teenagers. Both male and female walruses carry tusks, but tusk size is greatest in the male, where tusks reach lengths of 28 inches (70 cm). Walrus tusks continue to grow throughout the life of the animal, increasing in length as well as mass.

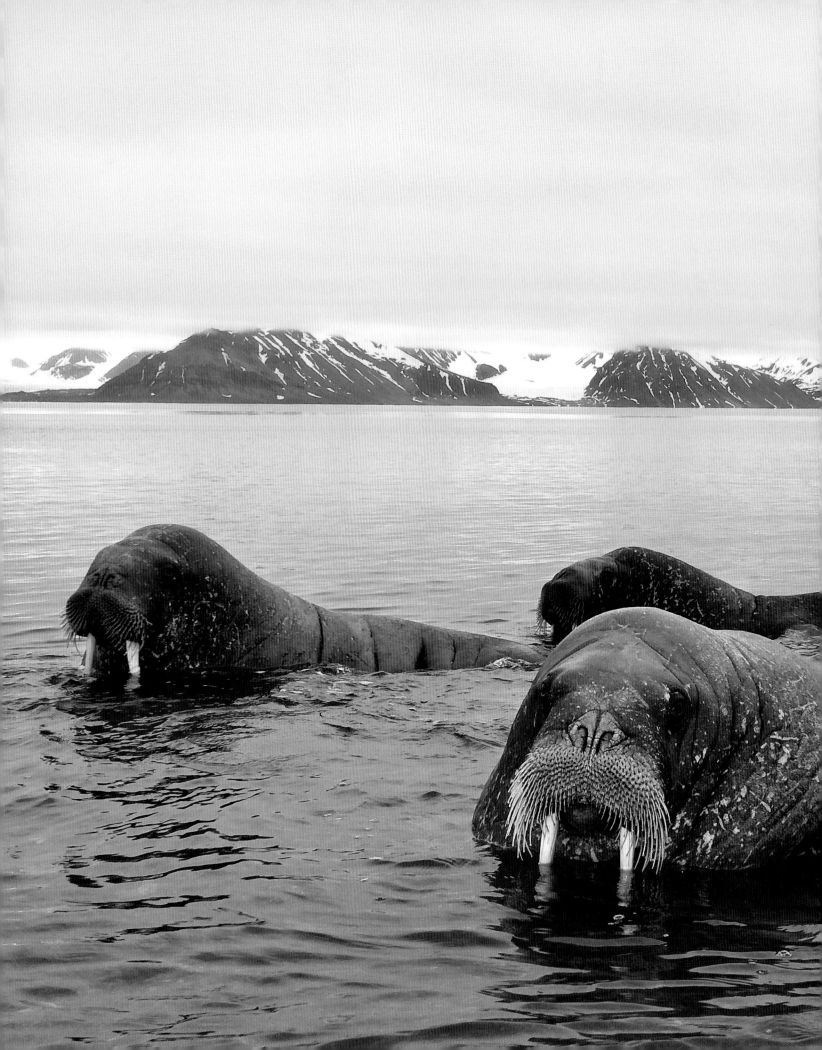

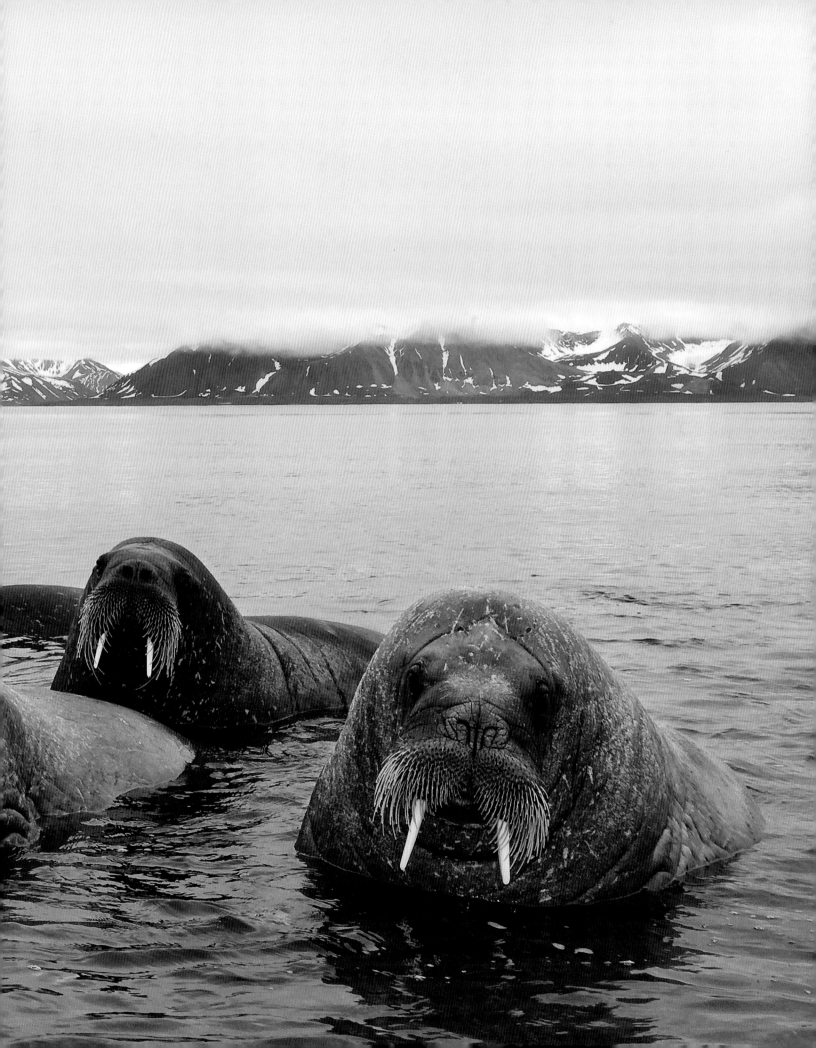

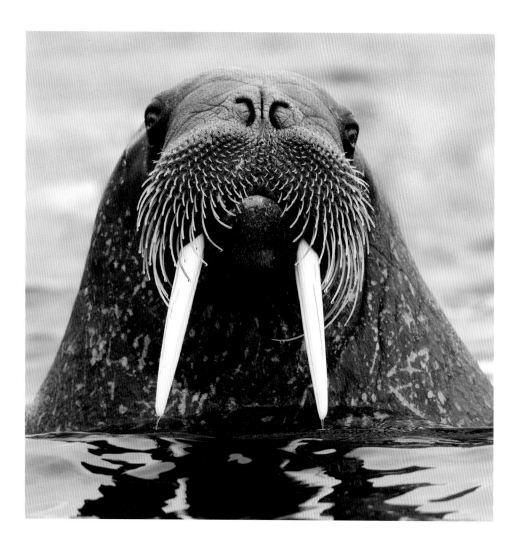

Above: The snout of every walrus bristles with from 500 to 700 thick, pointed whiskers. Each whisker moves independently, and each features a rich network of nerves that decode the details of everything it touches. European researchers have tested captive walruses and discovered just how sensitive these whiskers really are. Not only can a blindfolded walrus differentiate between a round wooden peg and one that is triangular, but it can do so with pegs the size of a wooden match. In the wild, the blubbery walrus uses its ultra-sensitive whiskers to locate up to 190 pounds (85 kg) of clams, mussels, worms and soft-shelled crabs every day.

Right: For several hundred years, people believed that walruses used their tusks to rake the ocean floor for food, unearthing clams, snails, worms and other edibles. In the late 1970s, however, researchers demonstrated that the primary function of tusks was not as instruments of excavation but as symbols of social rank used in ritualized dominance displays. Larger tusks reflect larger body size and greater age. That, in turn, confers a higher status and rank. When a large bull comes ashore, he may bulldoze his way through a dozing throng like the one pictured here, using his tusks to physically intimidate and punish lesser specimens that are reluctant to make way.

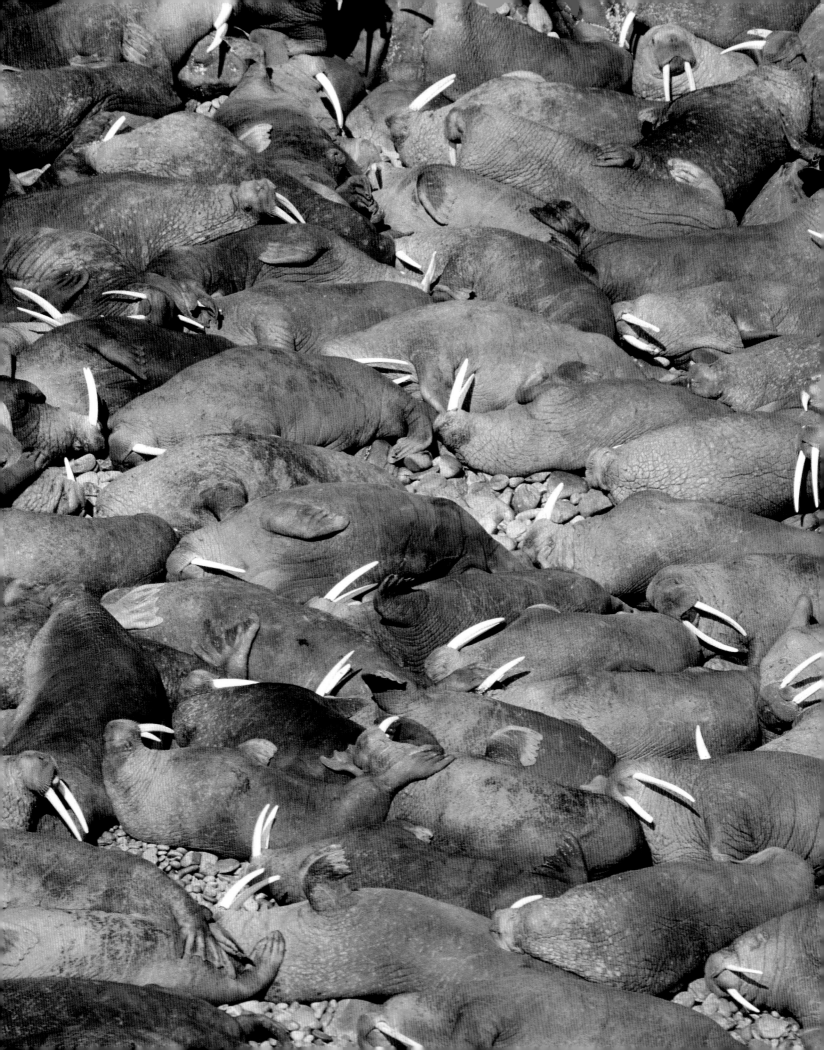

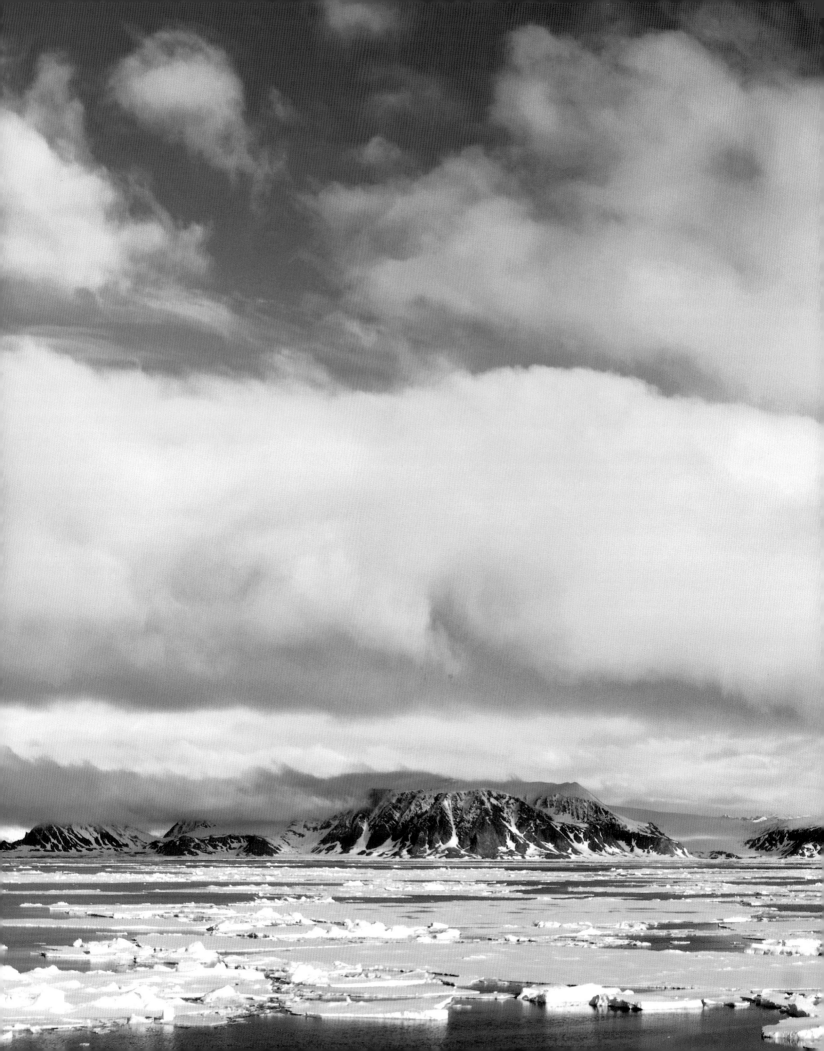

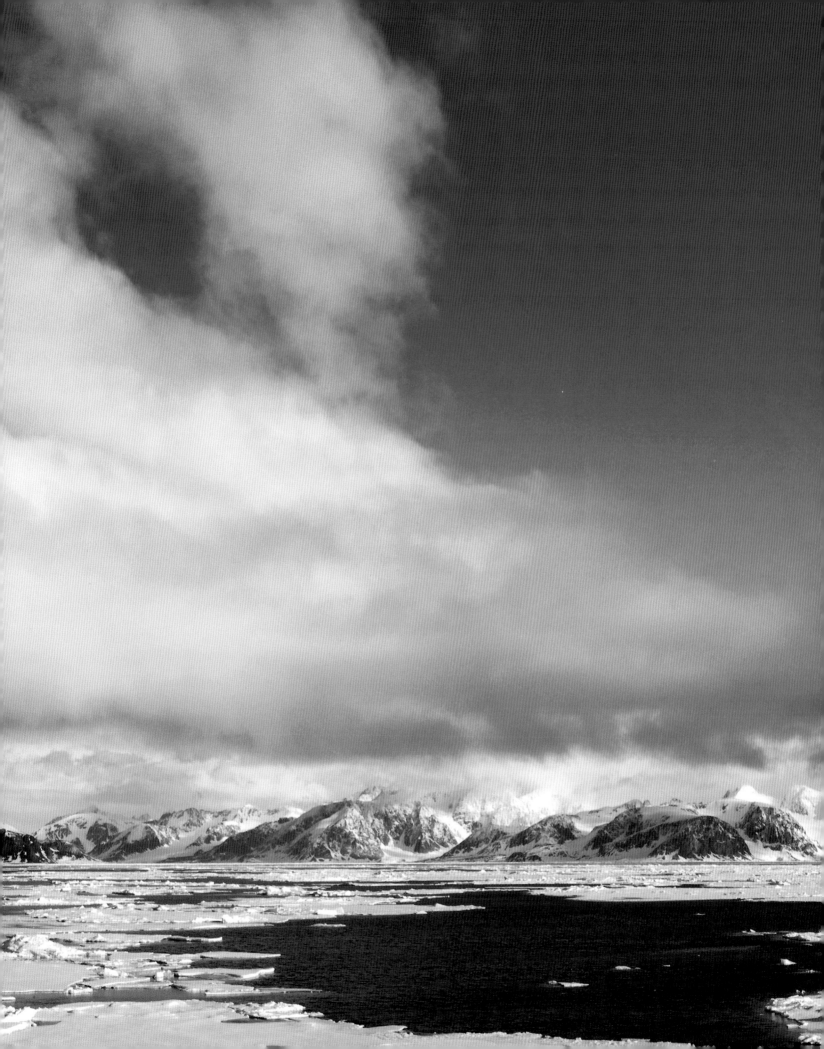

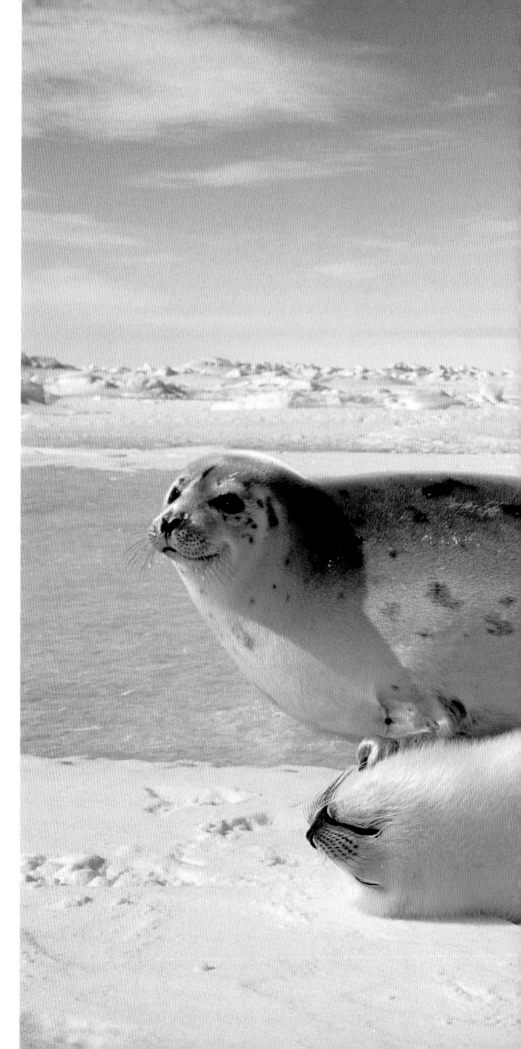

Previous spread: Unlike ice in a freshwater lake, pack ice moves. Driven by the wind and ocean currents, it may drift three to nine miles (9–15 km) per day, sometimes sailing as far as 25 miles (40 km) in a day. Such continuous movement causes the ice to fracture, and when large sections collide, the jumbled ice forms pressure ridges up to 50 feet (15 m) high and several miles long. This field of pack ice off the Northwest Islands in Svalbard is young annual ice in the process of melting and disintegrating.

Right: At birth, a white-coated harp seal pup (*Phoca groenlandica*) weighs 22 pounds (10 kg). For the first 12 days of the young seal's life, its mother is never far away, and the youngster simply dozes and dines, suckling six or seven times a day. On such a feeding schedule, the newborn seal pup seems to inflate like a balloon, and by the end of the 12 days, it weighs around 75 pounds (34 kg) and looks like an overstuffed sausage. Then, without warning, the attentive mother seal takes her leave. For several days, the young whitecoat cries out for its mother, but eventually, it accepts its new situation and begins life on its own.

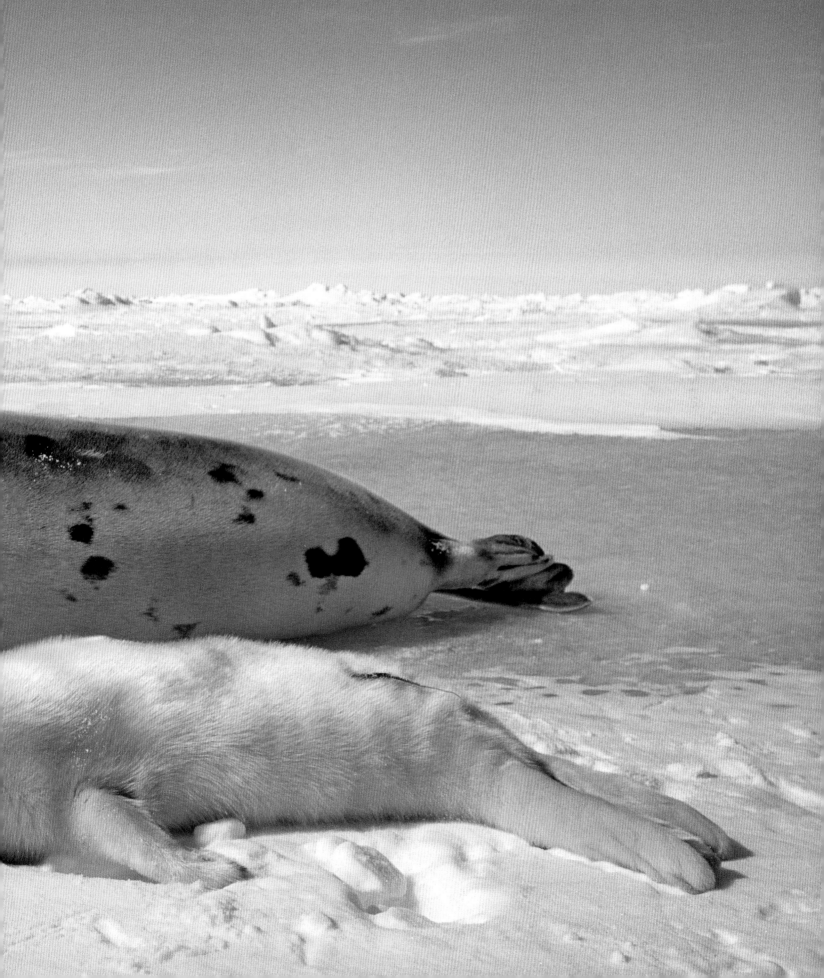

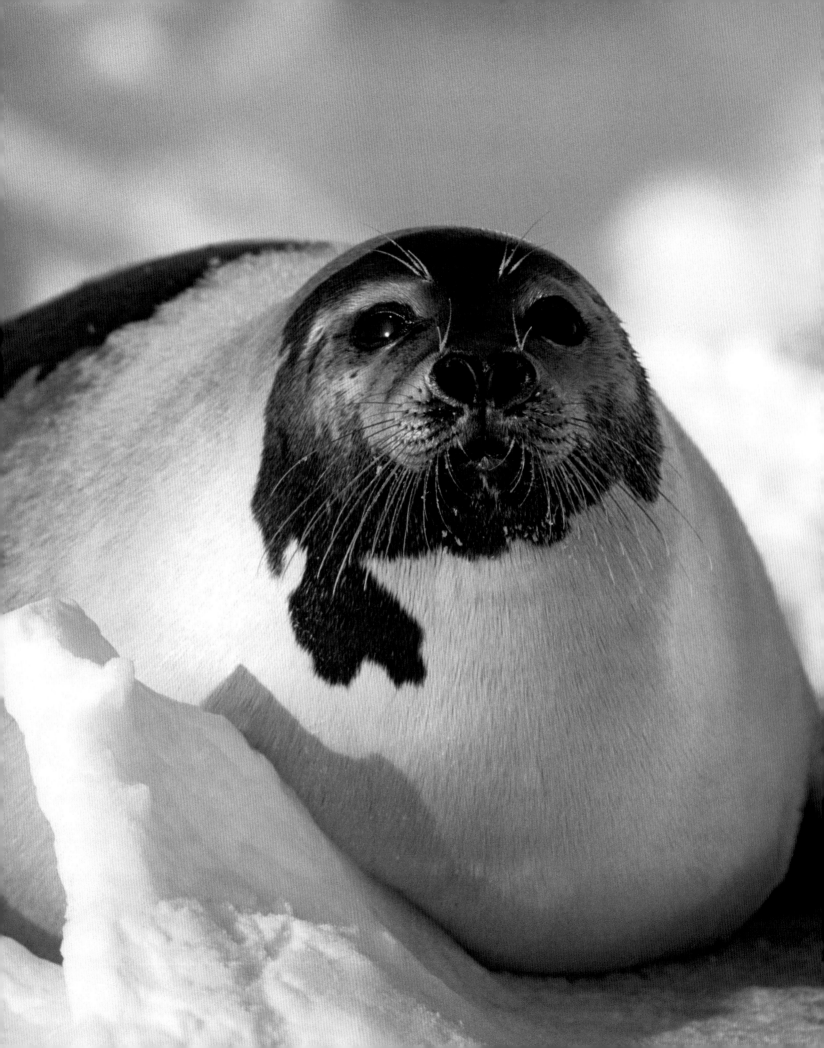

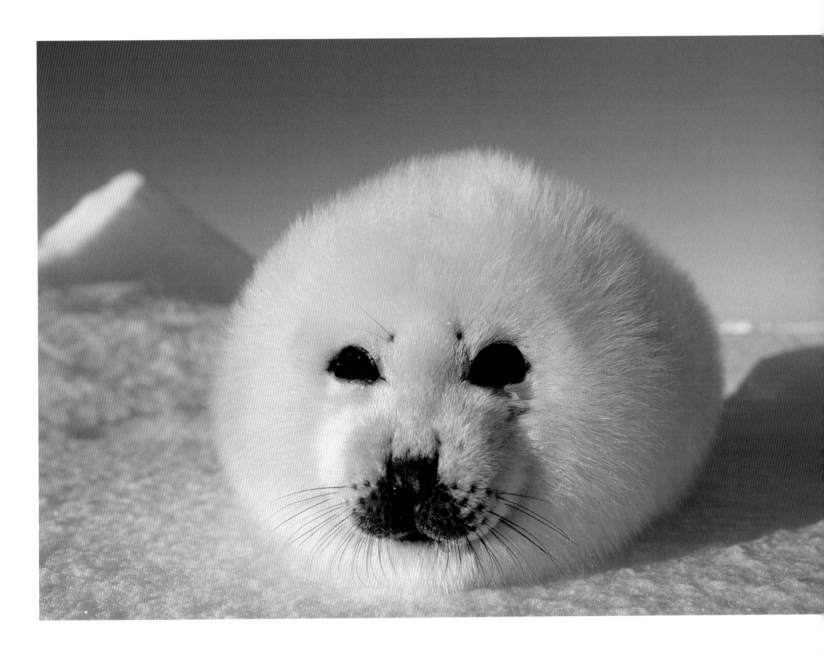

Left: Adult harp seal numbers in Canada's eastern Arctic peaked around 2002 at roughly five and a half million animals. Global warming may be responsible for some of the changes biologists are seeing in the seals' behavior. The adults are now whelping a week earlier in spring than they were a decade ago, perhaps to take advantage of more reliable ice conditions. And since 1998, researchers have noticed a greater number of severe winter storms with resulting increases in pup mortalities from drowning and ice crushing. In 2007, 90 percent of the Magdalen Islands population of harp seal pups may have drowned.

Above: Although it is less than two weeks old, this young harp seal pup is about to be weaned. A thick layer of blubber under its skin provides such good insulation that little of the pup's body heat escapes, and it is able to stay warm even during a winter storm. After the pup is weaned, it will remain on the ice for several weeks, drawing on its fat reserves while it molts its white natal coat, which is replaced with that of a silver-gray juvenile.

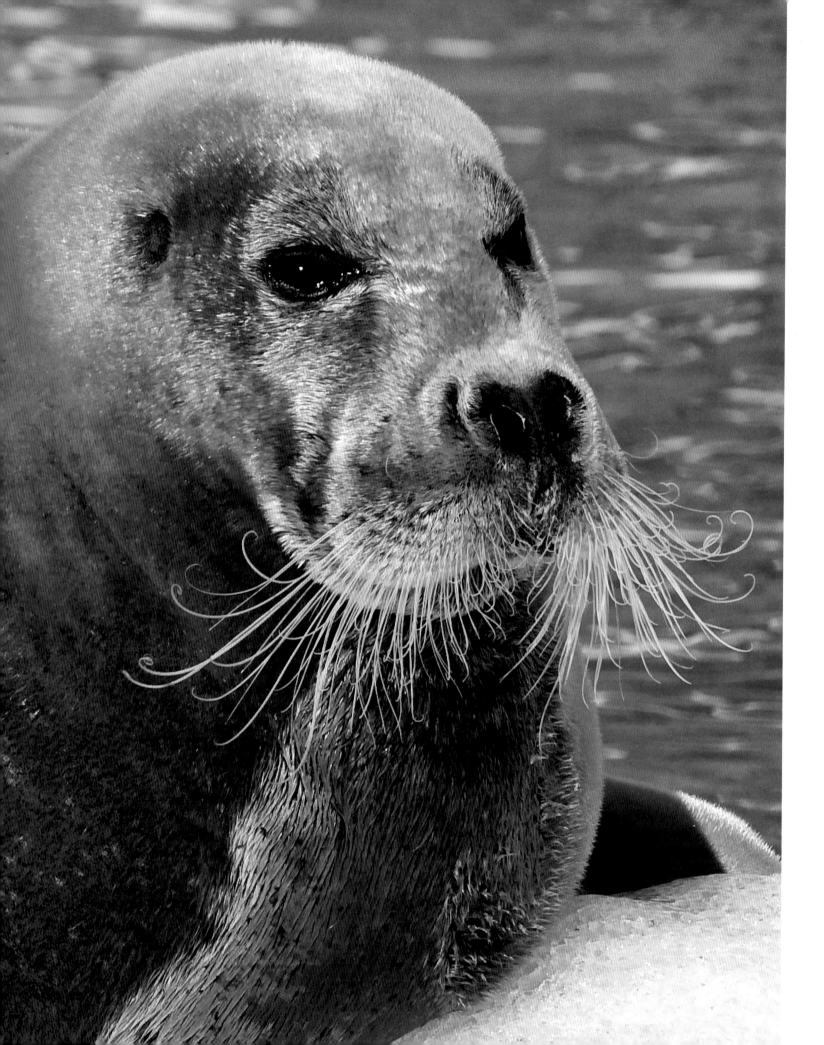

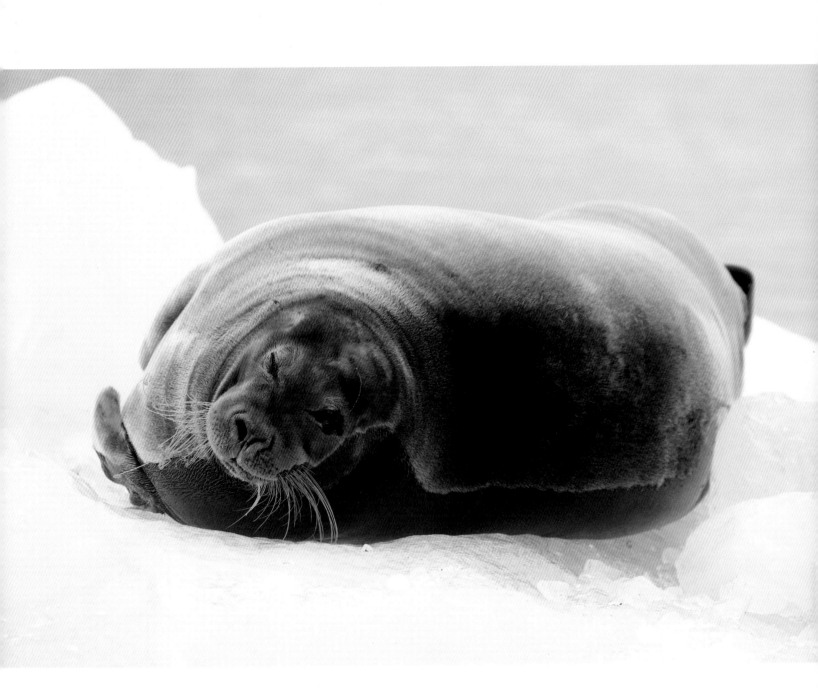

Left: After the heavyweight walrus, the bearded seal is the largest member of the seal family in the Arctic, weighing in at an average of 550 to 660 pounds (250–300 kg). A female bearded seal, which in this species is larger than the male, can weigh in excess of 940 pounds (425 kg) in spring. The seal's elaborate whisker moustache is the inspiration for its common name. When the whiskers dry out, they curl at the ends.

Above: The bearded seal is an ice-loving seal that rarely comes ashore to rest, preferring to haul out on a ledge of pack ice. The seal feeds on a variety of prey, including amphipods, clams, crabs, fish and squid. It frequently searches the soft sediments on the ocean floor, feeling with its whiskers and exposing hidden prey with strong jets of water from its mouth. The rust coloration on this seal's face is a result of exposure to iron compounds in the muddy sediments. When the compounds are brought to the surface, they react with oxygen, and rusting occurs.

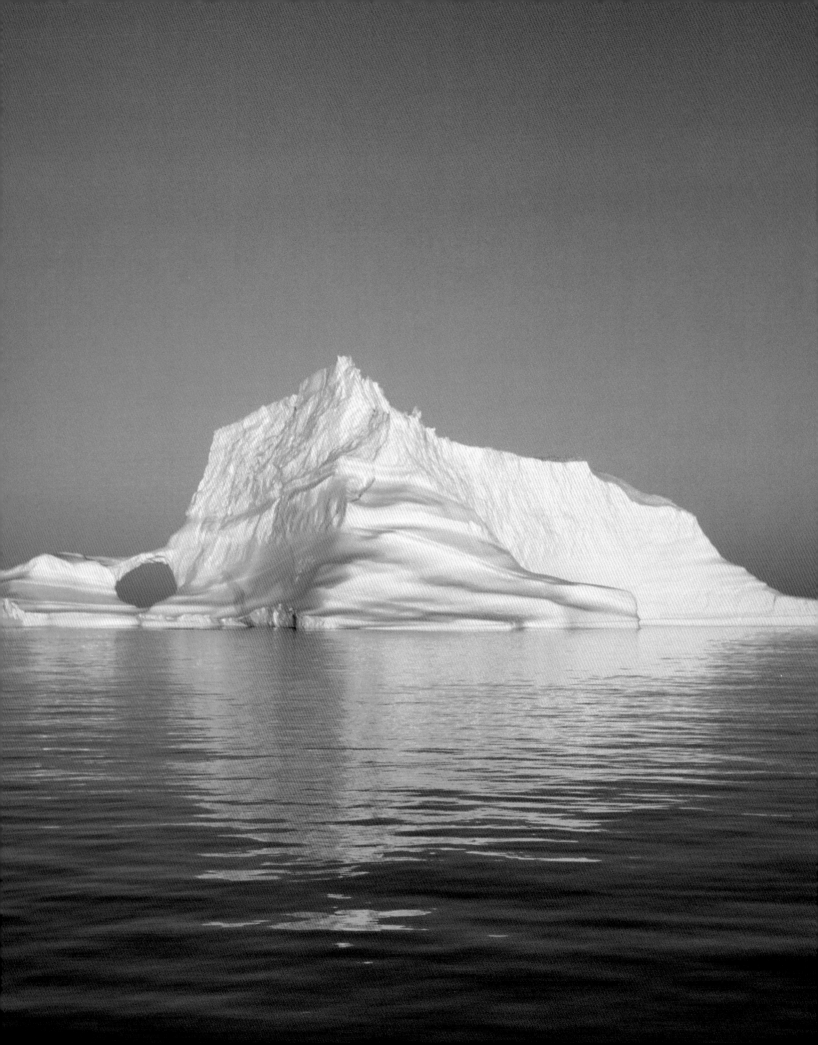

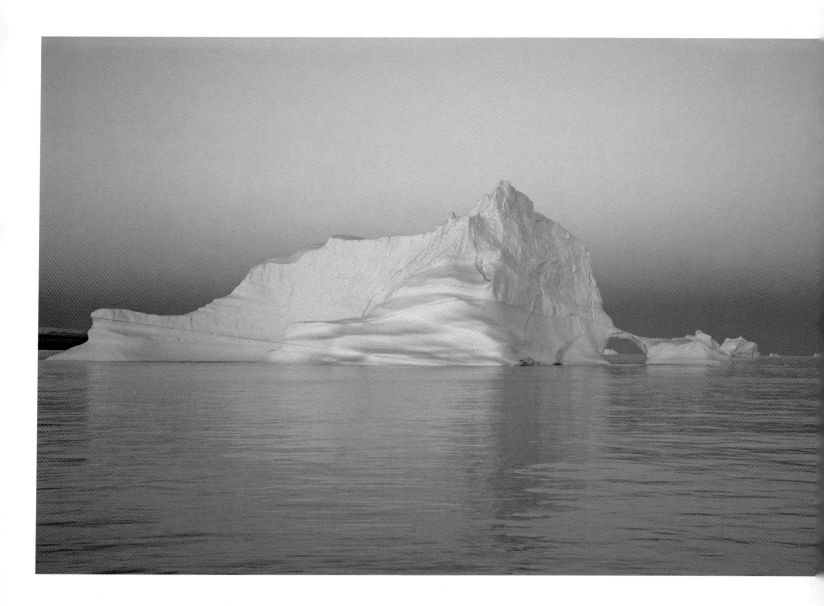

Left and above: To make an iceberg, you need only two things: a large advancing glacier and a nearby ocean. As the snout of the glacier slowly inches forward, pieces of ice continually break off and drop into the water, a process called calving. The pieces are then carried away by the ocean currents. These floating pieces of glacial ice are icebergs. In the Arctic, there are three main iceberg factories: Ellesmere Island in the Canadian High Arctic, the Svalbard Islands north of Norway, and the island of Greenland. Of the three, Greenland produces the greatest number of icebergs, about 15,000 per year, a third of which come from just six glaciers located along the country's southwestern coast. These are the fastest-moving glaciers on Earth, and they calve bergs almost like an assembly line. Most Arctic icebergs are relatively small compared with those in Antarctica. Nevertheless, some of them may be the size of a small island and long enough to allow a large cargo plane to land. The expression "just the tip of the iceberg" is an apt one – icebergs are always much larger underwater than they appear on the surface. In general, an iceberg is four to five times thicker below the water than above.

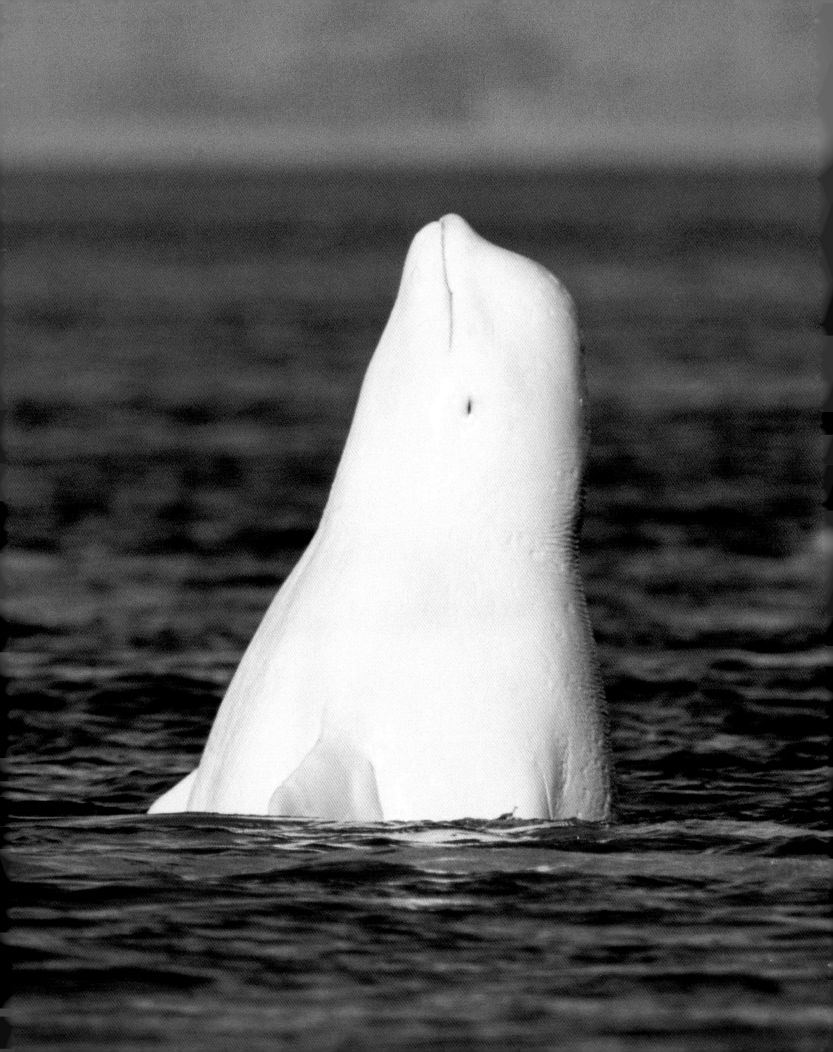

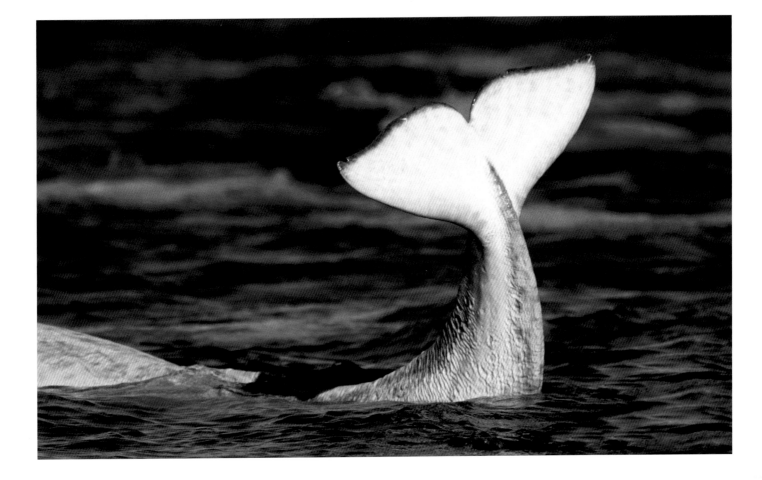

Left: Of the world's 84 species of cetaceans, only the beluga (*Delphinapterus leucas*), pictured here, the bowhead (*Balaena mysticetus*) and the narwhal (*Monodon monoceros*) are truly adapted to life in the ice. All three of these whales occur in the Arctic. (No ice-adapted whale species live in the waters of Antarctica, although more than a dozen different cetaceans have been sighted around the continent during the ice-free months of the austral summer.) If freezing seawater suddenly threatens to trap a beluga without a source of air, it can break through ice up to four inches (10 cm) thick using the padding around its blowhole.

Above: Belugas are unique among whales in that they undergo an intense period of molt every summer. To hasten the process, the whales may migrate to the warmer, less salty water at the mouths of large rivers draining into the ocean. Hundreds of belugas may gather at the outlets of certain rivers, such as Canada's Mackenzie River, which drains into the Beaufort Sea. The whale pictured here was rubbing itself on the gravel of the estuary bottom to remove its old wrinkled skin.

Following spread: After wintering along the southern edge of the pack ice, belugas migrate back to the Arctic each spring, often setting out in April, months before there is much open water to be found. Fortunately, these whales are adept at penetrating the pack ice. New channels regularly open up in this constantly shifting ice, and the whales skillfully follow narrow cracks and leads to move slowly northward. Cracks can close as rapidly as they open, however. Alternately, the water may simply freeze over in the cold temperatures. When that happens, a beluga is able to remain submerged for up to 20 minutes, during which time it may travel more than 1½ miles (3 km) in search of another patch of open water.

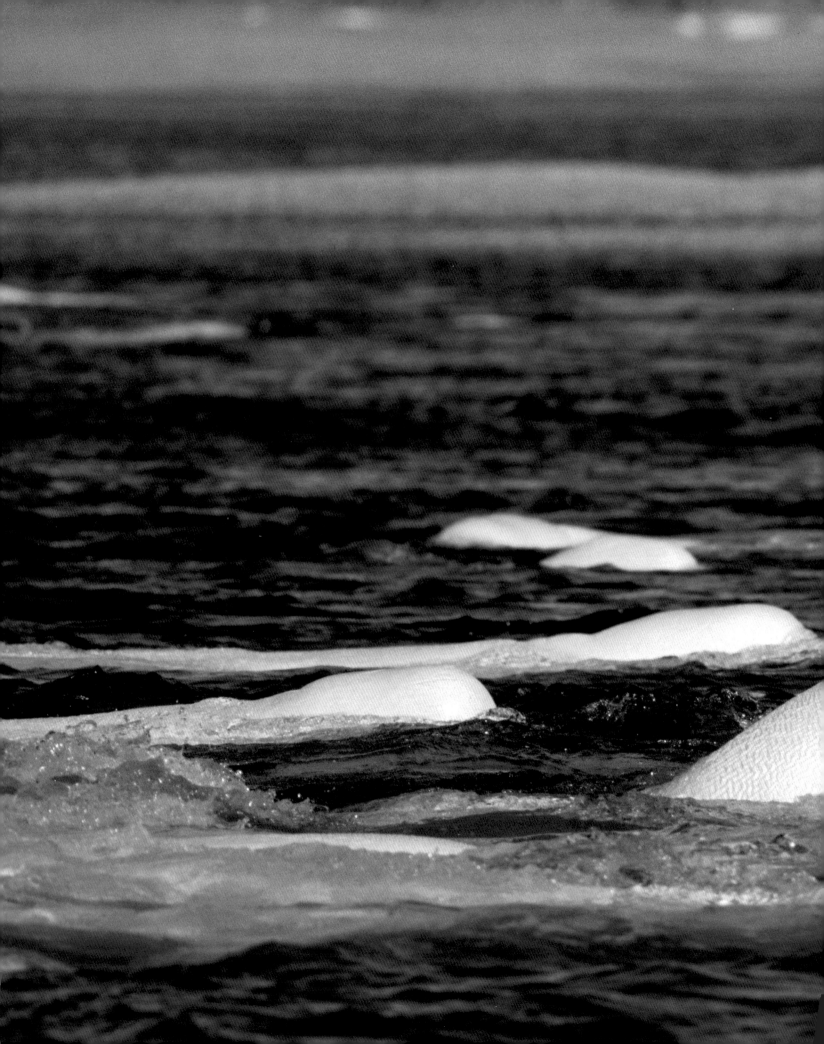

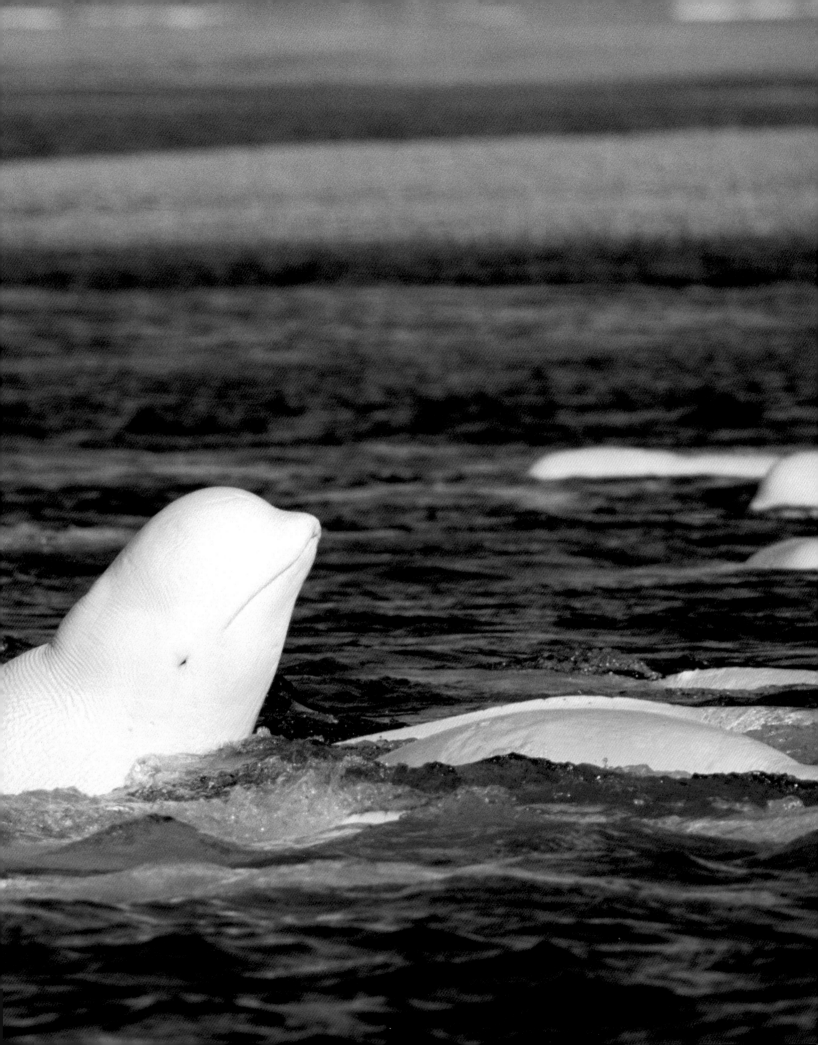

One of the main predators of the beluga is the killer whale (*Orcinus orca*), or orca, which hunts the depths of every ocean on Earth, especially the cold waters of temperate and polar latitudes. When a beluga first hears the navigational clicks of a roaming pod of orcas, it escapes under the ice edge or flees into the loose pack ice where orcas are hesitant to follow. Scientists speculate that the ice may confuse the orca's echolocation system. Also, this high-finned whale naturally avoids ice-filled waters to avoid being injured.

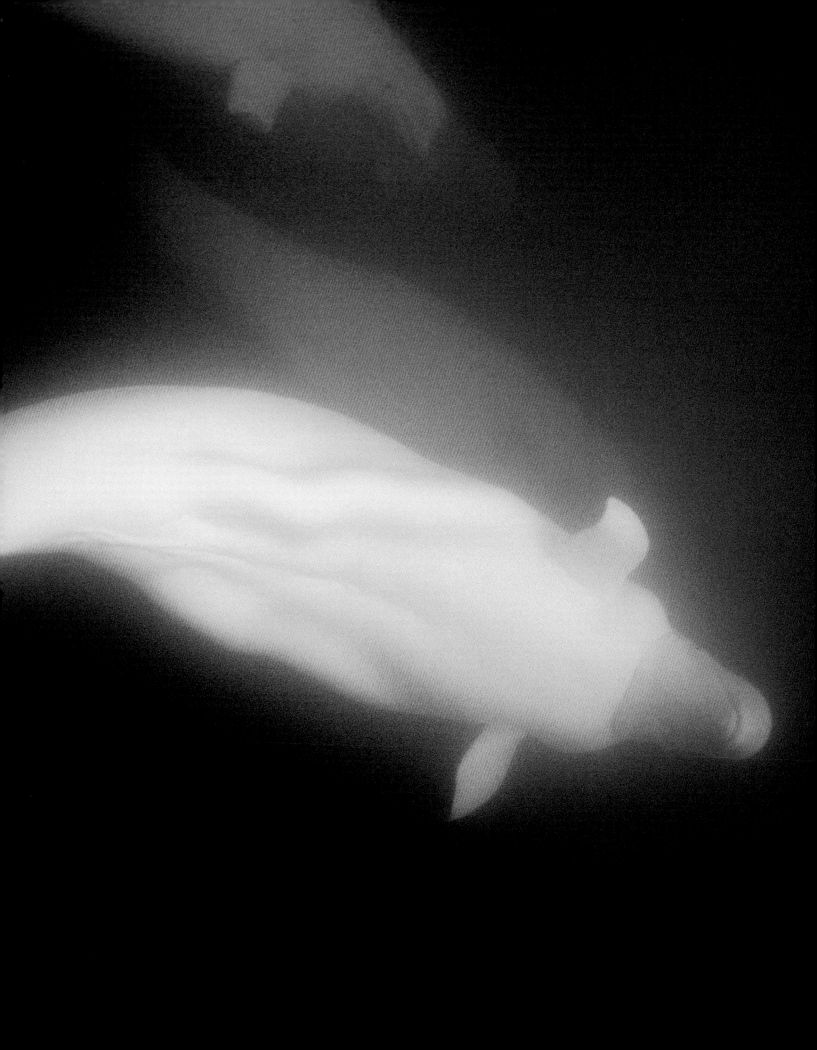

WATER

WINGS

The most northern island in North America is Canada's Ellesmere Island – a wild mountainous landscape tortured by long sunless winters and burdened by immense icecaps, some of which are 125,000 years old and half a mile (0.8 km) thick. Here, along its folded coastline, hundreds of glaciers coldly ooze toward the sea between fields of unnamed peaks that are punished and pulverized by wind and cold. This is the refuge of winter, where for 10 months of the year, the season flexes its frigidity, sometimes with such ferocity that even the rocks crack and crumble in despair. Clearly, if you want to witness the true tenacity and adaptability of life on land, this island of extremes is a good place to begin.

Yet even on Ellesmere, less than 500 miles (800 km) from the North Pole, some three dozen species of birds exploit the narrow window of summer. Among the feathered aeronauts is one of the most sought-after species in the Arctic: the elegant and ephemeral ivory gull (*Pagophila eburnea*). It was here that I had my first sighting of this enigmatic seabird. I was camped on Ward Hunt Island, a teardrop of tundra roughly three by four miles (5 by 6.5 km) in area, just off the northern tip of Ellesmere. Nothing but ice and emptiness separated me from the distant pole, and I hoped to watch birds that truly lived on the edge of life. I wasn't disappointed. Within an hour of my arrival, a lone ivory gull floated in off the ice and landed near my tent. It was one o'clock in the morning, and as the sun skimmed the northern horizon, the pure white gull was bathed in a golden glow. For a moment, it was not simply another remarkable bird of the distant frozen North but a living arctic angel. When I crawled into my sleeping bag two hours later, I was too buzzed to sleep.

If you fly in a small plane over many areas of the southern Arctic, you will notice the unmistakable glint of standing water. Even though the Arctic receives relatively little precipitation as rain or snow, water can accumulate on the surface of the tundra in innumerable lakes, ponds, rivers and streams. The underlying frozen ground, called permafrost, prevents much of the water from draining away; the cold temperatures decrease the amount lost to evaporation.

Water plays a vital role in the lives of many arctic birds, and one of its functions is to serve as a safe sanctuary for vulnerable chicks. The hatchlings of ducks, swans, geese and loons are able to swim when they are just a day or two old. Some make shallow dives at this early age. Should a fox, wolf or human threaten them, all of these birds will swim to deeper water with their chicks in tow. Many times, I've tried to sneak up on a family of geese grazing on the greenery of the tundra to photo-graph their behavior. More often that not, a wary adult has spotted me skulking around and led the family on a speedy waddle to a lakeshore or tide line, where they quickly swim out of camera range.

The summer molting period is another time when the presence of water is critical. At the end of the summer breeding season, all of the Arctic-nesting waterfowl completely molt their primary and secondary flight feathers, and the birds become temporarily flightless. In barnacle geese (*Branta leucopsis*), for example, the birds are unable to fly for 25 days or more; tundra swans may be grounded for up to 50 days.

It takes lots of energy to regrow large flight feathers, and most molting birds lose weight during this period. Researchers once assumed that the weight loss

occurred because the birds could not find sufficient food to keep up with their energy needs and had to draw on their fat reserves. Yet studies with captive barnacle and snow geese (*Chen caerulescens*) revealed that even when the geese were given access to as much food as they wanted, they still lost weight. Biologists have now concluded that the weight loss is a beneficial adaptation. As molting birds invest energy (and therefore body weight) to replace feathers, they are thereby reducing the number of days in which they are flightless.

Flightless birds are more vulnerable to predators, so molting typically occurs in safe, secluded locations where the birds can stay on the water or very near to it. Some species make lengthy migrations to special locations to molt. For example, pink-footed geese (*Anser brachyrhynchus*) in Iceland often fly to Greenland; greater white-fronted geese (*A. albifrons*) in mainland Arctic Russia frequently migrate north to the islands of Novaya Zemlya; and brant geese (*Branta bernicla*) in western Alaska may travel to Russia's remote Wrangel Island. It is interesting to note that all of these molt migrations are in a northern direction. Biologists theorize that locations farther north are safer and lack feeding competition with breeding birds and their young. In addition, the days are longer, and with increased daylight, molting birds have an easier time detecting predators. One author calls this strategy "avoidance of the dangerous dark."

Other arctic seabirds, such as puffins and murres, likewise molt their flight feathers all at once and are flightless for weeks. Since seabirds swim and hunt on the ocean, it's not a great inconvenience when they temporarily lose the power of flight, and many of them molt in the same areas where they spend the summer feeding and raising their young.

For a significant portion of arctic birds, the most important role of water is as an aquatic hunting grounds, where food is potentially plentiful and varied. Many of the smaller lakes and ponds in the Arctic freeze to the bottom in winter and so are devoid of fish. Even so, there are insect larvae and other invertebrates that are hunted by ducks and loons. The oceans in the Arctic, however, serve as the richest sources of food for resident water birds. King and common eiders (*Somateria spectabilis* and *S. mollissima*) stay fit and fat on a rich diet of amphipods, barnacles, marine worms, crabs and clams, all of which they crush with their heavy, broad bills. When foraging, these large diving ducks may reach depths of 130 feet (40 m).

Fish of one description or another are the mainstay of the larger arctic water birds, which includes the loons, puffins, murres and guillemots. These birds are the deep divers of the Arctic. The common loon has been recorded diving to 265 feet (80 m). In northern Hudson Bay, researchers attached time-depth recorders to thick-billed murres (*Uria lomvia*) and documented diving depths up to 690 feet (210 m). The murres may commute 105 miles (170 km) from their breeding colony to their ocean foraging areas, traveling each way in roughly a straight line, an indication that their destination is predetermined and that these birds possess impressive navigational skills. But these journeys are also a remarkable demonstration of the adaptive strategies that every arctic species must devise to survive in the frigid north.

Chapter opening: The scientific name of the ivory gull, *Pagophila eburnea*, is well-chosen. *Pagophila* means "lover of ice." This small hardy gull wanders over the endless pack ice, ranging as far as the North Pole, often miles and miles from the nearest land. The bird commonly scavenges the kills of polar bears and also feeds on their dung. According to Russian researcher S.M. Uspenskii, the gulls may intentionally follow the bears. "In early spring on Franz Josef Land," he observed, "each bear had its own group of ivory gulls, made up of four to six birds."

Right: Ninety-five percent of all seabirds nest in colonies, and the thick-billed murre (*Uria lomvia*) is a good example of that behavior. Roughly 50,000 pairs of murres were nesting in this colony in the Svalbard Archipelago, a small fraction of the 850,000 pairs estimated to nest throughout the islands. Downy murre chicks may jump from their lofty natal ledges when they are only 15 days old, but most of them make the great leap at three weeks. At this age, the chicks cannot fly, so they simply flutter their tiny wings and float to the ocean below, encouraged by their father's imploring calls. If the water is a distance away, the chicks bounce as they land on the tundra, then scuttle as quickly as their short legs can carry them to the water's edge.

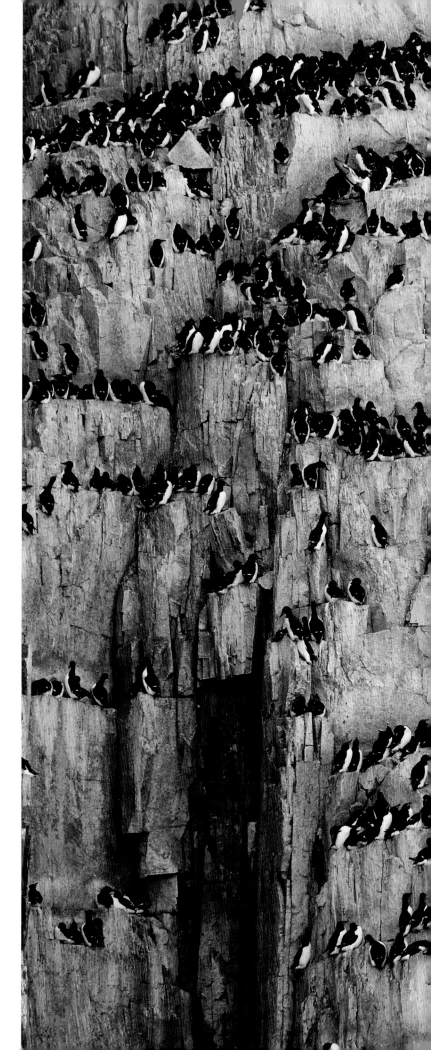

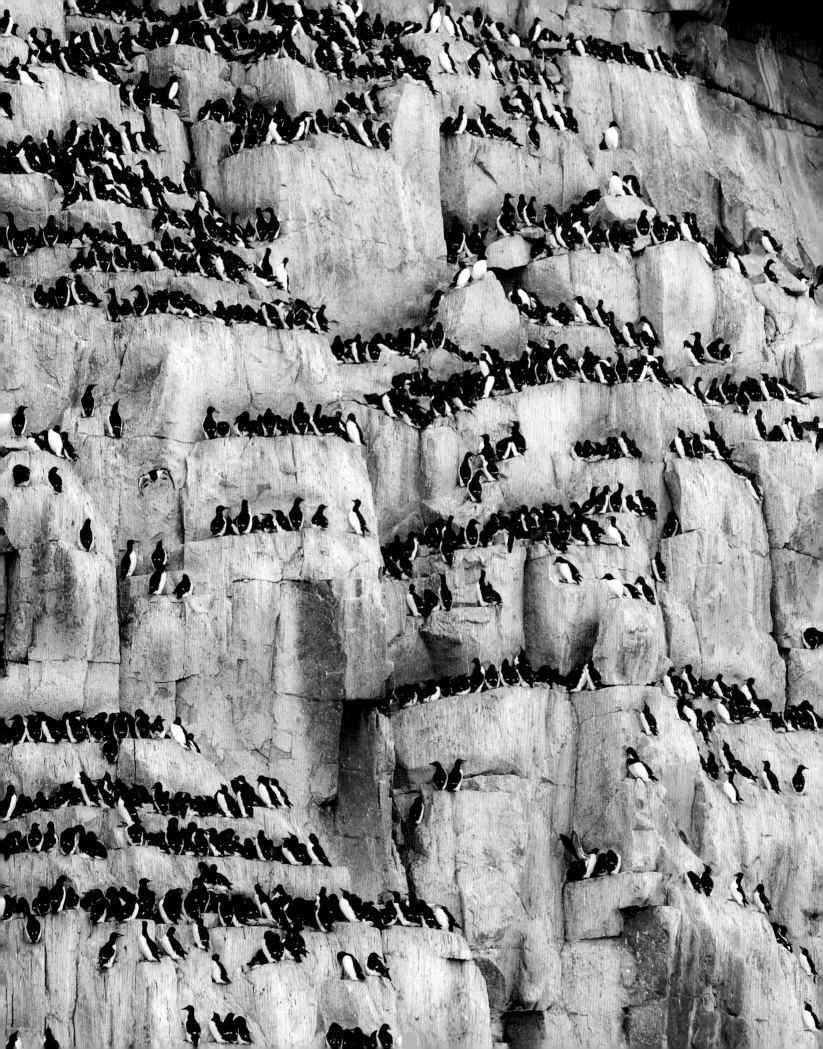

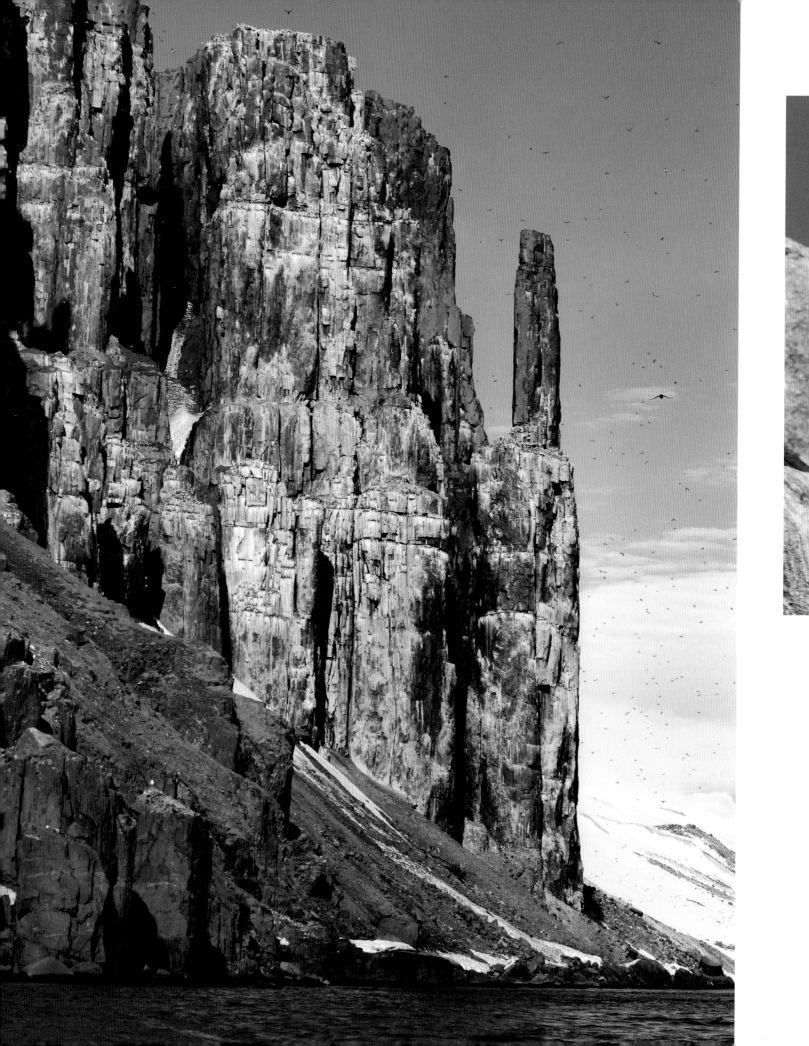

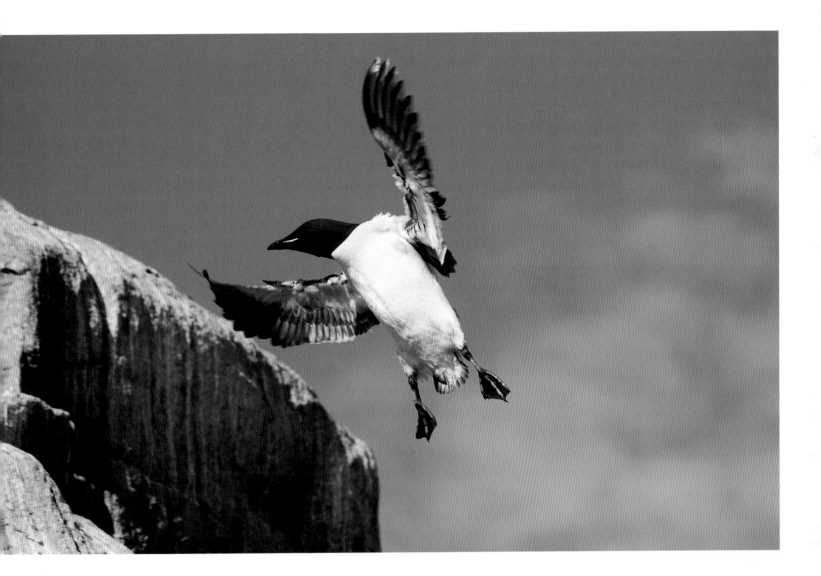

Left: When I traveled to this cliff in the Svalbard Archipelago, it was home to nesting thick-billed murres, black-legged kittiwakes, great black-backed gulls, black guillemots, Atlantic puffins and northern fulmars. With so many tenants vying for space, every nook and cranny, ledge and outcrop was occupied by a pinching beak with wings. Even so, the different types of seabirds were not scattered across the cliff face helter-skelter but were in fairly predictable sites. Puffins were in shallow burrows, wherever an adequate depth of soil had accumulated, fulmars were on wide ledges near the top of the cliff, while the murres were on narrower ledges lower down. Black-legged kittiwakes cemented their nests to rocky outcrops that the other birds avoided, and the black guillemots hid in the jumble of rocks at the base of the cliff.

Above: The thick-billed murre, called Brünnich's guillemot in Europe, can live for more than 25 years and doesn't begin to breed until it is five or six years old. Typically, it nests in dense colonies on the bare ledges of lofty cliffs, each bird claiming a narrow width of rock and defending it aggressively with its pointed beaks. A pair may use the same ledge in successive nesting seasons.

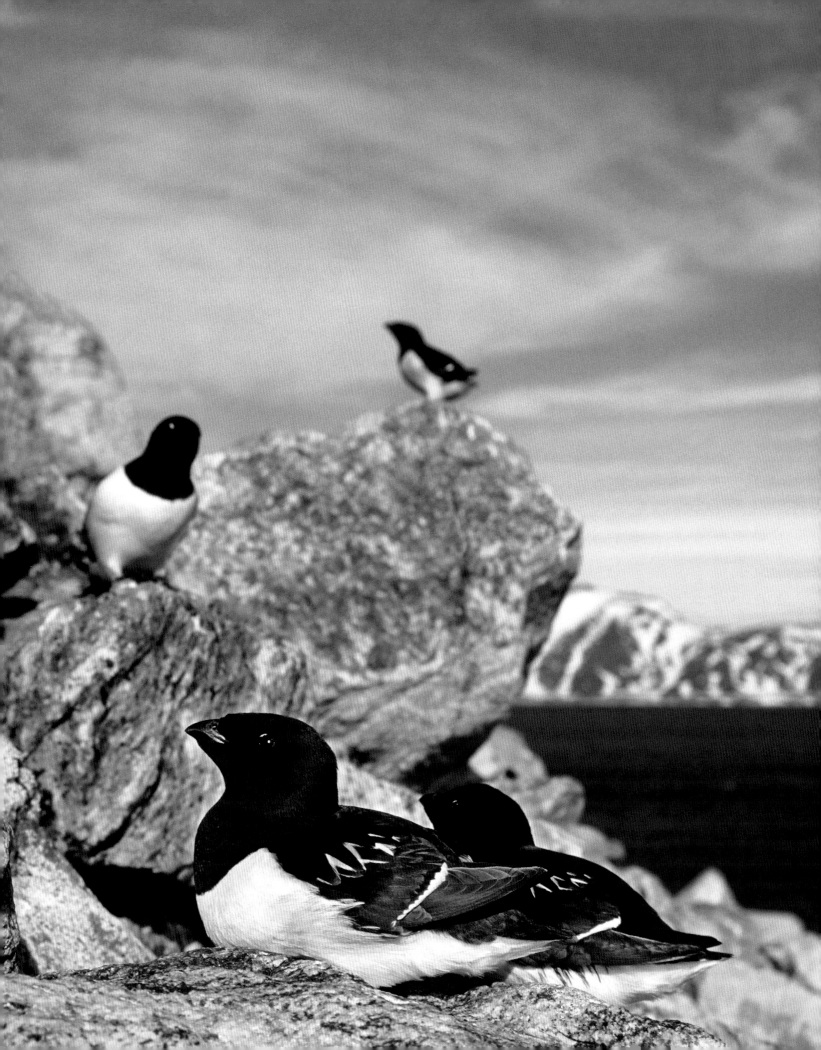

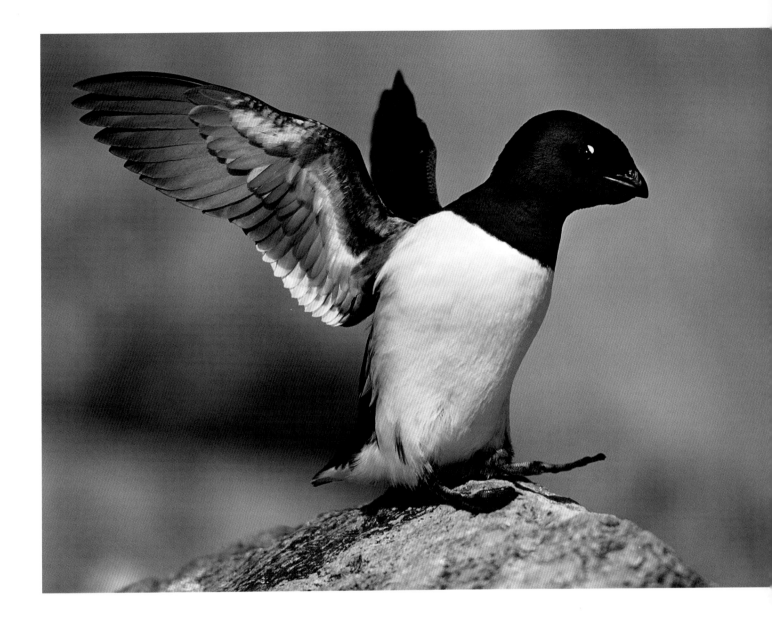

Left: Some researchers claim that the dovekie (*Alle alle*), or little auk, is the most abundant seabird in the entire Arctic, with a global population somewhere around 15 million pairs. The pairs nest in large colonies, sometimes containing hundreds of thousands of birds. This small seabird is a frequent prey of large predatory gulls and arctic foxes, so it lays its single pale blue egg deep in a sheltered crevice, typically in the field of boulders that accumulates at the base of cliffs. When I've explored these sites, the nests were always out of arm's reach and the access narrow enough to prevent a hungry fox from squeezing inside.

Above: The dovekie is the smallest member of the auk family in the North Atlantic. The auks are the Northern Hemisphere's ecological equivalent of the Southern Hemisphere's penguins. Auks and penguins are similar in many ways. Both nest in large colonies, forage underwater using their wings or flippers to propel themselves and feed on fish, squid and crustaceans. The difference is that auks can fly, while penguins cannot. Auks need flight to reach nesting cliffs that are inaccessible to predatory arctic foxes. Penguins nest where there are no native predatory land mammals, so flight is unnecessary.

I had my first glimpse of a tufted puffin (*Fratercula cirrhata*) through the fog on a wind-battered cliff in the Bering Sea. Like its relative the horned puffin, the tufted puffin lives in the cold fertile waters of the North Pacific. During the summer breeding season, all of the puffins have a large colorful beak, and this characteristic has earned them the nickname "sea parrots." In winter, all the puffins doff their handsome "wedding dress." The face of the tufted puffin darkens, it loses its golden tufts, and it sheds the bright colorful keratin sheaths encasing its beak.

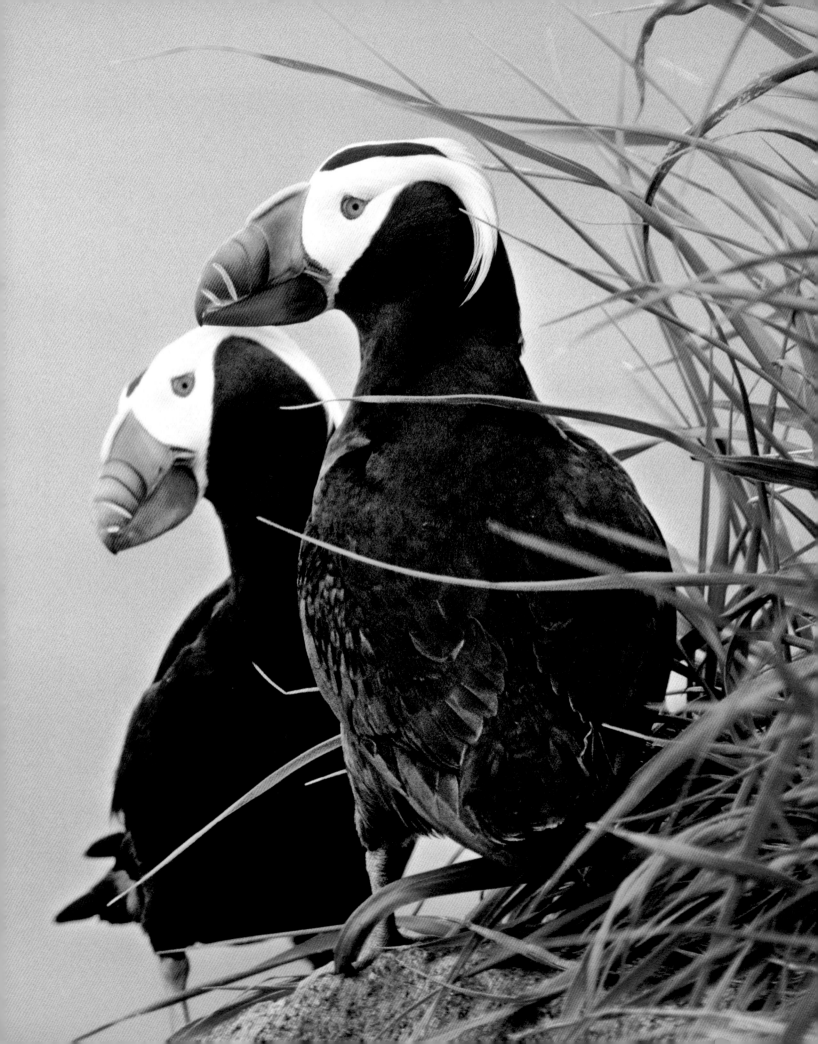

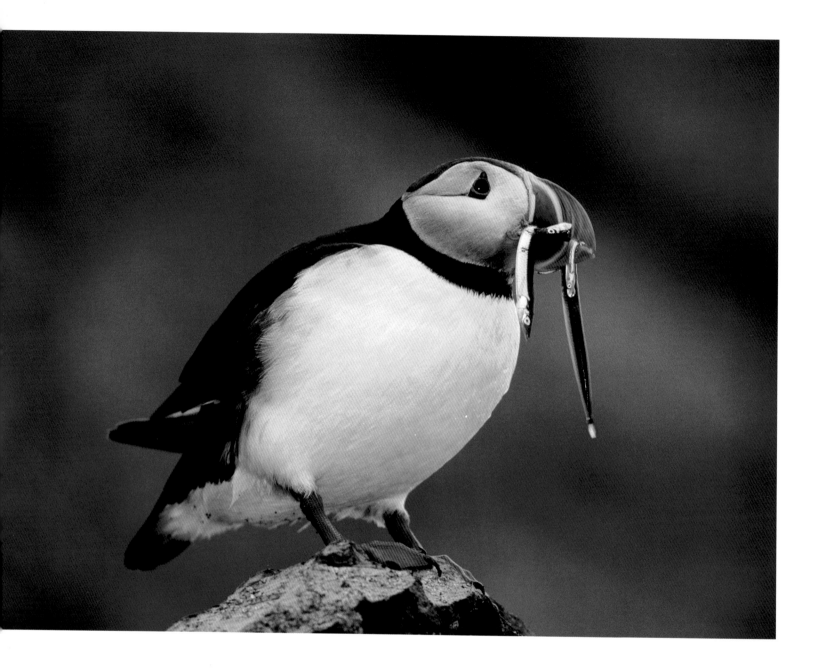

Above: More photographs have been taken and words written about the Atlantic puffin (*Fratercula arctica*) than any other arctic seabird. It ranges well into the Arctic along the west coast of Greenland and north to the Svalbard Archipelago, but it also occurs south along the temperate coast of eastern North America and western Europe. A foraging puffin can catch as many as 20 small fish in a single dive. The roof of this bird's mouth is covered with backward-pointing spines that grip the slippery prey and hold it in place while the bird continues fishing.

Right: The horned puffin (*Fratercula corniculata*) occurs in the Bering and Chukchi Seas of the North Pacific. After digging a nesting burrow up to 10 feet (3 m) in length, the puffin lays a single white egg on a bed of dry grass. All three species of puffins lay just one egg. A number of factors limit the clutch size to a single offspring: a relatively short nesting season, small food deliveries by the parents, and distant foraging grounds, where the adults may have to travel to find food.

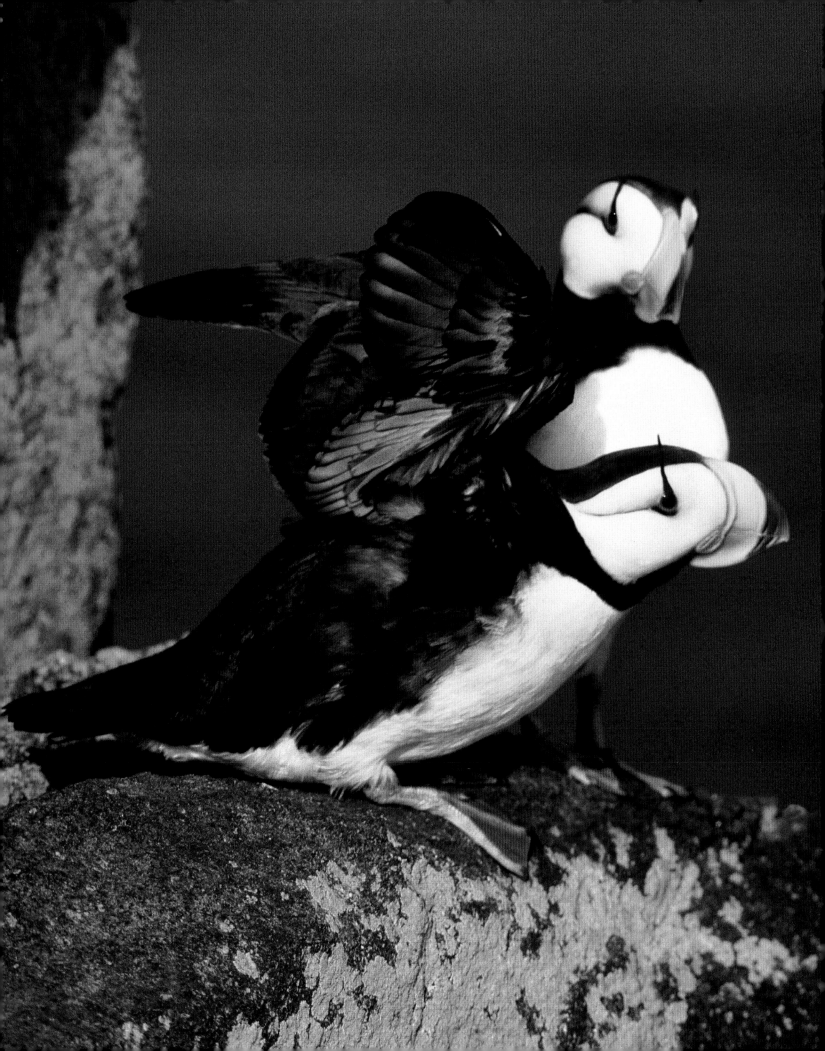

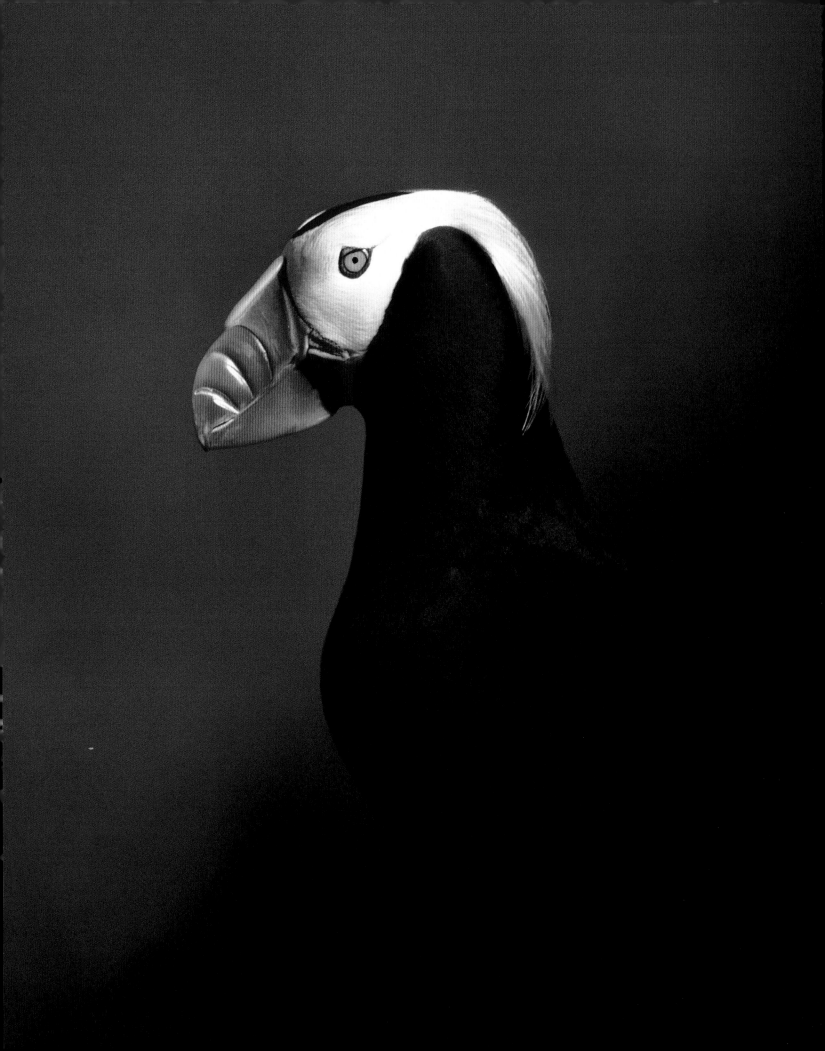

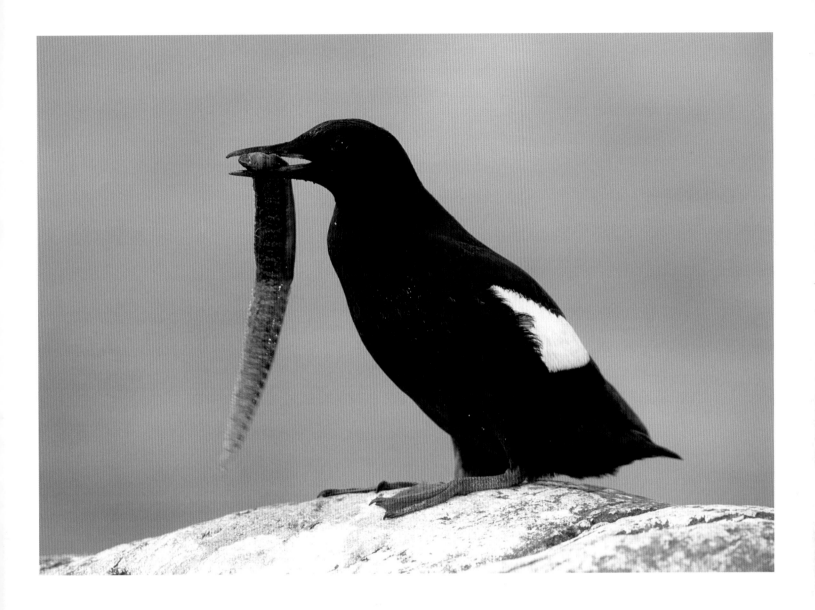

Left: It's been written that seabirds, such as this tufted puffin, nest in large colonies because there is a limited number of nesting sites and they must therefore squeeze together. Indeed, sometimes that is the case, but there are other important reasons why seabirds like to crowd and cram. One benefit is information sharing. When food is scattered and its location unpredictable, as fish commonly are in the Arctic, a few birds searching on their own may easily miss them. When a group of seabirds is foraging over a large area, however, there is a much better chance that at least some of the birds will discover where the fish are schooling. Later, members of the colony simply watch the direction taken by those birds that have successfully found food and follow them to the source.

Above: The black guillemot (*Cepphus grylle*) is another member of the auk family, which also includes puffins, murres, dovekies and others. Most of the northern-nesting auks flee from the Arctic in the autumn and spend the winter along the southern edge of the fragmented pack ice. The black guillemot is an exception to this rule. This tough little seabird often stays behind, finding small areas of open water that are kept ice-free by winds and strong currents. Here, it dives for crustaceans and fish, such as the sand lance pictured.

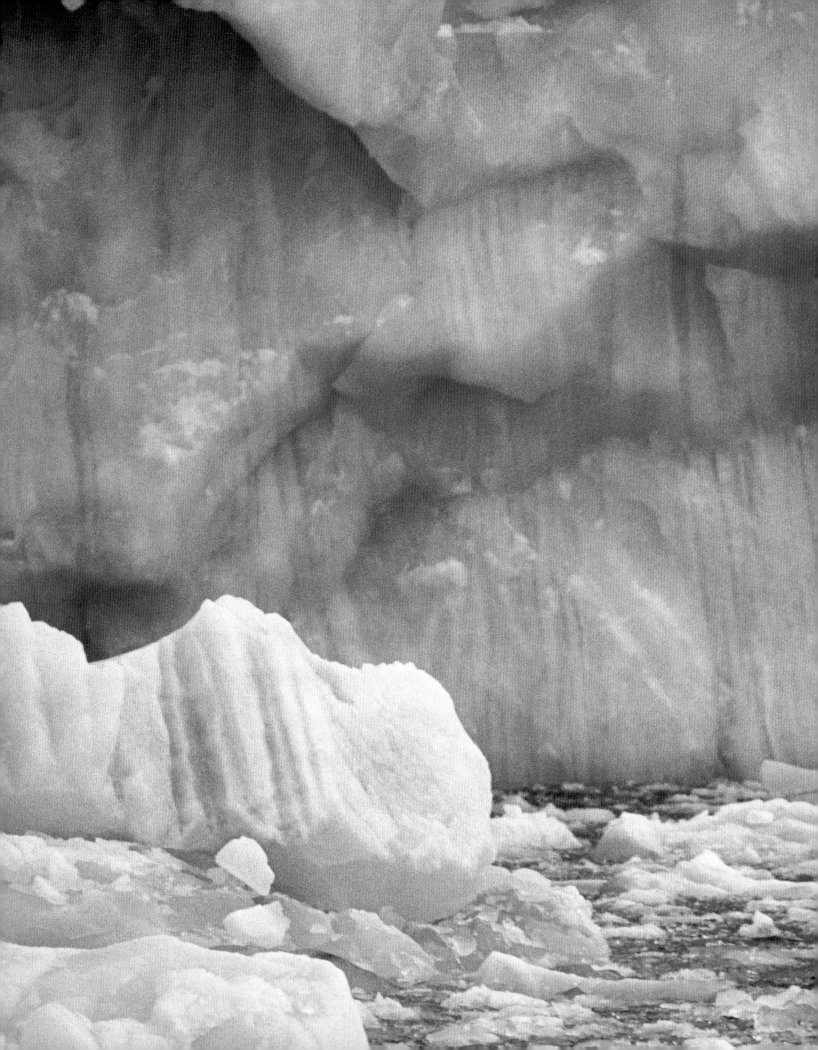

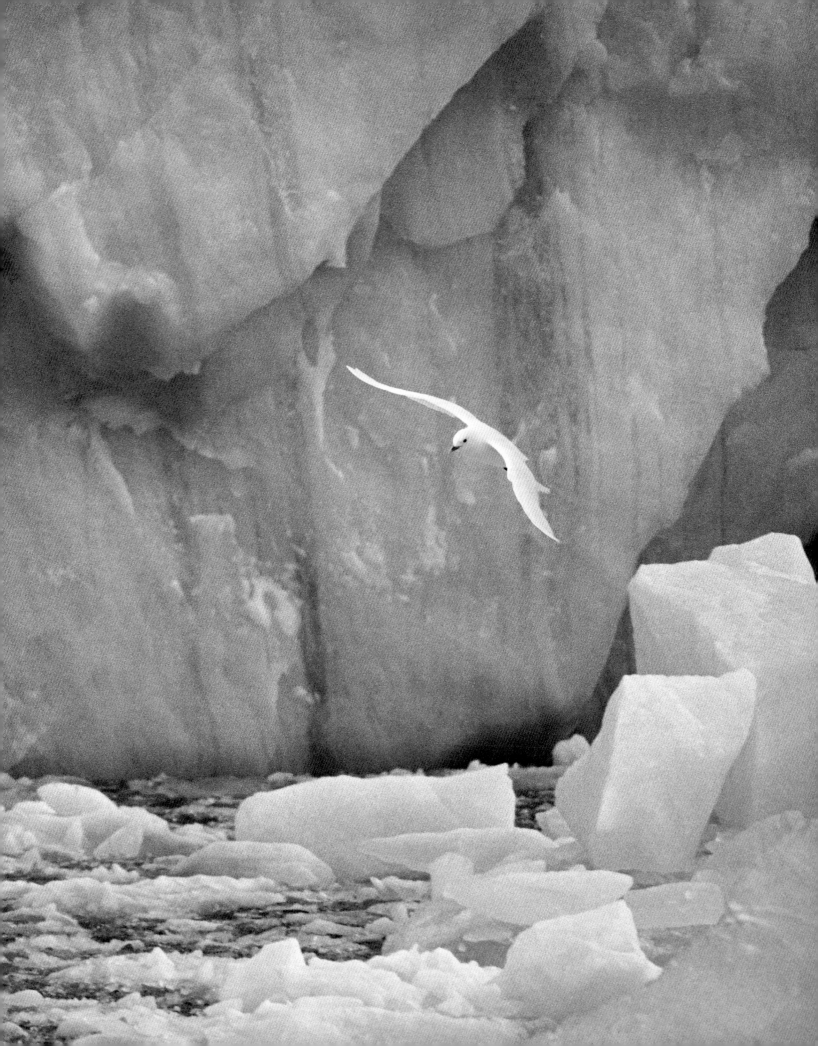

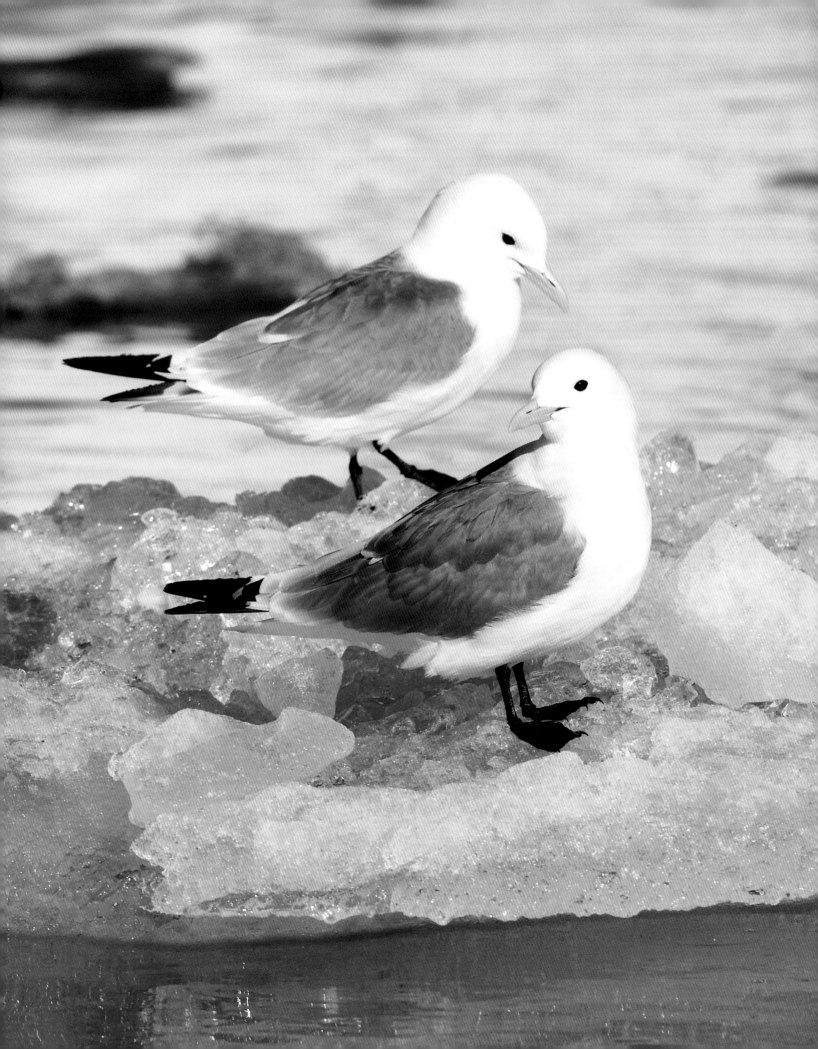

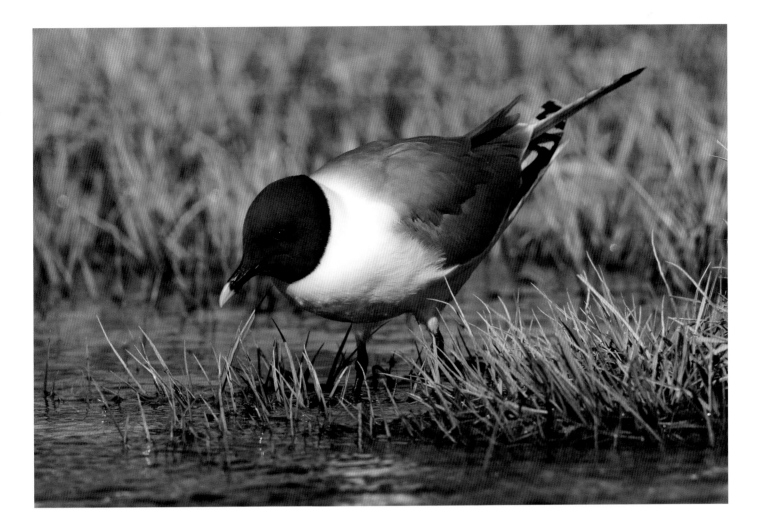

Previous spread: This ivory gull coursed back and forth in front of the imposing snout of the Monaco Glacier in Norway's Svalbard Archipelago. Farther along the glacier, three other ivory gulls were doing the same, searching for amphipods and other invertebrates that are carried to the surface as meltwater wells up from beneath the glacier. When prey is sighted, the gull lands on the water with outstretched wings, snatches the victim and takes off again in an instant.

Left: The common name for the black-legged kittiwake (*Rissa tridacyla*) is derived from the bird's melodious song, which is a repetitive "kitti-wake, kitti-wake, kitti-wake." The birds may nest in huge colonies containing over 100,000 pairs, where the racket from so many voices can be deafening. These kittiwakes are resting on floating fragments of glacial ice. Earlier, they fed on small crustaceans that had been flushed to the surface by an upwelling at the nose of the glacier.

Above: A Sabine's gull (*Xema sabini*) is searching for fingerling arctic char (*Salvelinus alpinus*) sheltering in the calm water along the edge of a fast-flowing stream on Victoria Island in the Canadian Arctic. Sabine's gulls migrate farther for the winter than any other gull in the Arctic. Those in North America travel to the central coast of South America, flying at least 8,000 miles (13,000 km) twice a year.

Above: The swan is unmistakable, and a single common species ranges throughout the circumpolar Arctic, although it has several different names. In North America, we call the bird the tundra swan (*Cygnus columbianus*); in Eurasia, it is Bewick's swan. The tundra swan is the largest bird in the Arctic, with males weighing up to 23 pounds (10.5 kg). These short-tempered birds are bold defenders of their nest and young. As a result, intruders are usually attacked unmercifully. Swans readily chase geese out of their territories, and if they catch the trespassers, they may trample and bite them repeatedly. The aggressive nature of these large powerful birds also serves them well in protecting their offspring from foxes, eagles, jaegers, ravens and gulls, none of which are likely to succeed in snatching a swan egg or hatchling if either parent is in attendance.

Right: The pink flowers blooming among the mosses are those of the moss campion (*Silene acaulis*). The flowers and mosses are fertilized by a large seabird colony nesting on a cliff beyond the left edge of this photograph. In the distance, Svalbard's 14th of July Glacier is calving small icebergs in the summer warmth. Tundra swans are rare non-breeding migrants to the islands with fewer than 20 sightings recorded. Clearly, swans are strong enough flyers to reach the Svalbard Archipelago, but the breeding and foraging advantages are too few for the migration to become a regular occurrence.

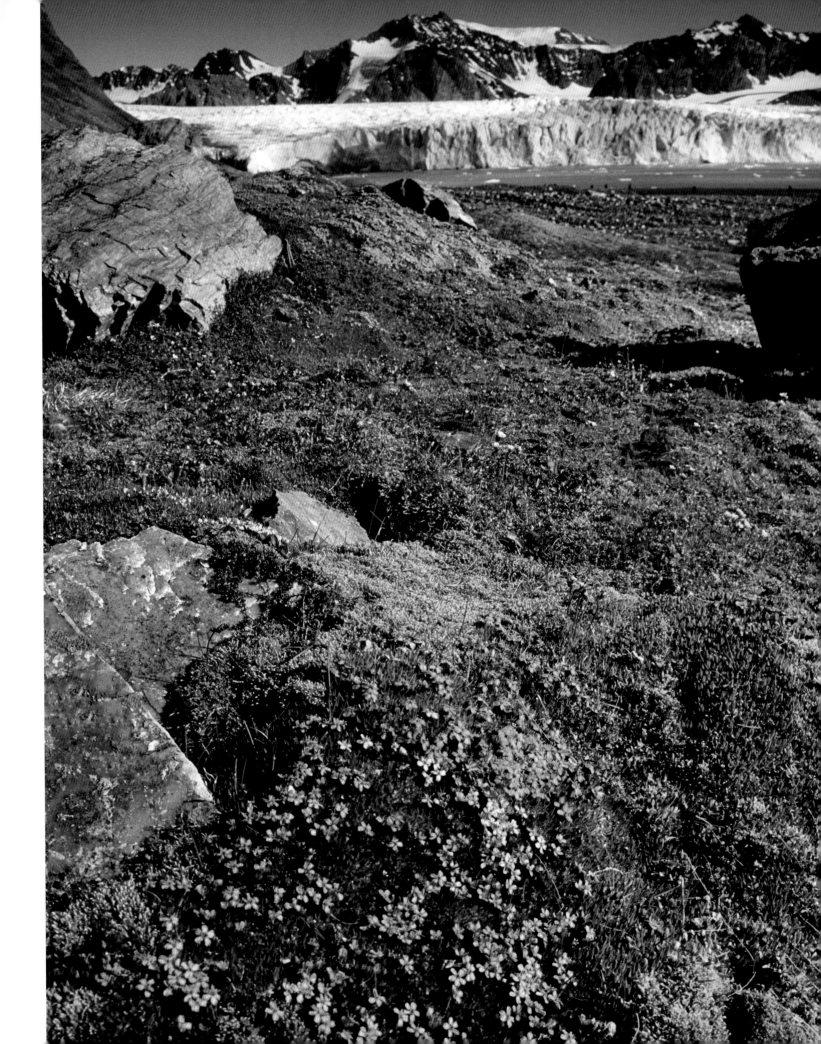

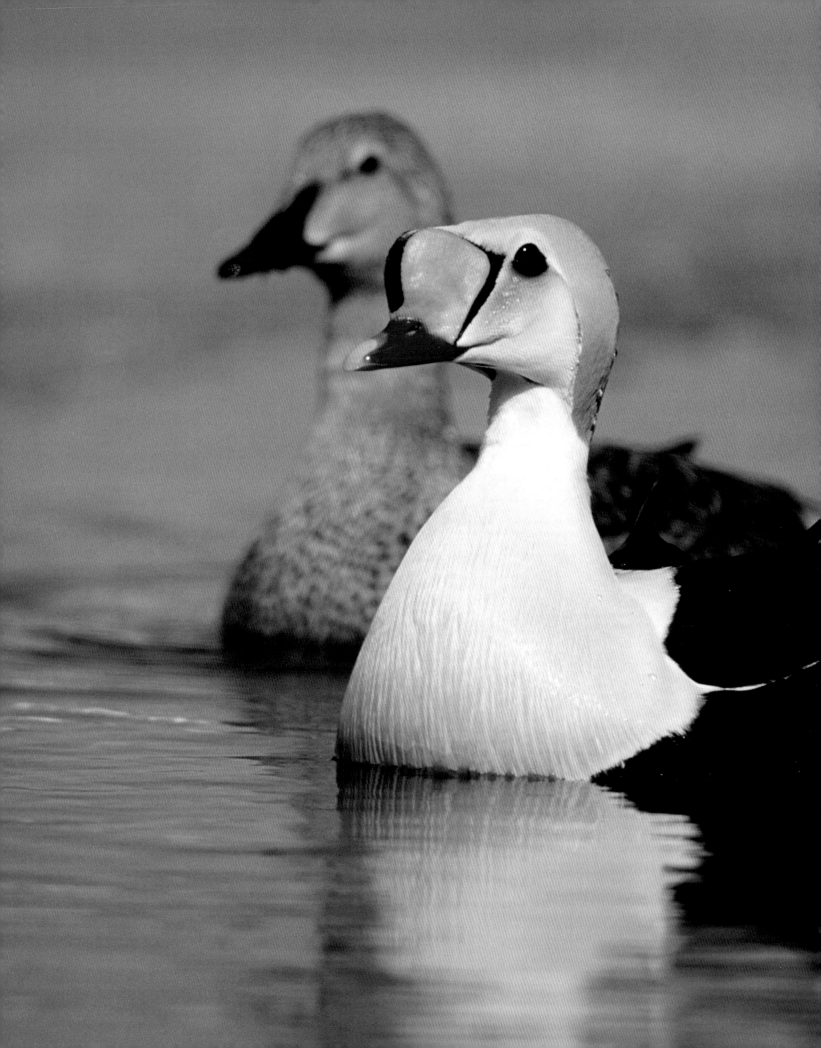

Three different male king eiders (*Somateria spectabilis*) were competing for the attention of this drab-colored female: several times, the males surrounded the female on the water. Courtship displays included rearing up out of the water and flapping their wings, rotating their heads rapidly from side to side and bobbing their beaks up and down while cooing loudly. In eiders, the male guards the female until her clutch is complete and she begins to incubate. By then, he is assured that another male will not fertilize any of the female's eggs, and he leaves her to search for another mate.

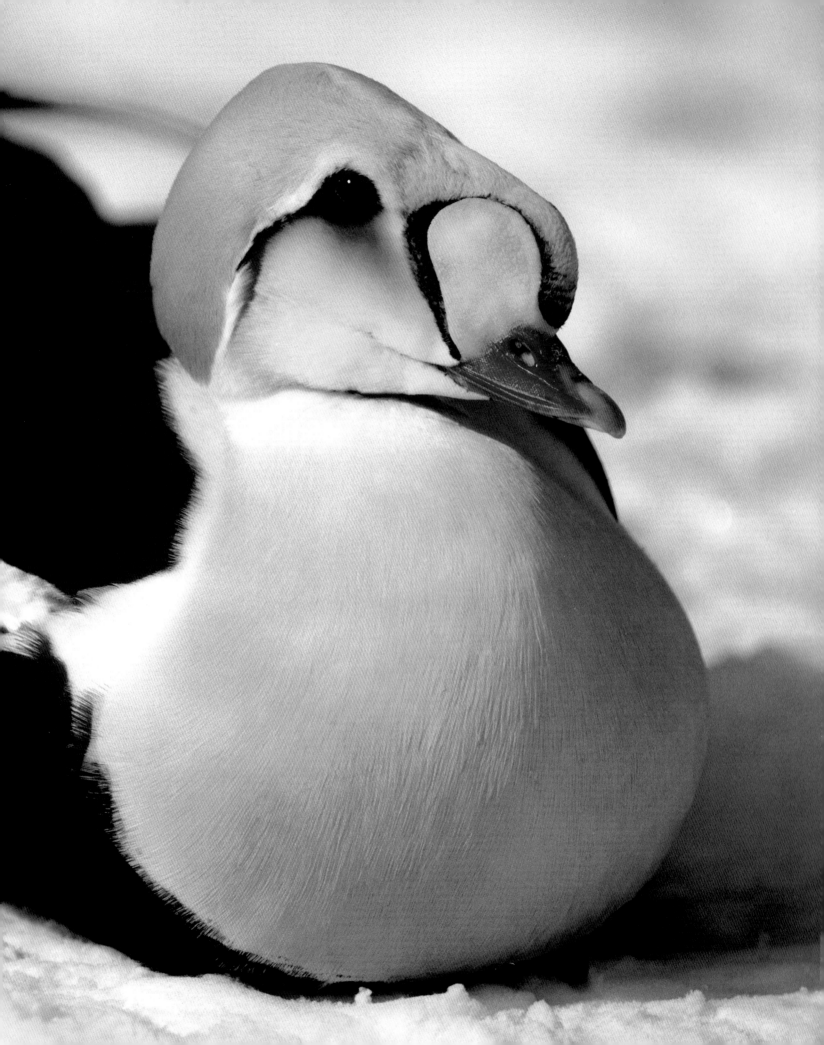

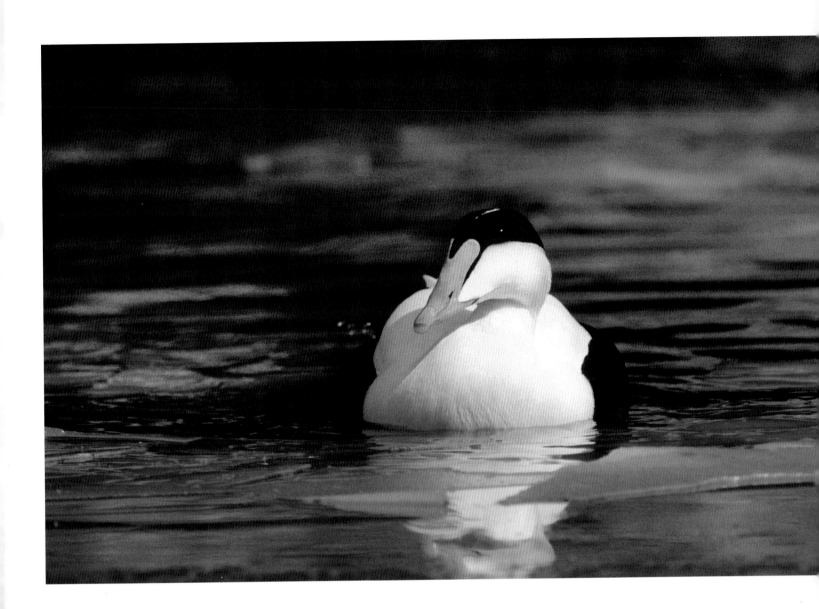

Left: The male king eider is arguably the most colorful, ornate bird in the Arctic. This circumpolar sea duck makes dives to depths of 50 feet (15 m) or more, where it scours the seabed for mollusks, crustaceans and sea stars. The colorful plumage and beak of the male king eider is an honest signal of the drake's health and vitality. Unhealthy drakes that forage poorly and/or are infected with parasites are less brightly colored. Biologists believe that female eiders use such colorful cues to evaluate the desirability of potential partners.

Above: The male common eider (*Somateria mollissima*) weighs up to 5¾ pounds (2.6 kg) and is the largest duck in the Arctic. These ducks are also the source of eiderdown, the famously warm filling used in sleeping bags, quilts and winter jackets. The all-brown female eider plucks the soft, fluffy feathers from her belly to line her nest. Once the ducklings hatch and leave the nest, the down can be collected, and this is done by people in many parts of the Arctic. It takes about 60 nests to produce a little more than two pounds (1 kg) of eiderdown.

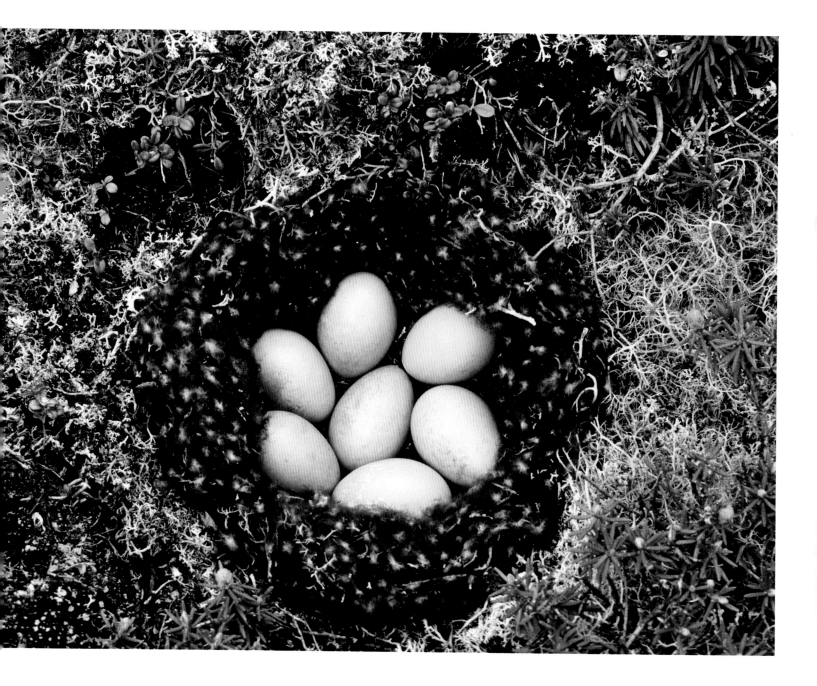

When making her nest, the female long-tailed duck (*Clangula hyemalis*) plucks down from her belly to insulate her clutch from the elements. She alone incubates the eggs; the male long-tailed duck, like most male ducks, has nothing to do with his family. After he inseminates his partner, he abandons her. An incubating female leaves her nest three to four times during each 24-hour period. Typically, she flies out to sea and returns within four minutes, but before setting out, she covers the eggs with down to conceal them from predators.

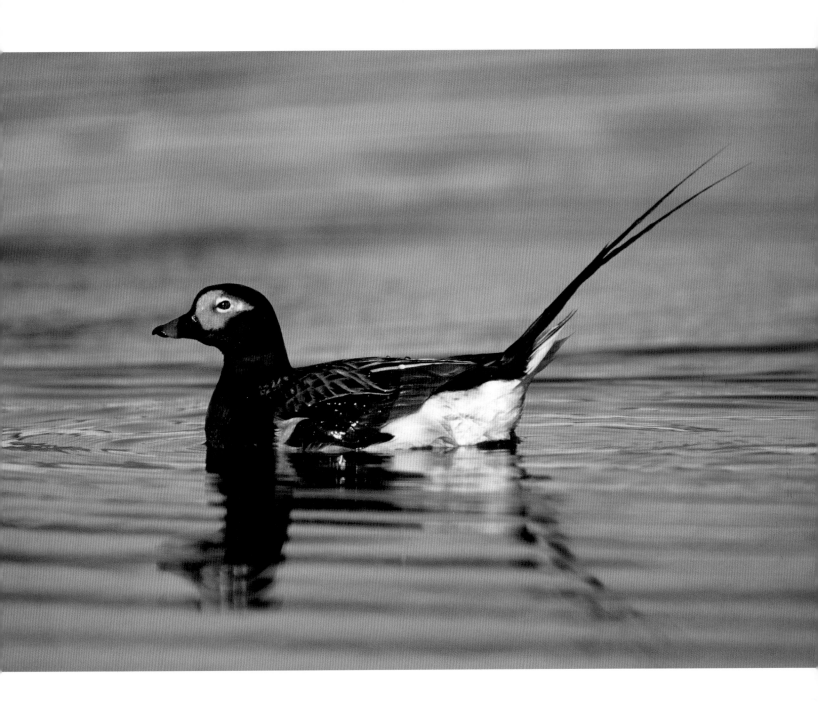

Hearing the melodious call of a male long-tailed duck is one of the great delights of awakening in a tent on the arctic tundra. The bird is more vocal than most ducks, and its talkative "OW-owLET, OW-owLET" carries a great distance across the water. The long-tailed duck's scientific name, *Clangula hyemalis,* is a reflection of the bird's favored habitat and vociferous nature – *Clangula* comes from the Greek word for noise, and *hyemalis* comes from Latin and means wintry.

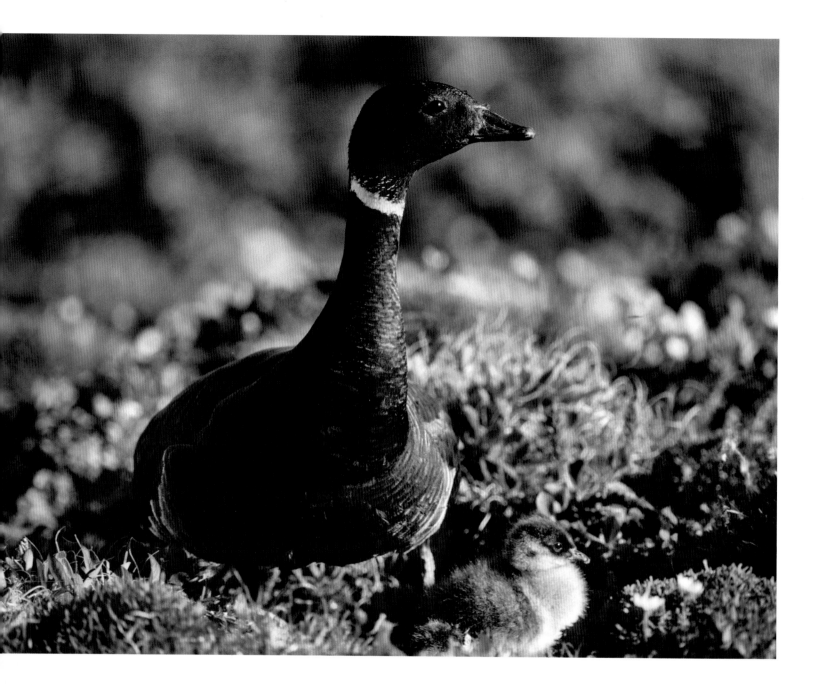

Above: This female brant (*Branta bernicla*) nested within 150 feet (45 m) of a nesting snowy owl, a common strategy in several species of arctic geese. The owl's aggressive defense of its own nest likewise protects the nearby geese from egg-stealing arctic foxes. In one study in Arctic Canada, snow geese were 90 percent successful when they nested near a guardian snowy owl. Only 23 percent of nests hatched successfully when no owl was nearby.

Right: The snow goose nests in the North American Arctic and on Russia's Wrangel Island off the northeastern coast of Siberia. It occurs as two subspecies, a larger greater snow goose and a smaller lesser snow goose. For many years, the "blue goose," pictured here, was thought to be a separate species. Eventually, biologists realized it was simply a color variation of the lesser snow goose. White and blue adults may mate with each other and produce young of either or both colors.

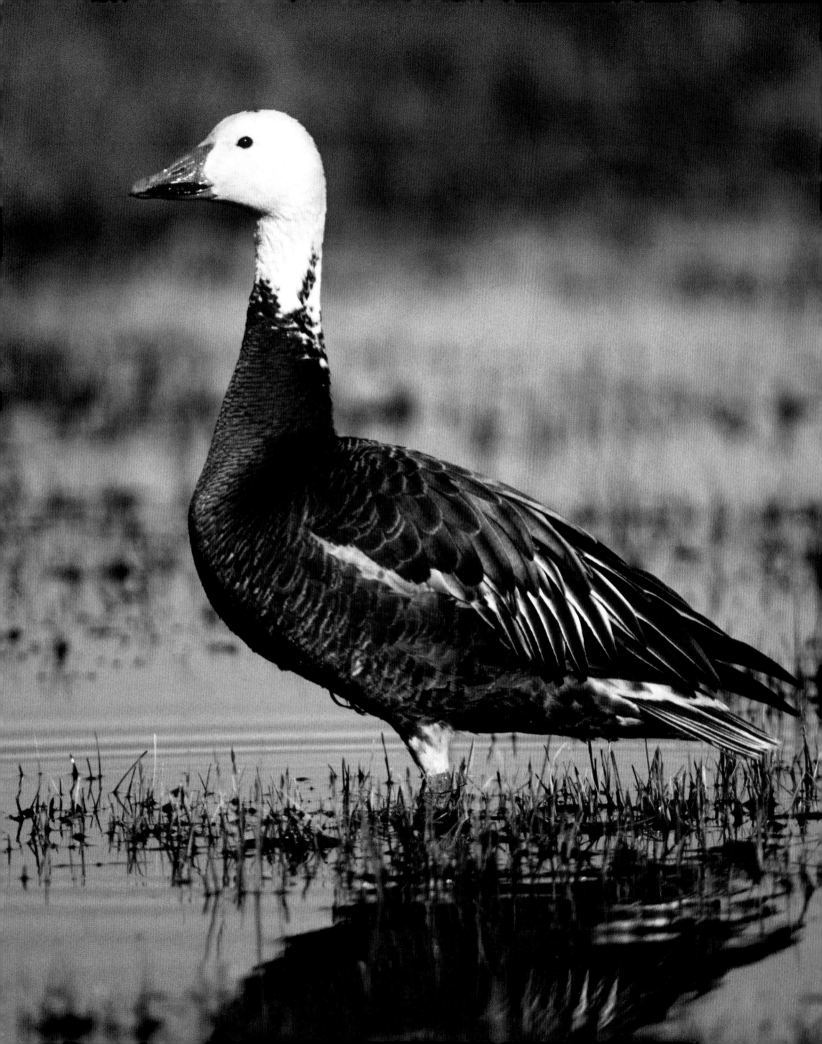

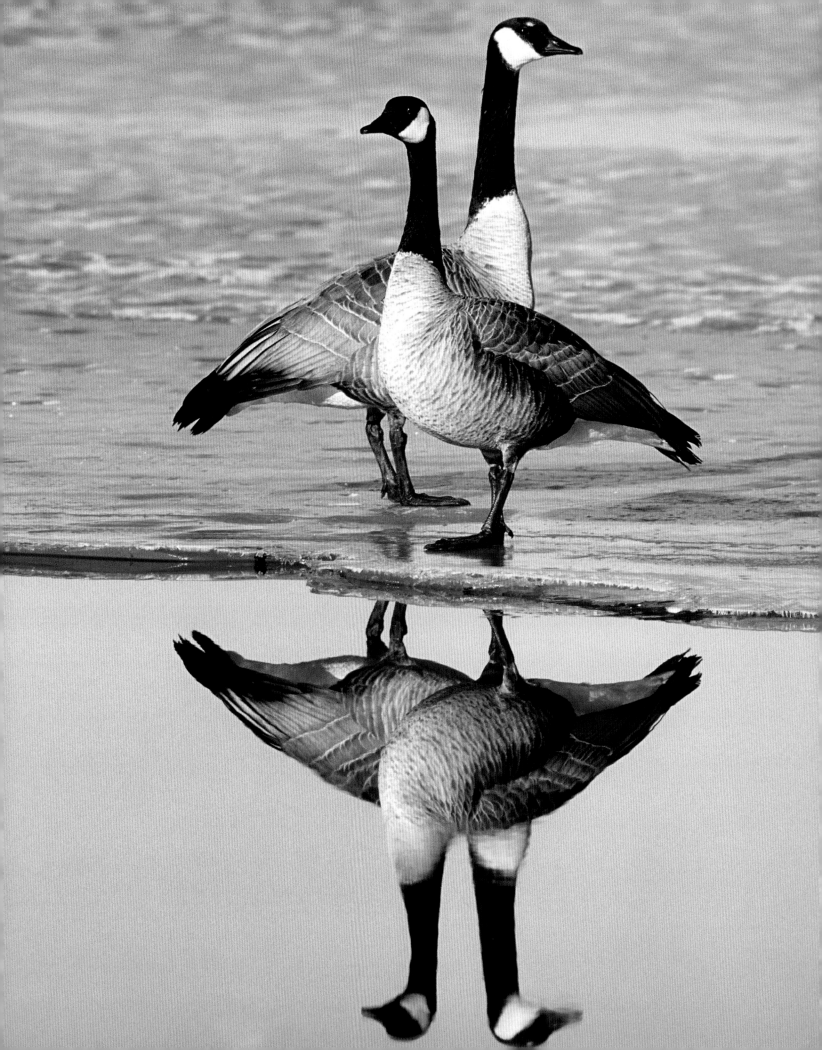

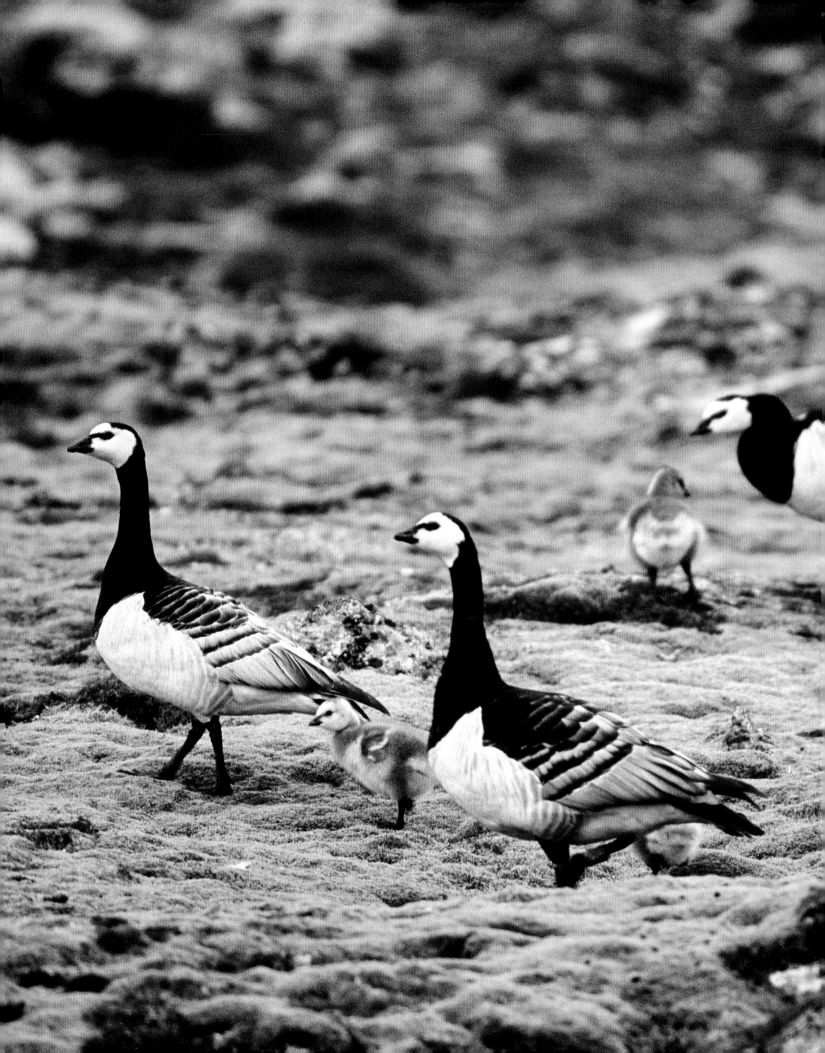